INSURGENT IMAGES

INSURGENT IMAGES

The Agitprop Murals of Mike Alewitz

PAUL BUHLE and **MIKE ALEWITZ**

Foreword by Martin Sheen

FOR AGITPROP ARTISTS EVERYWHERE

Library of Congress Cataloging-in-Publication Data

Buhle, Paul, 1944–
Insurgent Images: The Agitprop Murals of Mike Alewitz / Paul Buhle and Mike Alewitz.
p.cm.
Includes bibliographical references.
ISBN 1-58367-034-3 (pbk.)
1. Alewitz, Mike–Themes, motives. 2. Mural painting and decoration, American–20th century.
3. Labor unions and art–United States. 4. Politics in art. I. Buhle, Paul, 1944– II. Alewitz, Mike.

ND237.A345 A4 2001
759.13–dc21
2001030709

Monthly Review Press
122 West 27th Street
New York, NY 10001
www.monthlyreview.org

10 9 8 7 6 5 4 3 2 1

This book was made possible by a generous grant from The Puffin Foundation, Ltd.

DESIGN BY KEITH CHRISTENSEN
Cover photograph by Tony Masso

Contents

Foreword

YOU WON'T FIND MIKE ALEWITZ'S ART in the usual locations. His murals are in places like South-Central Los Angeles, or on the radiated walls of Chernobyl, or in the barrios of Nicaragua, Mexico City, and Oxnard, California. He paints in the bombed city of Baghdad.

Some of his creations are on the walls of union buildings, or in the schools and libraries of working-class communities. Many of his murals are not on walls at all, but are proudly carried on picket lines and demonstrations by people engaged in vital struggles for decent working conditions, an end to racist violence, or for the rights of immigrant workers.

Mike's murals often contain images of well-known working-class leaders: Martin Luther King, Emiliano Zapata, Harriet Tubman, Cesar Chavez and Malcolm X. Others are not so well-known or have been lost to us—like early labor leaders Lucy and Albert Parsons or Wesley Everest. Some are martyrs of our own times like Ben Linder and Karen Silkwood. And all of the paintings are peopled by unknown workers of all nationalities.

The murals tell the story of those who feed and clothe us—of those who produce all the wealth of humanity.

Who are the people that Mike Alewitz paints for? They are workers who stand on bloody floors performing the repetitive, grueling, dangerous, and alienating work that gives us our burgers. They are immigrant laborers who stoop all day in wet, dirty, and poisonous mushroom houses, or blazing hot fields to provide us with food. Alewitz's murals are painted for the striking-coal miners, teamsters and textile workers who keep us warm. They are painted for men and women exposed to the most toxic substances in chemical plants while creating our medications.

Despite their contributions, these workers rarely appear in art or the media, except as caricatures or buffoons.

The art in this book is quite unique—it not only has a working-class audience, but the workers frequently participate in the painting themselves. And most importantly, all of these art projects are tied to key struggles that the workers initiated. Mike's murals form an outline of recent labor history.

Some of this work has been censored or destroyed by those who fear the truth being placed on their wall. But while images can be removed from walls, the solidarity we are building lives on.

Today we are faced with an ever more militaristic and profit driven corporate America. We artists can play an important role in helping to inspire and mobilize support for the just struggles of those with no voice.

Mike's work provides an important example of how an individual, by basing his art on the creative power of the working-class, can create a body of work which helps to educate, organize and agitate for a better world.

MARTIN SHEEN
MALIBU, CA

VISUAL RADICALISM
IN THE UNITED STATES AND THE
MURAL ART OF MIKE ALEWITZ

En vägg full av k

□□ På västra stranden av Manhattan i New York, i skuggan av World Trade Center och två kilometer från Wall Street, ligger Pathfinder Building. Här pågår ett stort revolutionerande väggmålningsprojekt.

Today, mural painting must help in man's struggle to become a human being, and for that purpose it must live wherever it can...no place is bad for it, so long as it is there permitted to fulfill its primary functions of nutrition and enlightenment."

—DIEGO RIVERA

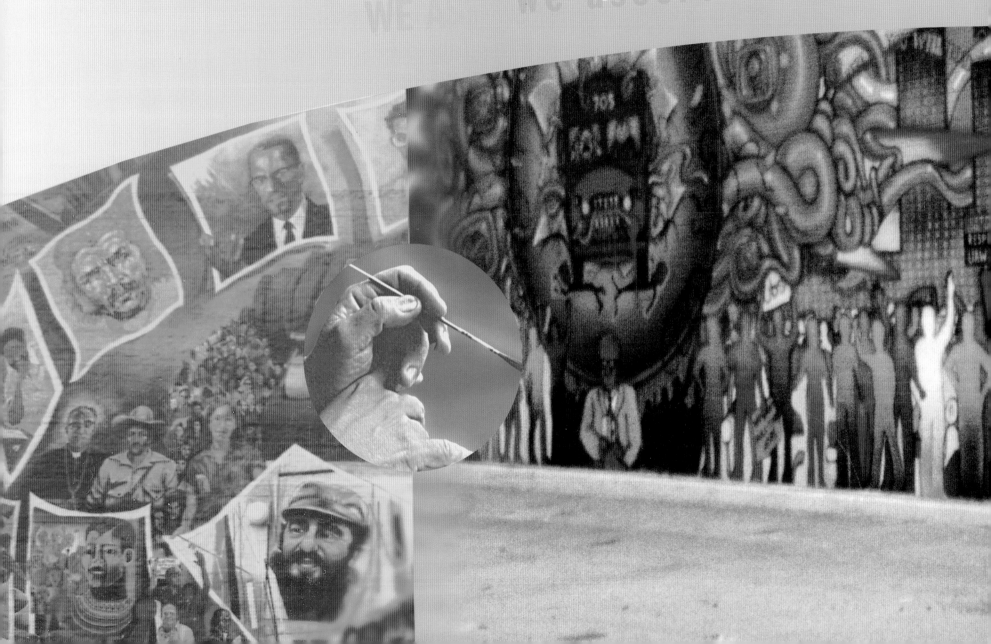

"When we make art in the studio
we assert our humanity.

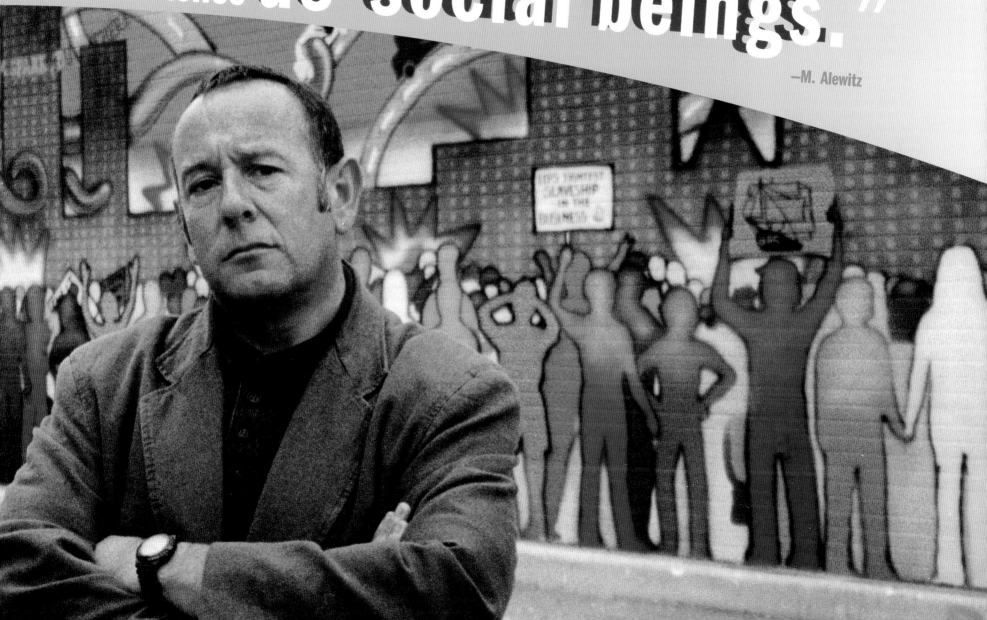

"When we make art in public, we assert our existence **as social beings.**"

—M. Alewitz

THE REAPPEARANCE OF THE MURAL marks the return of painting from the museum to its public role in the human community. The work of muralist Mike Alewitz and the collective character of his projects draw upon centuries or eons of collaborative activity, from cave paintings to Michelangelo, the Dada and Surrealist movements to political graffiti. Alewitz's approach is ideally suited to the postmodern and post-state socialist era when everything rebellious must be created anew and when "culture" along with "labor" is urgently needed to salvage a world from eco-disaster, perpetual war, and the plundering of human possibility. The art of Alewitz and Co. (with the Co. constantly changing) has already been part of labor's recovery from decades of poor leadership, part of the struggle for democratic unions in a changing global marketplace and with a rapidly changing workforce.

The murals in the following pages stand broadly in the tradition of the three great Mexican muralists: Diego Rivera, David Alfaro Siqueiros, and José Clemente Orozco. Their murals had a strong impact on the United States during the 1930s, not only because of the artists' own travels and work in what Frida Kahlo called "Gringolandia," but also because, with the development of the Works Progress Administration (WPA) of the New Deal, American artists were able to create their own counterparts to such work. Stepchildren of the best WPA–funded efforts, Alewitz's murals reflect the traditions of agitational and political public art in every medium, from the nineteenth century to the present. The depiction of the class enemy and the class struggle by the cartoonists and assorted graphic designers of the IWW and the politically influenced urban murals of the 1960s through the 1980s in Chicago, Los Angeles, San Francisco, and New York feed directly into his work. Following no particular school, but instead seeking his own genius of particulars, Alewitz is unique even among these highly varied and admirable efforts.

Alewitz's murals have been particularly marked by a vernacular quality—their humor, their historical references, their accessibility—with origins in the history of the American class struggle. Nearly every wall landscape, most of them commissioned or at least supported by working-class institutions, documents specific events, definitely local but with transcendent

Diego Rivera

schemes. No less important, in subthemes often little observed even by Alewitz's admirers, each mural draws upon the many neglected traditions of anonymous radical working-class artists, forgotten proletarians armed with paint brushes or quill pens, whose traditions are close to Alewitz's own heart.

Today's art historians remember the Ashcan school, or the remarkable muralists and painters of the depression era such as Ben Shahn, perhaps even a handful of poster makers for the vibrant protest theater of the 1930s. But the beloved Wobbly cartoonist who called himself "Dust," to take but a single example, is all but forgotten; the lithographers, cartoonists, and assorted illustrators of the radical press from the 1890s to the present, radical drama set designers, Bread and Puppet Theater operators, and a host of others have rarely had their work anthologized, let alone recognized for its personal stamp subtly individual to each artist. The importance of Alewitz's work can be measured in the diverse strains of influence that make up his murals, but also in the conscious restoration of the collectivity that belongs to the ages—and to our age as well.

RIVERA AND THE MEXICAN MURALISTS

"Today," Diego Rivera writes in the introduction to his *Portrait of America by Diego Rivera* (1934), "mural painting must help in man's struggle to become a human being, and for that purpose it must live wherever it can." As if in sympathy for the walls as well as the artist, he

adds, "no place is bad for it, so long as it is there permitted to fulfill its primary functions of nutrition and enlightenment."[1] Rivera stood firmly in the centuries-old, great tradition of public art, often explicitly religious in nature. Occasionally attached to the name of the designer and leading painter, public art was more often anonymously created, the mason and bricklayer working alongside the painter. According to an apocryphal tale, one day Rivera, Orozco, and Siqueiros sat around a table discussing murals and they happened to observe a pulqueria painter, that is, an artisan who painted the popular wall paintings in pulquerias or "taverns" where pulqueria was served; they drew their inspiration for the work to come, it is said, from his grasp of Mexican traditions. This anecdote probably merges many real-life experiences of observing folk and commercial artistry. But the emerging giants also looked to European masters for guidance, and not only to the muralists. Unlike the creators of the great frescoes, the artists of the European medieval and Renaissance revolt, such as Albrecht Dürer, showed the horrors of social oppression in exacting detail and visual metaphor. It remained for artists of the modern era to develop the styles and techniques suitable for restoring public art to its communal status and lifting revolutionary art to its potential.

Rivera's renown prompted such commissions in the United States as the Pacific Stock Exchange's Luncheon Club in San Francisco, the Detroit Institute of the Arts, and the Rockefeller Center in New York. Never one to shirk controversy, Rivera shocked his patrons time and again with overtly revolutionary references. He landed in the middle of a storm of protest when the Rockefeller family resolved to have his work effaced from "their" Center. The mural was first covered with canvas and then destroyed, a notorious incident that remains a *cause célebrè* in modern art history.[2]

Another of Rivera's major American works suffered a similar fate. His mural of American radical history, the most sweeping single treatment of the subject ever made, was dismantled when the sponsoring New Workers School dissolved the institution and switched its allegiances from socialism to American intelligence operations.[3] Rivera's 1930s efforts that survived these assaults included mostly minor works, with one major exception. The Detroit mural, nearly destroyed during the McCarthy era, was

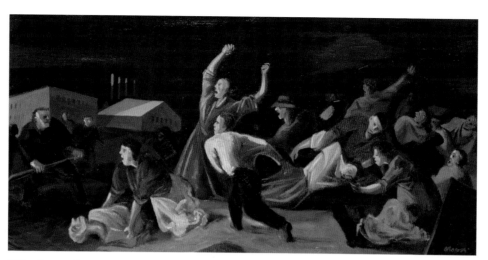

William Gropper, *Youngstown Strike,* 1937. The Butler Institute of American Art, Youngstown, Ohio

ironically saved by members of the Ford family concerned with the value of their own collection.

Rivera's scope and explicitly revolutionary intentions, based in the asserted dignity of labor and the indignity of exploitation, opened the door for a contemporary working-class artist like Alewitz, who chooses to emphasize minority groups and women's labor and places internationalist themes at the center of his work. The cross-border character of many of Alewitz's projects has developed naturally from the artist looking south toward Mexican and Latin American struggles and looking around him in the United States as Mexican and Latin American working people struggle to transplant themselves and their traditions.

Alewitz's work also draws power from the work of Rivera's contemporaries, the American muralists of the 1930s. Thanks to the radical mood of the depression era and the formation of the Works Progress Administration, unemployed artists of great talent were briefly invited to stake their claim upon American life and culture. Mitchell Siporin's celebration of working people's dignity, Anton Refregier's honest reflection upon the underlying cruelty of American life, the social and factory scenes by Reginald Marsh or William Gropper remain powerful today, and not only as examples of the period that they represent. Posters by some of the same artists advertising Federal Theater productions, notably inventive in design and color scheme, also offer

social commentary. Nearly all the radical artists identified with the Popular Front, placing themselves within the political vicinity of the American Communist Party; but the then current Soviet doctrine of "socialist realism" had little effect upon the artistic individuality or the artists' tendency toward allegorical expression.

HUMOR AND LABOR CARTOONS

By and large, most of the mural work of the early part of the century was humorless, as must be said even of the magnificent work of the Mexican giants, and also of the great majority of murals (with striking exceptions, naturally) destined to arise from the community projects of the 1960s–90s. Why this should be is an intriguing question. The grim heritage of dispossession, exploitation, racism, and class struggle do not automatically raise the issue of humor, and intellectuals or artists attaching themselves idealistically to the struggles of lower classes often consider levity unsuitable, demeaning the causes to which they have committed themselves. Those at the receiving end of oppression, and those involved in the lower ranks of progressive social movements of various kinds, however, often take solace and inspiration from satires on their rulers and on the foolishness of the credulous and blindly submissive worker or community member. The popular (if ostensibly apolitical) turn-of-

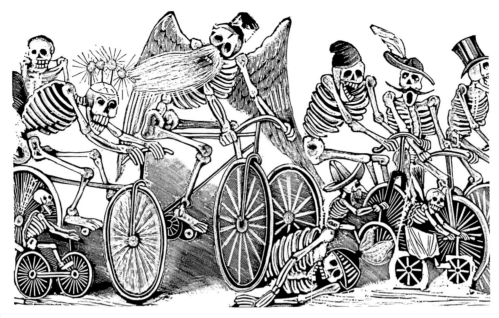

José Guadalupe Posada, *Calavera*

the-century Mexican illustrator José Guadalupe Posada, another major influence on Mike Alewitz, humorously portrayed a number of serious subjects with unflinching candor.[4]

Most readers' favorite page of any left-wing or labor publication, has been, for generations, the page with the cartoon of the week. As in the best of the commercial press, the condensation of meaning from the printed word to the pungent illustrations or comic captures popular understanding and applies a sharp tap to the funny bone as well.

Radicals, for their part, mounted the occasional illustrated agitational poster, arguably the earliest American version of the pictorial style that would become the mural. Inspired by classical themes and by rage at the swift rise of monopoly capital, the artists struggled with themes of wrong-doing, mainly as violations to

the republican ideal.

The earliest publications of the American Left, during the decades after the Civil War, often adopted visual themes of virtuous workers or farmers wronged by the swift rise of monopoly capital. At the first appearance of a vibrant socialist movement, utopian images by the British artist (and intimate of poet William Morris) Walter Crane could be found frequently, with the rising sun in the distance heralding the birth of cooperative society. But the most distinctive American radical school of agitational art grew from the Industrial Workers of the World (IWW), founded in 1905.

Something about the Wobblies brought out the best in visual humor, a style that survives today in Alewitz's murals. From the icon of the "Sabo-Tabby" little black cat, who promises sabotage to capitalists mistreating fieldhands and factory workers, to drawings of "Scissor-Bill," the boss-loving worker, to the "silent agitator" stickers affixed to walls, benches, and bathroom stalls across the country, these drawings spelled revolt. Whether worded in English, Italian, Hungarian, Spanish, or even Finnish, the agitational satires signaled unwillingness to yield to the supposed sacredness of private property and the patriotic glories of war.[5]

Art Young, ever-popular with Wobbly readers, was the socialist counterpart to the IWW

artists and easily the most popular comic artist in several generations of the American Left. Converted to socialism at the turn of the century, he lent his pen (with his intense, cross-hatching style) to the ridicule of capitalism's assorted claims, and to sympathetic treatment of the melancholy pervasive of gentle hearts in class society. When Alewitz's murals express moods from Wobbly-style humor and rage at oppression to sorrow for human possibilities lost, we find some of Art Young's presence lingering on in them.

Radical Jews had their very own humor as well. For almost two decades after its founding in 1907, the weekly Yiddish-language *Groysser Kundes* (the title a satire on President Theodore Roosevelt's militaristic threat to carry a "big stick" to intimidate other countries) caricatured Lower East Side personalities, assaulted pompous figures, lionized striking workers, and bemoaned war. For all its literary and anecdotal topicality, the *Kundes* treated working people and labor issues more seriously, with more visual depth, and from more of a socialistic standpoint than any previous American publication. An imitation of contemporary European socialistic publications like *Simplicissimus* or *Wahre Jakob*, and with few if any readers outside the Yiddish-language world, the *Kundes* also utilized popular cultural forms for the kinds of radical purposes that Alewitz would have in mind, generations later (his own grandparents may well have been among its popular

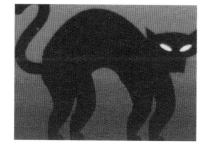
Alewitz version of the Wobbly "Sabo-Tabby" cat

readership, as his parents encountered Art Young many times in the left-wing press).

The left jokes didn't die with the mass arrests and the assorted repressions of the later 1910s, fostered by Woodrow Wilson's "liberal" administration and carried out by the new Bureau of Investigation, headed by J. Edgar Hoover. But the humor turned bitter. The best of the cartoons of the next decade, in Yiddish left-wing publications, by artists like Zuni Maud and William Gropper, ridiculed labor bureaucrats gone outright racist and reactionary, knuckling under to the reactionary 1920s of the Ku Klux Klan and the fleshpots of capitalism. On the positive side, and to a degree rarely seen before, these artists and their contemporaries hailed the anticolonial and anti-imperialist revolts across Asia, Africa, and Latin America, offering a graphic imprint of a new internationalism. Now it was indeed a global struggle, not just about Europe and the United States, or about the factory worker, farmer, or slum. Russian muralists and painters, amid the violence of uprising and White Terror, had literally painted the political road for the

Art Young, *Capitalism*

peasants to follow, and alert artists across the world took heart.

MODERN ART

A second thread in Alewitz's work can be traced through very different, albeit sometimes intersecting, skeins. The famed Armory Show of 1913 introduced Americans to Modernism, and turned attention to a range of non-representative styles sweeping the salons of the Continent. In crisis-ridden Russia, young Jewish artists such as Marc Chagall and El Lissitsky moved both backward and forward in time, investigating traditional artifacts of Jewish culture while simultaneously embracing expressionism as a medium for the interpretation of meaning in the present. The Russian Revolution and the initial encouragement given by the Bolsheviks to Jewish art found the Yiddish theater in its all-time glory, with some of the world's leading Jewish artists designing stage sets and costumes.

The inspiration for a Jewish national art based in *Yiddishkayt* (vernacular and secular Yiddishness) rapidly faded with the bureaucratization of the Revolution, and would never return again to such a high point of creativity. But the meaning of that high point for Jewish radical artists remained for generations to follow, a col-

"Good art is controversial, and we should welcome that controversy. Through discussion and debate we can learn much about our own culture, and educate and inspire our class to political action. There is no 'correct' way of making politcal art."

—M. Alewitz

lective self-reflection that was also an embrace of the public issues of art, the art for the masses who would see themselves and their enemies in posters, theater, in murals as in the new cinema.

The American Jewish artists, especially those in the Communist-Yiddish circles of the 1920s and 1930s, vigorously embraced the idea of a self-identity that was also a revolutionary internationalism. *Der Hammer* (the Yiddish counterpart to the left-wing *New Masses*) embraced expressionist celebrations of African or African-American culture as well as devotion to Jewish themes, sometimes by the same

artists. Max Weber, Louis Lozowick, Ben Shahn, Moses Sawyer, William Gropper and Saul Raskin (the last two of them former contributors to the *Groysser Kundes*, and most of them contributors to one publication or another of the Communist press) struggled for a realism which was also a super-realism, a metaphoric and symbolic use of form to capture the excitement and tragedy of modern life.

The Ashcan artists of Greenwich Village had, even before 1920, carried these impulses upward into the apex of modern art—before they and their work were captured by the museum gentility immeasurably far from the street life that they brilliantly depicted. William Glackens, Robert Henri, Everett Shinn, George Bellows, and John Sloan, all of them close to the *Masses* magazine of the middle–1910s, depicted city life as no one before, in America or abroad. Manhattan, but especially lower-class Manhattan, was their subject, and the fluidity of their work owed much to their experiences as sketch artists for the contemporary press, and just as much to their collective political conscience. Like Alewitz generations later, they firmly believed that the masses of ordinary folk were gathering, intentionally or not, the experiences required to displace the swindlers and exploiters with a government of their own making. They also believed, perhaps more than any artists of the past, in the crowd, the energy of people in motion—from the amusement parks to picnics in Central Park to the daily gatherings at subway stops.[6] The crowdedness, the encounter, contained possibilities to be explored in every artistic dimension.

Louis Lozowick, *New York*, 1925, lithograph. Walker Art Center, Minneapolis, MN. **Lozowick played a key role in the international dissemination, and later, the domestication, of the Suprematist and Constructivist styles of the Russian avant-garde.**

On a technical level, something more stood out about the Ashcan artists' particular uses of color in canvases and on magazine covers. Gray-toned paintings for waterfronts, glorious vividness for weekend outings, black and white contrast for illuminated night scenes, all these offered a modernism that transcended the old gallery expectations as much as did Cubism, if more subtly. These moves also pointed to the prospect of adapting the contemporary commercial use of color, tone, and dynamism.

Thus Hugo Gellert, a major *Masses* contributor (and lifelong Hungarian-American radical),

first sent abroad to study in a Paris conservatory, gathered his most vivid impressions from a Michelin advertisement on the street outside. That, he recalled later, was the way he saw and wanted to use art, the revolutionary sweep far beyond the secluded setting of the normal successful artist.[7] Dadaists, some of them active in the United States during the First World War, glimpsed the same potential. Here and there, most often in the cover illustrations of the *Liberator* (successor to the suppressed *Masses*), the possibility came closer to realization.

The 1930s WPA murals, for all their variety and close attention to detail, never realized the full potential immanent in the metaphoric and symbolic material of mass life. "Socialist Realism" has sometimes been blamed for the stylized work of men and women who viewed themselves as radicals, but the "Democratic Realism" of the New Deal years, heavy on sentimentalism toward the national saga, would have been quite limiting enough by itself. Besides, and more important, the glorious Bolshevik moment of 1917 was gone, along with true Greenwich Village bohemianism, free love, low rents, and the promise of modern art to advance beyond mere gallery painting to a revolution of the senses. Despite the presence of talented artistic revolutionaries, despite the emergence of the Congress of Industrial Organizations and the widespread hope for a cooperative society succeeding the New Deal, a cultural Thermidor had arrived. Most of the 1930s WPA murals promised traditional solidity of family and community, safety from the threat of fascism, but not a leap out of history and

oppression. In the artistic contest between democracy and fascism, more than a few of the best murals pointed in hopeful directions, but the radical promise was lost.[8]

THE COMIC STRIP AND COMIC BOOK

Or the spirit went underground, at least in radical and formal artistic terms. Perfectly evident in Alewitz's work is something little known in any formal art until bastardized and merchandized as high art by Roy Lichtenstein and Andy Warhol: the influence of the comic strip and comic book. From the dawn of the century, with the hallucinogenic drawings of Windsor McKay's Little Nemo, the comics had been a highlight of virtually every Sunday paper in towns across the nation. Along with a great deal of banality, one could find all manner of visual acrobatics, class-conflict gags (the boys with the snowball mowing down the tall silk hats of the capitalist offered one viewpoint, but the Katzenjammer Kids types and the attack on paterfamilias was more prevalent), and experimentation with semi-realist and super-realist forms.

Not that comic strips dealt with labor in any recognizable way. J. R. Williams (of *Out Our Way*) was said to have been the first mainstream comic artist to draw factory scenes, most of these concerning the production woes facing foremen, and also the first comic strip artist to draw a corpse—which may or may not be a coincidence. Although a flapper strip (even the early *Blondie*) might focus on clerical work life, the office was almost always someplace to dream about romance or just plain escape. But whether or not they were reflected in comic-strip

story lines, working people did read the comics, craving at once the familiar and the unusual, the recognizable and the exotic, from super-mundane *Gasoline Alley* (a semi-working class, if conservative, strip) to the wildly imaginative *Krazy Kat* (the only major strip by an African-American artist).

Comic books stretched the constituency to younger audiences and, during the later 1930s, swiftly developed a cult following of young working-class (as well as middle-class) readers. Here in the early 1940s, we can begin to locate some of Alewitz's early childhood influences and immediate antecedents, intense young Jewish men using the techniques of modernism in the most seemingly mundane media, inventing "funny animals" by the dozens, revitalizing classic literature (later on, some of the best plots of *Classic Comics* were scripted by blacklisted left-wingers), opening up strange dimensions (in horror and science fiction comics) and hilarious ones (self-satirical heroes like Plastic Man), and, of course, doing quite a lot of hack work with hack themes, characters, and plots as well. Superman himself was created by two socialistic Jewish teens from Cleveland Heights, Ohio, not far from Alewitz's home neighborhood a generation later.

During the ten years after the Second World War, EC Comics, the father (and mother) of so much of the revolutionary graphic methodology that appeared a generation or two later, unleashed the left-of-center promise of the genre in both style and substance. EC's war comics, singularly realistic, treated the gore more than the glory of battle. Their horror

comics promised revenge against powerful evil-doers who through manipulation of authority seem to escape the consequences of their actions. Their science fiction line tweaked contemporary issues, especially racism and the consequences of the arms race.

Most of all, *Mad Comics* (1952–1955) under the guidance of Harvey Kurtzman, made hilarious, iconoclastic sense of the stale commercialism sweeping through the themes and styles of contemporary American life. If other EC lines had been remarkably realistic, *Mad* (and its short-lived EC partner, *Panic*) was instantly surrealistic: "Walt Dizzey" seen as a totalitarian; television's right-wing *Dragnet* exposed as moronic; commercial magazine advertisements exposed as stupid, lying, and malicious; and the television favorite panel show *What's My Line* rendered into the Army-McCarthy Hearings with hucksters offering the television public retouched photos and assorted invented evidence, just like the real hearings. The crowded panels of *Mad Comics* and its successor *Mad Magazine*, with their intricate little signs and notes on the page borders, inspired some of the imaginative corners of Alewitz's work decades later.[9]

The iconoclastic story lines of the *Mad* drawings were not the only elements of the work to leave a lasting artistic imprint. As some of the most important later comic artists would testify, critique of social absurdity depended upon a rendering of detail at once precise and wildly exaggerated, a sampling of modern art (emphatically including Dada, one major inspiration to the *Mad* crowd) and Jewish comic shtick

Ralph Fasanella, *May Day*, 1948, Courtesy, A.C.A. Galleries

rolled up into a neat package. By refusing to grant dominant forms the dignity of their claims to define the look of reality, *Mad* injected satire into the objects themselves. The underground comics of the 1960s–70s, vehicles for the next comic art revolution, carried the lesson forward.[10]

ART OF THE WORKING CLASS

The saga of one mid-century artist, Ralph Fasanella, brings the complex sequence of art by and about the working class from another corner of the political left into the public eye. Fasanella, Italian-American neighborhood activist in the American Labor Party of the 1930s–40s and a close follower of Congressman Vito Marcantonio, labored over his "primitive" paintings of working-class metropolitan life while working part-time at his brothers' gas station in the Bronx of the 1940s–50s. The Spanish Civil War veterans, Greenwich Village bohemians, longshoremen and assorted other unionists, all crossing paths in neighborhood bars, had trained him to observe aspects of life that go-for-the-gold America seemed to ignore. His memories of Lower Manhattan, still (until at least 1950) one of the major small-manufacturing districts on the planet, gave him a vivid sense of working-class culture, both politicized and apathetic. The real social, and even occa-

sionally socialistic, moments of May Day parades, demonstrations against the execution of the Rosenbergs, sports events and other public celebrations, all provided Fasanella with visual epiphanies against which to measure the more placid realities of everyday life.

Above all, however, in Fasanella's work can be seen crowds of faces and bodies, in spaces large and small, acting together, sometimes conflicting, different ethnic and racial types sharing the same setting (so unlike most of the WPA drawings, which are bland in that respect, and the comic books to an even larger degree), with images of both women and men. Fasanella was never didactic; but he expressed his notions in ways always suggestive of working-class promise, working-class dreams, emphatically including his own. The public and monumental character of his art, achieved once he had gained recognition, demonstrated his lasting importance, probably more so for muralists than other painters. The best Fasanella works dominate a whole wall, mural-like in that they draw all attention toward their loving detail, their energy, their inventive use of color, and their flashes of humor.[11]

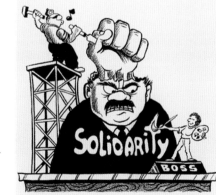
Mike Konopacki, *Solidarity*, 1995

Fred Wright was the Fasanella of the contemporary labor press, internationally famous decades earlier, if also forgotten sooner. Working musician, sailor, and occasional labor cartoonist of the later Depression years, Wright found himself on an army base during the war, drawing cartoons steadily for the first time, and quickly graduated after the war to the National Maritime Union weekly, the *Pilot*. Like Fasanella, he felt the sting of the Red Scare (Wright was offered a continuing slot at better pay if he would draw the Red unionists, now on the run, as rats) and he opted to go in his own direction. *UE News*, publication of record for the leading left-wing union in the postwar period, made him staff artist for nearly forty years, until his death. From this bully pulpit, Wright traced the life of the common factory Joe and Jane, not heroic, not complacent, but simply hard-pressed by speed ups and endless assorted efforts of management to chisel on the union contract, by crooked politicians and by inflation, by racism and sexual harassment. Occasionally, usually around summer vacation time, Wright used a full page of the *UE News* for a mini-mural, crowded with working-class personalities of all types, a hint at larger projects that he never completed.[12]

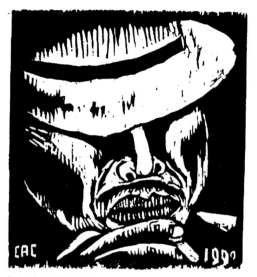
Carlos Cortez, *Banditos*

Wright's work notwithstanding, labor cartooning more or less withered on the vine by the 1970s. Cartoonists faced the impossible task of pleasing the bloated bureaucracies of Teamsters, auto workers, or even teachers, allergic to the most obvious subjects of satire, i.e. union officials themselves. Only two major exceptions emerged: the former cartoonist of *Racine Labor* (one of the handful of surviving independent-minded local labor papers), Gary Huck, and the former Madison busdriver, Mike Konopacki. From the early 1980s, these two characters sent out their work in a weekly packet, a sort of humor news service, to the surviving labor press. About a decade later, Huck replaced the late Fred Wright at *UE News*, and the outflow of topical work continued.[13]

Still further toward the margin, the *Industrial Worker* boasted the cartoon work of Carlos Cortez, poet and printmaker of the Wobblies. Son of a noted Chicano labor organizer and imprisoned during the 1940s for draft resistance, Cortez provided spiritual sustenance to the aging constituents (and the Wobs' irregular Mexican immigrant following, too anarchist-minded for the regular American Left). He served for a time as editor of the *Industrial Worker* with a side career as a lithographer. The *Rebel Worker*, published by young Chicago Wobs

of the middle 1960s, encouraged the growth of yet another artistic impulse: the surrealists. These artistic-minded radicals issued manifestoes on art and public life, staged exhibitions in the spirit of the old European-based surrealist movement, supported black nationalism in music and art, and generally encouraged the rapprochement of cultural militants and labor issues.

But these were bald exceptions to the main trends. By the time Alewitz emerged as a student militant at Kent State, shortly before the infamous massacre of 1970, labor culture had effectively been squashed from above. Far from meeting the burst of late 1960s cultural energy halfway and embracing its idealistic impulses, labor chiefs snarled at the blossoming resistance to the Vietnam War, the anti-racism of assorted movements, and above all at the creative restlessness of radicalized younger working people.

Notwithstanding crocodile tears for the murdered Dr. Martin Luther King, Jr.—whose opposition to the Vietnam War they despised— the AFL-CIO hierarchy saw its idealized images in the white, male, muscle-bound, building-trades patriots who pounded antiwar demonstrators on Wall Street in President George Meany's proudest political moment. The monumental style of lavish, multi-million-dollar international union headquarters, the corporate-looking offices (not to mention the leisure-swank of the Miami Beach hotels and Vegas casinos where the beefy AFL-CIO leaders partied, boozed, and chased young women), fairly marked the bureaucrats' artistic tastes as

well as their political mentality.[14]

Too many in the contemporary campus-based New Left treated this mentality as characteristic of working people at large. For this reason, the explosion of cultural energy around the anti-war movement, the women's movement, and later the gay and lesbian, environmental, and Third World support movements had little clear class orientation. Not surprisingly, the "underground" agitational art from 1966 onward, spurring in turn the development of the "underground" comic artists and their sometimes political-minded publications, displayed scarce labor content. The new era of poster art dating from 1970 explored every potentially rebellious issue except class, and explored them in terms that were new for American public art, creating artists and methods that would serve different purposes in the era ahead.

Artists with family backgrounds or sympathies in the Old Left breached this gap here and there, especially where (as in the Detroit alternative press) working-class issues remained central or where race and gender could be configured with class. Only in the 1970s, with the maturation of poster art with community themes, did class begin to return as, for instance, the saga of the Chicano working-class across the borders and the century, a thematic shift that coincided with the rise of newer murals. Back in the world of underground comics, the United Cartoon Workers of America (UCWA), a loose organization of underground cartoonists who aspired to professional status, sprouted in San Francisco, Chicago, Milwaukee and elsewhere, highlighting a broadly class-conscious approach

among a generation of artists already radical but looking at other themes. By 1980, the work of R. Crumb, Bill Griffith, R. Diggs, Harvey Pekar, Howard Cruse, Leonard Rifas, Diane Noomin, Roberta Gregory and Jay Kinney had all offered fresh visual approaches toward the depiction of work and working, quiet rebellion and, in general, an anarchistic rejection of wage work itself.[15]

Wimmin's Comics (variously titled *Women's Comics* and *Women's Liberation Comics*) examined current and historical views of women's work, from the Triangle Fire to Rosie the Riveter of the 1940s to the latest flaps on sexual harassment and the income gender gap. Trina Robbins (daughter of a noted left-wing Jewish journalist), Sharon Kahn Rudahl, and others struggled within a diminishing medium before abandoning the field of independent comic publishing.[16]

THE RESURGENT MURAL MOVEMENT

A new movement announced itself when William Walker helped create the "Wall of Respect," on the side of a condemned building in Chicago. Twenty-one black artists, drawn together by the assassination of Martin Luther King, Jr., made a sensation as *Ebony* provided a cover story on the mural. Other walls of respect appeared within the next half-dozen years in mostly aging neighborhoods, usually displaying themes of race or ethnicity and sometimes commemorating local or historical events.

Chicago's murals took precedence in the eyes of many observers, probably because of the involvement of the city's leading artists: Walker, Eugene Eda, Mark Rogovin, Ray Patlan,

and John Weber. Created (in contrast to the WPA murals) without government support, these murals urged rebellion. Images of resistance to urban renewal jumped off the walls at viewers, warrior-like evocations of the Black Panthers, Malcolm X, and determined farm workers encouraged neighborhood struggles. Neighborhood residents were involved in planning as well as painting the murals. Indeed, collective mural teams congratulated themselves on their direct effect upon specific issues, like gang warfare or housing.

Thus began one of the great underreported social movements of the 1970s and 1980s: projects by gang members and university-trained artists to cast a different light upon their experiences, and thereby find a way out of society's dilemmas. The determinedly non-elitist methods of working encouraged an eclecticism of theme and approach that spanned the gamut from underground comics to near modernism to socialist realism, and from deep ethnic-centrist to pan-ethnic humanism.

Ironically, as the social movements of the 1960s–70s faded into history, arts and humanities councils reached out to embrace some of the mural projects. Federal and local dollars flowed, even occasionally from corporations,

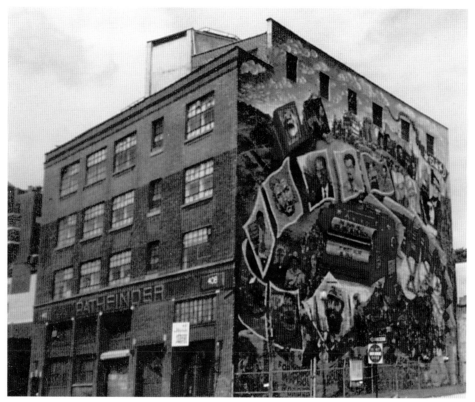

Pathfinder Mural Site, 410 West Street, NYC, 1988

Inspired by revolutionary struggles in Cuba, Grenada, Nicaragua, and South Africa, the Pathfinder Mural Project was initiated in 1988 as an international collaboration. Dozens of artists participated in what would be one of the largest political murals in the world.

into youth employment centers and programs, establishing a community arts culture unimaginable only a few years earlier—with all the inherent contradictions of such funding. The Chicago Mural Group led by John Weber, the Public Art Workshop led by Rogovin, and Movmento Artistico Chicano (MARCH) led by Jose Gonzales and Marcos Raya, all gained fame for demonstrably radical projects. The CityArts Workshop of New York provided a model for community

participation projects while the West Coast–based Chicano projects, organized mainly around community art centers like the Social and Public Arts Resource Center (SPARC) of Los Angeles, managed funding despite militantly anti-racist and strong class-conscious depictions.

National muralists' conferences blossomed from 1976; newsletters, magazines, and books appeared. The incoming Reagan administration clamped down on much of the funding. But the outrages perpetrated by the Reaganauts at home and abroad also inspired new themes and protests, from the mural and allied art work around the great "Freeze" antinuclear marches of 1982 to the support movements around Central American issues in the following few years. Mammoth projects sprouted—like the World War III project in New York and several dozen murals in San Francisco's Mission District—many of them with Central American themes and indigenist motifs.

PATHFINDER MURAL
New York City, NY

THE PATHFINDER MURAL

One of the movement's recording angels, Eva Cockcroft, coauthor of the totemic *Toward a People's Art: The Contemporary Mural Movement*, ended a 1990 report by hailing the most explicit political mural thus far created in

"...The entire phenonomen, of which the painted image is the center, must be seen as including what the mural says, how it says it, the process of its creation, and the reaction to it."

—Tim Drescher

"Rising above New York's West Side Highway, for a late summer unveiling, is a 75-foot-high mural celebrating Marx, Lenin, Trotsky, Mao, Castro, and Che, a six-story shrine to communism, a Marxist Mount Rushmore in Greenwich Village..."

—Patrick Buchanan, *Washington Times*
May 22, 1989

the Marxist tradition.[17] At Mike Alewitz's suggestion, Pathfinder Press, the publishers for the Socialist Workers Party, had commissioned a wall of the party's West Street headquarters, with Alewitz and others devising and completing a revolutionary saga equal to the narrative composed by Diego Rivera at the New Workers School forty-some years earlier. Donors in the United States and elsewhere contributed $100,000 to this new effort, and even the New York State Council on the Arts kicked in $500.

The immediate result was perfectly amazing, not only to see but to experience in process. As a *New York Times* arts reporter observed in September of 1988, Alewitz ("a sturdy-looking man of thirty-seven wearing cut-off jeans and a single earring") stood confidently in charge of a crew both eclectic and international, neighborhood members as well as European and Latin American artists. Despite some protest from neighborhood right-wingers, and more than a touch of police harassment, the project was carried on to a successful conclusion. As planned, a red printing press stood at the center, with posters of assorted revolutionary heroes above, oceans and crowds on the sides and below.[18] Even an attack

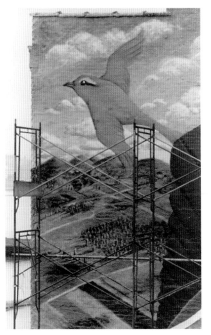

Pathfinder Mural detail

Two Nicaraguan birds were to have Nora Astorga and Ben Linder astride their backs. When Alewitz was removed from the project, these images were painted out.

by Patrick Buchanan in the *Washington Times* ("a six-story shrine to communism, a Marxist Mount Rushmore in Greenwich Village") could be seen as evidence of the anxiety a mural could provoke.

Alewitz intended the mural to be a celebration of an envisioned convergence of world revolutionary forces. The (temporary) victory of the Nicaraguan and Grenadan revolutions, Cuban resistance to U.S. domination, the freedom struggle in South Africa, and other important struggles provided a moment of radical optimism. Artists around the world were invited to work on the mural. Two groups of Canadians participated, including Armand Vaillancourt, a leading Québécois sculptor who had earned his place in agit prop history by spray-painting a high-profile piece with a pro-independence slogan on San Francisco's Embarcadero during the War Measures Act imposed upon Quebec. Dumile Feni, exiled sculptor from South Africa, participated as the representative of the African National Congress, contributing a portrait of Nelson Mandela. The ANC sent a representative throughout the United States on behalf of the project. The FSLN of Nicaragua sent two representatives, artists Arnoldo Guillien and Carlos Montenegro. Other

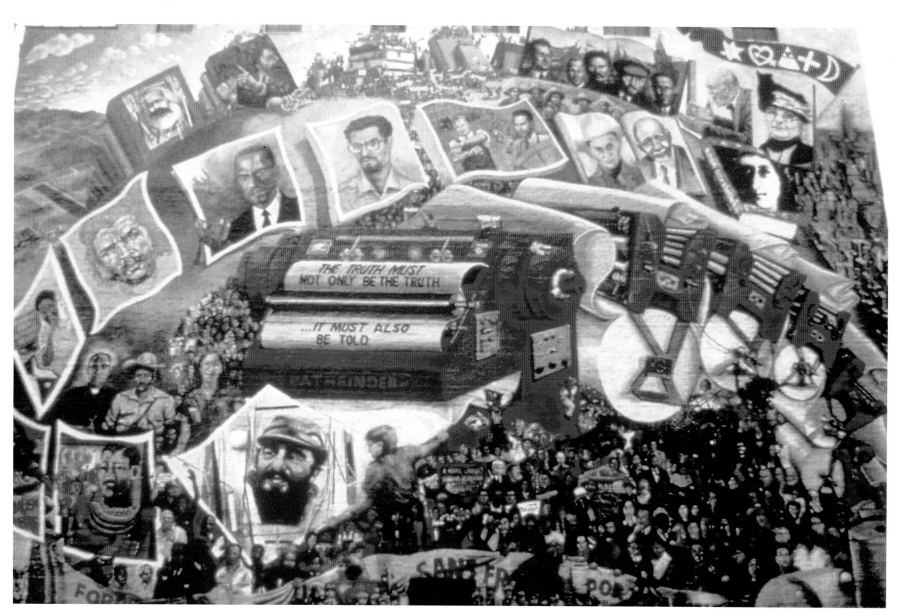

Pathfinder Mural

REFLECTIONS

"As the mural was nearing completion, we began to receive a series of sectarian and sometimes bizarre demands from party officials to paint the 'right line.' This included convoluted political directives (such as how big Trotsky's head should be) as well as arbitrary orders handed down from party officials regarding colors and such.

I responded by writing an article in the internal pre-convention party bulletin explaining that this policy of interference into artistic freedom was not in the tradition of the revolutionary movement.

That sealed my fate. The planned convention was cancelled. A short time later I was expelled by the central leadership of the party, and subjected to a slander campaign that included charges of anti-Semitism, egotism, racism, homophobia, etc. I was not permitted to respond to any of these charges.

As soon as I was expelled, the printed brochures were destroyed, and new ones were produced that did not mention my participation. Party officials altered the mural by removing many surreal, humorous, and autobiographical elements. The history of the mural was rewritten, and I became a non-person. I was officially shunned by the party membership.

People have compared what happened to me with what occurred to Diego Rivera at Rockefeller Center. But what happened to me was very different. First, I was not Diego Rivera, but a struggling working-class artist. Secondly, Rockefeller was a capitalist—doing what capitalists do. What the SWP did was far worse, for they claimed to be socialist."

—M. Alewitz

artists famous and unknown contributed to the grand mosaic. Octogenarian Abe Graber, a member of the 1930s John Reed Clubs, climbed the scaffolding to create a portrait of the great revolutionary journalist. Maureen McCann, a working nurse and amateur artist, came after her shift day after day and lovingly brought to life the image of John Brown. May Stevens, physically unable to paint her mural portrait of Rosa Luxemburg, handed a drawing to Alewitz, who reproduced it to scale on the wall.

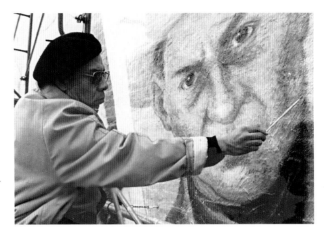

Arnoldo Guillien with his portrait of Sandino

Pathfinder Mural design by Mike Alewitz, 1988

But ultimately, there were problems, and the story has several unhappy endings, typical of the political difficulties of the era and of Marxist dogmatism going far back in radical history. The artist's vision ultimately received party criticism precisely because he had in mind a light-hearted exercise in community participation along with a serious presentation of events and personalities. Alewitz saw the mural as a way to make the revolutionary heroes of the past into human beings who would march and dance with the crowd in the streets. But he declined to lend sufficient

homage to the party saints, and gave too much space to the artists' own ideas of interesting faces and scenes. The passages from Eugene Debs's famed 1917 Canton, Ohio, antiwar speech (which landed him in prison), intended to be placed at the center of the mural, were eliminated, a party mantra inserted in the space. All visual references to Alewitz were also removed, including depictions of two martyred students at Kent State University (Allison Krause, a supporter of the Student Mobilization Committee, and Sandy Scheur, who had been a close friend of Alewitz's). Alewitz found himself expelled from the organization that he had called home for twenty years, and naturally excluded from the mural's opening ceremonies. He had always intended the mural to be repainted intermittently to reflect new realities, but a few years later the mural was entirely effaced. These were surely bad developments for American murals (still worse for Alewitz, because a self-described revolutionary movement had done them). But they had one major liberating consequence: he was now on his own.[19]

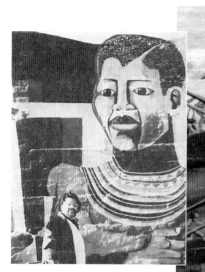

Exiled South African artist Dumile Feni with his portrait of Nelson Mandela

A striking Hundai auto worker in Korea

James P. Cannon by Bob Allen

Pathfinder Mural details

Carlos Montenegro

Carlos was one of the many artists throughout the world who participated in the mural project thanks to the efforts of solidarity groups like *Ventana*, and its leader, composer and musician Thiago De Mello. As the mutilation of the mural began, De Mello remarked to Alewitz:
"It is as though you were composing a beautiful piece of music and someone began to go through and change notes here and there."

Sacco and Vanzetti by Keith Christensen. He also painted portraits of Goodman, Chaney, and Schwerner, martyrs of the civil rights movement.

Eva Cockroft with portrait of Mother Jones

A section of the mural showing portraits of socialist leader Eugene Debs by David Fichter, Mother Jones by Eva Cockroft, and Rosa Luxemburg by May Stevens

THE EDUCATION
OF A RADICAL ARTIST

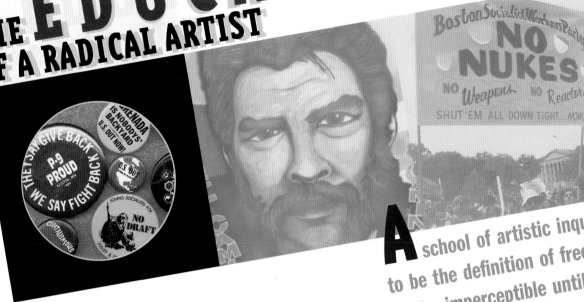

A school of artistic inquiry is invented which is said to be the definition of freedom, but this 'inquiry' has its limits, imperceptible until we clash with them, that is, until the real problems of man and his alienation arise. Meaningless anguish or vulgar amusements thus become convenient safety valves for human anxiety. The idea of using art as a weapon of protest is combated. Those who play by the rules of the game are showered with honors—honors as a monkey might get for performing pirouettes. The condition is that you not try to escape from the invisible cage."

—CHE GUEVARA

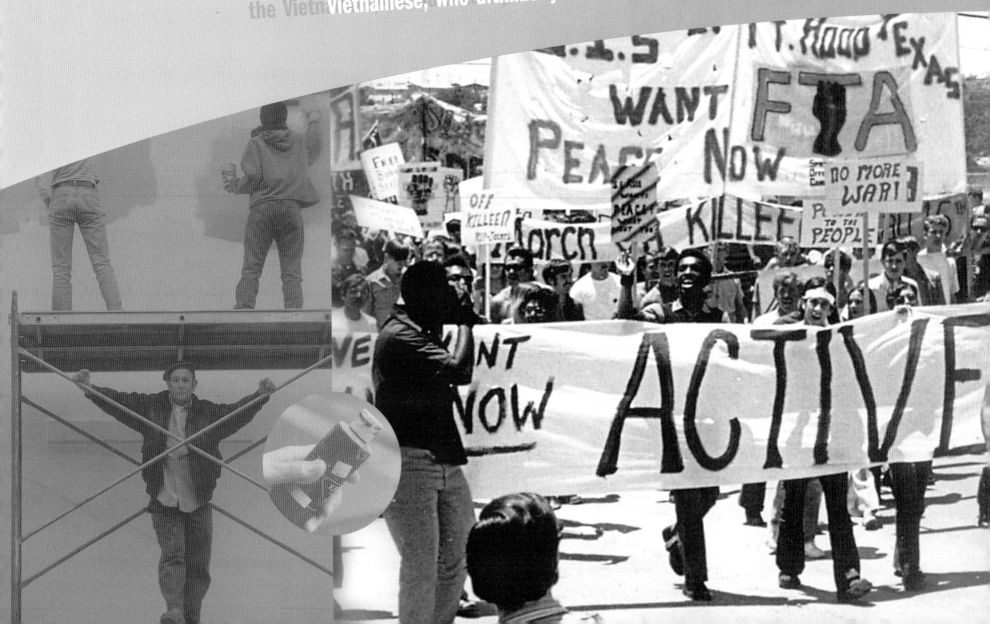

"The active-duty soldiers against the Vietnam war are among the great heroes in the history of the North American working-class movement. It was they, along with the Vietnamese, who ultimately forced the United States out of Southeast Asia.

The anti-war movement was conclusive proof to me that a group of determined activists could **build a movement to change the world. "**

—M. Alewitz

U.S. OUT OF S.E. ASIA
MARCH ON KILLEEN NOW! MAY 15

VIETNAM
LOVE IT &
LEAVE IT

STUDENTS

STUDENTS UNITE AGAINST WAR!

DEMANDS

imme
FREE
ME

ALL

FREE

DUTY I

AGAIN
THE V

Demonstration of antiwar GI's outside Fort Hood, Killeen, Texas, 1970.
Melissa Singler front and center, Mike Alewitz far right.

A case, heir to tough cases. His paternal grandfather, an immigrant from the European Pale to the Lower East Side, had the reputation during the 1910s–1930s of being an anarchist of sorts, a briar against the flesh of the nominally socialist (but deeply bureaucratic) leaders of the garment unions, above all the scheming, ballot-stuffing boss David Dubinsky. His maternal grandmother was one of the many Yiddish-accented New Yorkers who talked up Bolshevism around the sewing circle's samovar. His parents were active in the Left during the 1930s and early 1940s, exposed to enough left-wing culture to mount a Robert Gwathmey print of field workers up on their apartment wall, but disillusioned with Russian leadership as well as most of the American labor movement. Born in 1951, Mike grew up in the non-Jewish industrial town of Wilmington, Delaware, then Cleveland Heights, scarcely aware of left-wing politics, alienated and restless, uninterested in academic work and lucky to graduate from high school.

Thanks to open admissions, Alewitz began college at Kent State in 1968, just barely conscious of the growing movement against the Vietnam War. Once there, his political interests blossomed, but he found himself at odds with the leading campus radicals of Students for a Democratic Society (SDS). Like so many others from the lower middle class or working class, he found SDSers' unconscious sense of class privilege annoying, their counterculture off-putting, and their political practice irresponsible.

Why did he turn to an old-line Marxist movement? It's a question deeply, if indirectly, related to his art-work years later. Before making any real contacts with living movements, he came into contact with the Akron branch of the old Socialist Labor Party (SLP) by using their study guide—heavy on early twentieth-century socialist Daniel DeLeon's writings—for his own self-education.[1] Soon after, he found the Socialist Workers Party. Reduced from its 1940s apex to a few hundred members, the SWP ardently believed in the potential of the working class, a perspective that set them apart sharply from most of the New Left.

The Beatles' ambiguous declarations of socialism (or a dopey anarchism) agitated the counterculture radicals, but the May–June Paris events of 1968, which brought students together with workers in a common revolt, provided real inspiration to a young activist like Alewitz. Likewise, while too many of the leaders of the campus New Left barely read the back covers of current radical paperbacks before giving effusive but garbled public speeches, the campus Marxists burned the midnight oil reading and discussing theoretical works of all kinds. The Socialist Workers Party formed the Student Mobilization Committee (SMC) and its affiliate, the Kent Committee to End the War, with widespread support from faculty liberals and community members outside the SDS network. Alewitz, a leading light of the SWP's youth-wing Young Socialist Alliance, was an overnight SMC factotum, with a campus newspaper column and a perpetual public presence. He also took art classes, which he rarely attended.

It is interesting to note that Alewitz spent some time poster-making at this

Allison Krause collecting for the Student Mobilization Committee Against the War. After the shootings, the mass antiwar movement was written out of the history of KSU. Most of the histories of the student movement at Kent state have focused on the activities of Students for a Democratic Society (SDS), and have ignored the Kent Committee Against the War, and later, the Student Mobilization Committee Against the War. Those organizations mobilized thousands of Kent students in antiwar demonstrations.

"WHEN President Richard Nixon announced the invasion of Cambodia, and the

widening of the war, on April 30, 1970, it was met with universal revulsion. Student protests began to erupt all across the country. At Kent State, a series of protests took place from May 1 to 3, including graduate students symbolically burying the Constitution, black students rallying against the war, unrest in downtown Kent, and students burning down the ROTC building, a dilapidated old wooden structure. Kent was no stranger to protests. Although largely written out of the history of the Kent events, the May events were preceded by years of mass mobilizations against the war which involved thousands of students in street demonstrations. On May 3, the Ohio National Guard was called out against the students by Governor James Rhodes. Rhodes echoed the words of Nixon, who called the student protesters "bums." On May 3, at a press conference, Rhodes said of the students: "They're worse than the brownshirts and the communist element and also the nightriders and the vigilantes. They're the worst type of people we harbor in America. I think we are up against the strongest, well-trained, militant, revolutionary group in America." The basis was laid for the murders—all that remained was to pull the triggers. On May 4, students formed on the Commons, a traditional free speech area, in a peaceful protest against the war and the military occupation of the campus. After students refused to relinquish their right to protest, we were barraged with tear gas. At this point the protest was essentially over. The guardsmen continued to march over Blanket Hill, to a practice field on the other side. They crouched and aimed at us. They got up and began to walk back over the hill. But as they neared the pagoda, without provocation, they turned

KENT STATE MASSACRE
Kent State University, Ohio

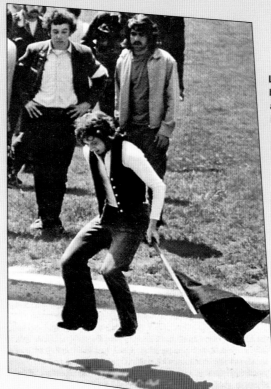

REFLECTIONS

Left: May 4, 1970. "A student jumping in blood. Jerry Persky, a fellow antiwar activist, and I are looking on. The shootings at Kent and Jackson unleashed the fury that the American people had for the war. The student strike that followed the massacre was the largest political demonstration in U.S. history. I was a frequent participant in antiwar rallies and events throughout the country, and had a chance to see first-hand the creative powers of millions of people unleashed when they moved into political action."

and fired at the unarmed students. The students shot were from 71 to 495 feet away. Most were shot in the back or sides as they attempted to flee. Four students lay dying: my friend Sandy Scheur, SMC activist Alison Krause, Jeffry Miller and Bill Schroeder. On May 14, ten days later, 75 Mississippi state cops, armed with carbines, shotguns and submachine guns, fired 460 rounds into a dormitory at protesting students at Jackson State. They killed James Earl Green and Phillip Lafayette Gibbs, and left 12 wounded. National student strikes fueled by hatred of the war and the shootings at Kent and Jackson triggered what became the largest political demonstration in U.S. history, a national student strike which shut down most major universities. On campus after campus, students began to meet and discuss how to turn their universities into real institutions of learning, and how to build a movement to end the war. We patterned our strike on the actions of students in other countries, most notably in France. There, in May–June of 1968, students engaged in massive political struggles that involved the working class in a massive general strike. The student anti-war movement helped to fuel and support the antiwar soldiers. The army began to collapse in Vietnam. Eventually, in April of 1975, the United States was forced to completely withdraw. The military defeat opened the door for the next stage of U.S. involvement in Vietnam: an economic war which has continued to this day."

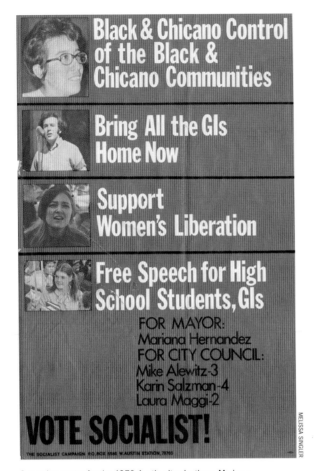

Black & Chicano Control of the Black & Chicano Communities

Bring All the GIs Home Now

Support Women's Liberation

Free Speech for High School Students, GIs

FOR MAYOR:
Mariana Hernandez
FOR CITY COUNCIL:
Mike Alewitz-3
Karin Salzman-4
Laura Maggi-2

VOTE SOCIALIST!

THE SOCIALIST CAMPAIGN, P.O. BOX 5586, W. AUSTIN STATION, 78763

MELISSA SINGLER

Campaign poster for the 1970 Austin city elections. Mariana Hernandez headed the ticket. Nineteen-year-old Alewitz was a candidate for city council. He later ran for lieutenant governor.

point, but did not consider his role as artist-on-hand particularly important or fulfilling. The loopy poster styles of the day, reflecting a druggy, Day-Glo sensibility, did not attract him. He was verbal instead. When the shootings at Kent State rocked the nation, setting off a national campus strike wave from coast to coast, activists were quick to form a Committee of Kent State Massacre Eyewitnesses. As National Chair of this instant organization, Alewitz left school behind to tour and get out

the word. He spoke at mass rallies in a number of cities and saw first-hand the potential of the student movement as it strove to challenge the power of those who ran the universities. He became part of the national student strike's broad leadership which sought to follow the French example of the "red university," with the campus seen as a base for reaching out into blue-collar life.

While on tour, he came to Austin Texas, where he realized that he could get into the University of Texas—thus into a very different political world—at a bargain-basement price. He left Ohio behind with two boxes of worldly belongings to show for his past. He was nineteen years old.

The GI antiwar movement had now nearly reached its peak, and army bases, from Fort Sam Houston to Kileen, practically surrounded Austin. The October 1970 Austin demonstration, the largest in the country on that date (and chaired by Alewitz), featured thousands of active-duty GIs at the head of a parade of 20,000. The radicals had reached the working class, or the working class had reached the radicals. The faith of die-hard Marxists had finally borne fruit, as the initial rejection of the GIs by the antiwar movement ended and spirited efforts went to winning them over. Alewitz

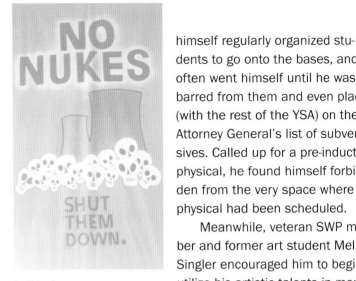

No Nukes banner

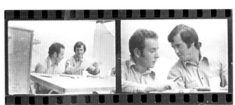

Mike Alewitz and wounded-student Robbie Stamps at a press conference for the Committee of Kent State Massacre Eyewitnesses.

GET OUT OF VIET NAM

himself regularly organized students to go onto the bases, and often went himself until he was barred from them and even placed (with the rest of the YSA) on the Attorney General's list of subversives. Called up for a pre-induction physical, he found himself forbidden from the very space where the physical had been scheduled.

Meanwhile, veteran SWP member and former art student Melissa Singler encouraged him to begin to utilize his artistic talents in more creative ways for political organizing. He became one of the artists who would stay up the night before demonstrations lettering slogans in freehand. Thus Alewitz became both artist and commissar, an interesting and rare combination.

As time went on, increasing numbers of unpredicted, spontaneous touches began to appear on his work.

The political victory of the Raza Unida party (RUP) in Crystal City, Texas, marked another important step in political outreach and coalition. RUP had formed a few years earlier as a movement of high-school students protesting discrimination against Chicano cheerleaders in heavily Mexican-American Crystal City. That movement gave birth to a genuine progressive and independent working-class party that won elections in several small towns and politically

challenged the two-party system in many places throughout the Southwest. The state's antiwar movement eagerly joined in alliance with the movement for Chicano Power. Alewitz ran for Austin city council and lieutenant governor on the SWP ticket. The same Alewitz could pass out zany, irreverent flyers at a Socialist Workers Party branch without fear of discipline for what might have been considered "humor infractions." He was too valuable to censor.

From there, Alewitz shifted to Los Angeles, as citywide YSA organizer, and then on to Cleveland. By now, Socialist Workers Party leaders had concluded that the student movement had eclipsed, and set their task on "industrializing" the party's young and overwhelmingly white, middle-class membership.

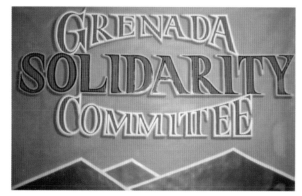

Grenada Solidarity Committee banner

For most participants, not only in the Trotskyist movement but across the spectrum of erstwhile New Leftists, it was a doomed idea: the very factories selected were often in the process of retrenchment and in any case unlikely places for campus types to operate comfortably in the long haul.

Soon, the impossibility of creating a proletarian movement out of the middle class drove the leadership of the little party into ever more fanciful

Mike and Max, members of the New York Sign Painters Local

visions of new global strategies, and ever more rigid organizational responses to fresh political failures. Still, if the sixties movement was to survive, it had to broaden somehow. Here and there (especially but not only among the Teamsters, hospital, health and service workers), a minority of those who set out to do the work managed to find accommodating environments and even a life's work. Alewitz, dedicated and not at all uncomfortable in working-class life, settled in, but with a difference.

He decided to learn about professional art work. He went to work as a pasteup artist for a commercial print shop. His employers soon realized that he didn't know anything about the work, and fired him, but not before he began an ill-fated union drive.

While he was there, an old sign painter revealed to him the artistry of a dying trade: the use of a quill, the perfect brush for lettering. When Alewitz and his new companion Christine Gauvreau left Ohio for New Orleans and another experience at "industrializing" (he became a clerk on the Southern Railroad), he would go to work in minimum-wage sign shops whenever he faced a layoff. As he soon discovered, commercial sign painting was still

done entirely by hand. Learning the lettering, scale, staging, and becoming accustomed to heights all offered interesting challenges.

When the pair moved on to Boston two years later, Mike worked for a couple years on a rail gang, repairing tracks. During winter layoffs he would ply his sign-painter trade in a unionized sign shop. He next worked as a clerk and laborer for Amtrak, then as a production machinist in a Lynn, Massachusetts, GE local long known for its radicalism. There, he painted the banners for a contingent organized to go to Three Mile Island, site of a nuclear near-melt down. While working third-shift at GE, he took advantage of a clause in the union contract that

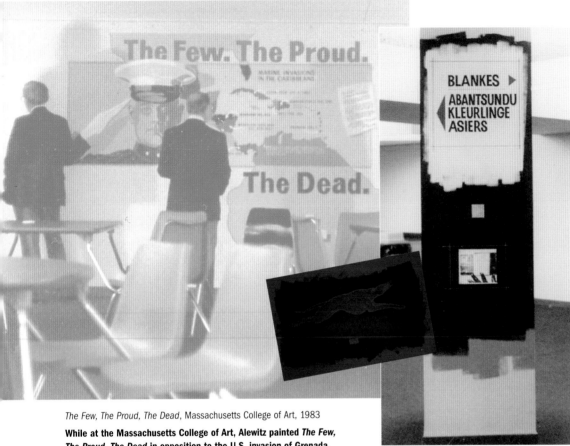

The Few, The Proud, The Dead, Massachusetts College of Art, 1983

While at the Massachusetts College of Art, Alewitz painted *The Few, The Proud, The Dead* in opposition to the U.S. invasion of Grenada. Alongside the mural he posted giant sheets of paper for people to make comments, and a lively written debate ensued. One night, right-wing protesters tore down the comment sheets. Students responded by pasting the torn sheets back together and adding a banner across the top: "The Price of Freedom is Eternal Vigilance."

Alewitz used a column in the school cafeteria and other school walls to mount changing pieces on contemporary issues. This included *Mad Dog with Scabs* during the Greyhound workers strike and this commentary on apartheid.

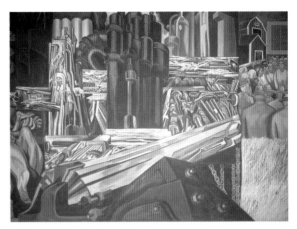

Jose Clemete Orozco, Mexican (1883-1949), *The Epic of American Civilization: The Machine* (Panel14), 1932-34, Fresco, P.934.13.14. Commissioned by the Trustees of Dartmouth College, Hanover, New Hampshire. © Licensed by Orozoco Valladares Family through VAGA, New York, NY.

obligated the company to pay for schooling. He registered at the Massachusetts College of Art, and for the first time in his life, paid attention in class.

ELIJAH PATE MURAL
Massachusetts College of Art
Boston, Massachusetts

With his acquired outdoor skills, he was soon teaching a murals class. Eventually he got a BFA in painting and an MFA in the Studio for Interrelated Media. He also got into a free speech fight with the administration over a political mural about the police murder of a young African-American man, Elijah Pate, that Alewitz painted on campus. The mural was first vandalized by cadets from the Boston Police Department and then painted over at the behest of the college president.

Increasingly discouraged by the deteriorating political atmosphere inside the party even while he enjoyed political agitation on the job, he toyed with various ideas of what he might do best. He got part of the answer from ruminating

on sign painting. The reinvention of the mural, he realized, depended upon the kinds of skills that billboard painters already had, without knowing what they could do beyond commercial advertisements. On a trip to New Hampshire, he viewed the most precious possession of Dartmouth College: a fresco that Orozco had painted for the Baker Library between 1932 and 1934, *The Epic of American Civilization: God and the Modern World.* He lost interest in performance and video once and for all. This was the thing for him to do, if only he could find a way to do it.

NICARAGUA

Many events made 1981 a year to remember. New president Ronald Reagan broke the strike of air controllers (a union that had supported his election), prompting the "Solidarity" labor march on Washington, the most impressive union event in a generation. For the political sur-

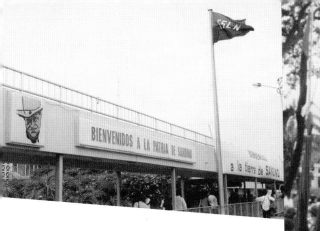

ABOVE LEFT: Managua airport. CENTER: Sandinista demonstration. RIGHT: Nicaraguan artists on either side of muralists Susan Greene and Mike Alewitz

A CUALQUIER COSTO CUMPLIREMOS CON LA PATRIA

vivors of the sixties (and previous generations), 1981 also saw the limited but real consolidation of the Sandinistas in Nicaragua, seized from Somoza's dictatorship two years earlier. Labor's radicals attacked the furious Cold War schemes of an AFL-CIO leadership designed to place America's friends back in power; if official labor's International Department worked intimately with the CIA, their opponents worked directly with the Sandinistas through educational campaigns, material support, and highly unofficial labor delegations like the one Alewitz and Gauvreau joined. The artist-in-the-making was stirred, as one can only be when the radical transformation seems dim at home but bright elsewhere.

The Nicaraguan Revolution inspired artists around the world. The Sandinistas' stubborn resistance in the face of growing United States–sponsored military intervention seemed to him incredibly courageous, so courageous that it might somehow hold on until some other breakthrough took place. The immediate rewards of the revolution could be seen in the flourishing of culture. Extensive,

Sandino poster

highly successful literacy campaigns went on apace. The poetry that Nicaraguans had so cherished was given support and brought to those who had once been excluded. Traveling, taking in the excitement, Gauvreau and Alewitz opened their eyes to the revolutionary process and glimpsed the beginnings of the late twentieth century's greatest mural movement, which created nearly three hundred murals during the Sandinistas' decade of power.[2]

Internationalista artists like Alewitz came to learn and to teach, to contribute their talents to reinventing a visual culture for Nicaragua. Here, the demands of the situation were most pressing, and here he began to see his art as agitprop (agitation-propaganda) in the deeply practical sense of the artist hard at work, doing what he does best. The corrupt Somoza government had not only inflicted terrible pain upon the population of this small,

The organization *Ventana* (artists from the United States) poster

Artists' solidarity groups like *Ventana* and Arts for a New Nicaragua organized numerous artists' brigades to Nicaragua. The brigades conducted workshops, performed, and painted murals.

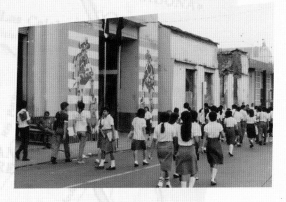

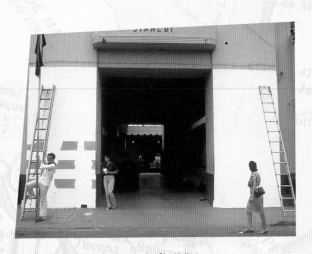

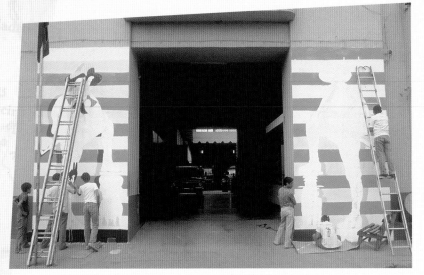

Two Sandinos, a group project at the City Hall in Leon, Nicaragua

Envisioning a project that provided for group participation while maintaining a strong design, Alewitz made two large images of Sandino. Volunteers from the Center for Popular Culture filled the silhouettes with assorted imagery. One side was the "defense" of the revolution, and the other was "democracy."

TWO SANDINOS MURAL
Leon, Nicaragua

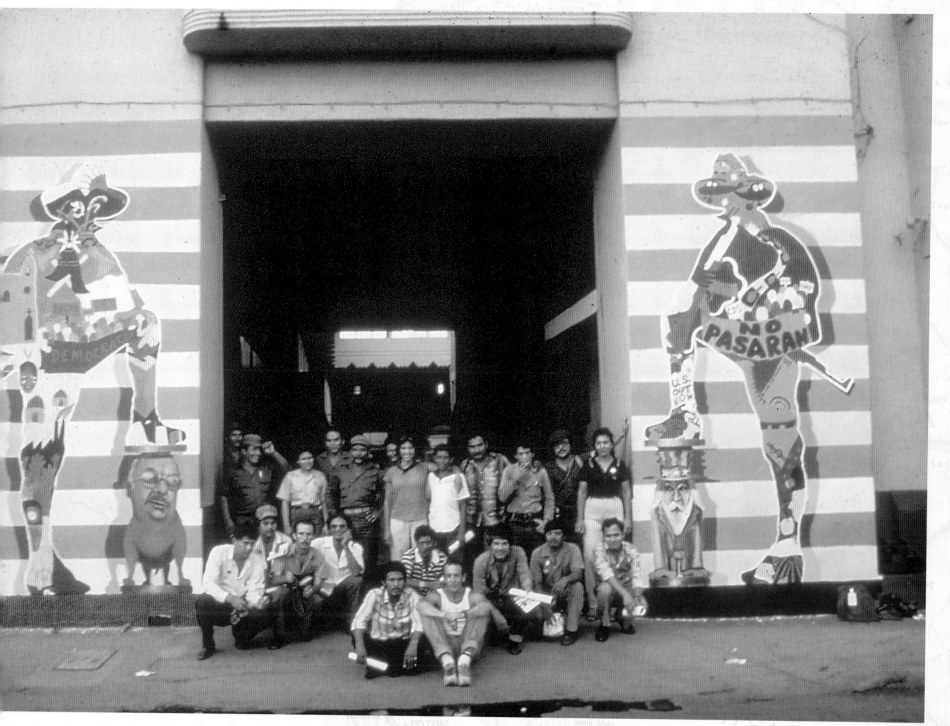

"What we have created here stands in stark contrast to the actions of the U.S. government. We are in solidarity with the artists and workers of this country, and I hope you will let others know that we have come to paint and to learn. There may be very hard times to come in Nicaragua, but we will always remember these times— when we came here to build international solidarity—to fight together against the U.S. war machine. We will continue that fight when we return to the north."

—M. Alewitz
Dedication speech
Nicaragua, 1983

impoverished country, it had also badly damaged the once-rich artistic traditions, institutionalizing a style that Nicaraguans scoffingly called "Miami kitsch." Reinvention-on-the-spot demanded close attention to local perceptions, and quick response to the requests of activists and workers who wanted a mural here or there. As a sign painter, Mike had indeed learned to work quickly and accurately, so his talents lent themselves to an immediate, responsive (later "performance") art.

In 1983, on a second tour, Alewitz joined with Arts for a New Nicaragua, mostly musicians and a few fellow muralists including David Fichter, Susan Greene, and Joel Katz. At that moment, his mural skills really began, in Leon, with *Two Sandinos*. Mike's own conception for a design that could be filled in by a squad of trained amateurs (thus retaining a signal clarity for the mural at hand, but also diffusing the necessary skills) had been inspired by the work of Chileans working using a similar format. In the mural, one of the two Sandinos sym-

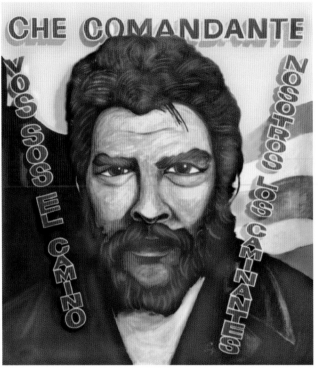

Che, Sandinista Youth Building, Esteli, Nicaragua, 1989

bolized the great reforms, like the redistribution of land previously held by Somoza's cronies (and, after the 1989 "democratic" restoration, safely back in crony hands), the other Sandino symbolized defense of the gains of the revolution.

Returning to Nicaragua again in 1989, under the auspices of the official Nicaraguan artists' union and its supporters in New York (organized in large part by the Brazilian jazz musician Thiago DeMello), Alewitz honored an American martyr, Benjamin Linder, a water purification *internationalista*, who sidelined as a clown for village children. In Alewitz's version, the brave and kindly Linder was a red-nosed idealist playing god's own fool (or holy clown of carnival tradition) before being gunned down by the Contras.

On this third trip Alewitz painted *Mother Earth* at the Children's Hospital in Managua. Designed primarily as a fantasy to distract the children from their pain, the mural depicted an outstretched woman as the earth. Her mountainous breasts were applauded by hospital

officials then supporting a national breast-feeding campaign (for which the mural became a popular photo backdrop). It also contained its share of subversive elements. The woman's hair became a river with a school of fish, a genuine school for the revolution as some of the fish were reading Marx and Malcolm X. Lenin can be found fishing in the river alongside Max, the heroic Alewitz frisbee-catching dog.

Every one of Alewitz's murals was effaced, as a matter of course, after the massively destructive Contra War and the American-orchestrated vote against the Sandinistas in 1989. How could the new rulers leave behind evidence of another way of thinking, glimpses of another way of life?

On both mural trips, Alewitz worked closely with local FSLN leadership. The total integration of his work into the revolutionary process had a profound effect on his thinking. As he worked and traveled with the Arts for a New Nicaragua musicians and muralists, and as he learned about the various ways in which Chilean and other international artists worked, he began to ask himself if a movement of artists to aid emerging struggles could be established back in the United States. A good idea, it took years to percolate. Just before the final swing through Nicaragua in 1989, Alewitz threw himself into another project in the small industrial city of Austin, Minnesota. Here he found a new artistic approach to the history and the current struggles of the American working class.

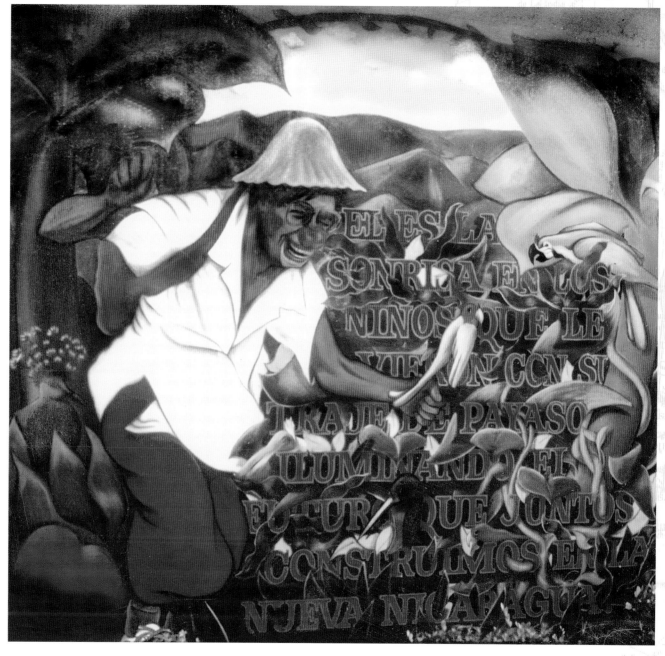

Ben Linder, NICA School, Esteli, Nicaragua, 1989

"He was the sunrise in the smile of the children who saw him in his clown suit, illuminating the future we are constructing together in the new Nicaragua."

—Daniel Ortega

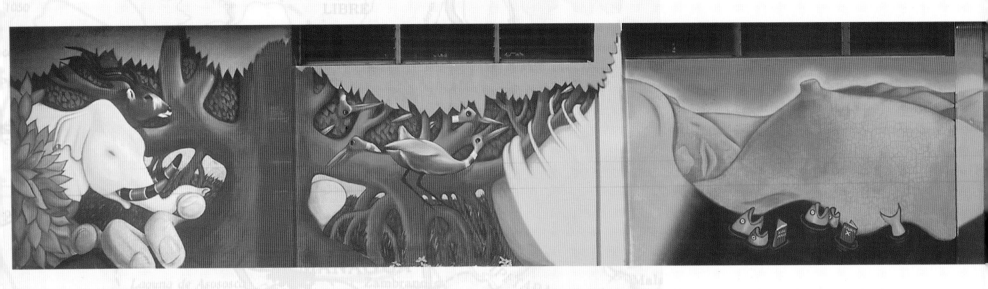

"The mural is a most beautiful allegoric mural using [the artist's] own materials and talent. It gracefully adorns the little park which the hospitalized children visit constantly in order to obtain a bit of diversion in the midst of their suffering in this unjust war. The children are the victims."

—Dr Fernando Silva, Director, Hospital Infantil Manuel de Jesus Rivera "La Mascota"

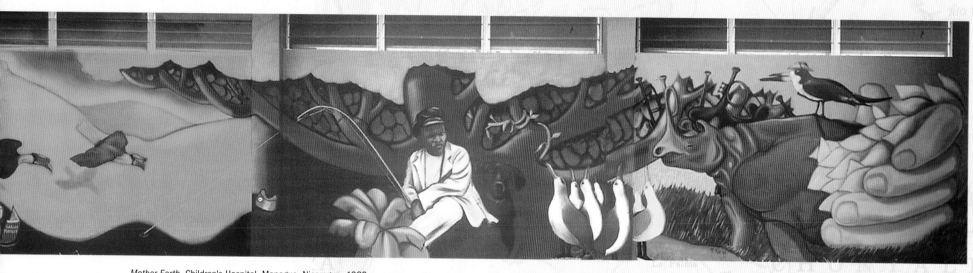

Mother Earth, Children's Hospital, Managua, Nicaragua, 1989

CHILDREN'S HOSPITAL
MURAL
Managua, Nicaragua

P-9, THE AUSTIN MURAL

So the artist has a great wonder and a tremendous influx of new life and at the same time has a great responsibility, because he must bring his skills to the rising people who contain the creation of the new world. It no longer exists in the middle class...They just want you to perfume the sewers...There is no art arising except from the struggle of the people."

—MERIDEL LE SUEUR

"One of the reporters asked me before why I was willing to come here, since I was from out of town. I told her. . . in my opinion, this wall on this building is the most important wall in the United States today. Because the P-9 strike is the most important labor struggle that has taken place in this country in decades.

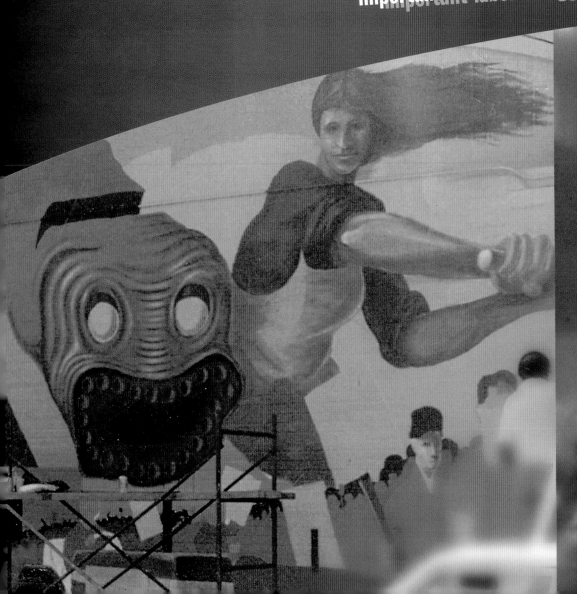

And if I had a choice of **any wall to paint on, it would have been** *this one.*" —M. Alewitz

SOLIDARITY WITH P-9
BOYCOTT HORMEL

THE MEATPACKERS' STRUGGLE outside Minneapolis-St. Paul in the mid-1980s marked a new and dramatic phase of American labor history, and a remarkable moment in public art as well. Labor here as elsewhere had been drifting downward since the 1930s and 1940s, when the Congress of Industrial Organizations had emerged as a vital source of industrial democracy and a major player in New Deal politics. Bureaucratic sclerosis had set in rapidly, followed by the Cold War, which chilled any remaining dynamism and virtually obliterated efforts to reach minority and women workers, from southern factories to the new clerical workforce. By the time of the merger of the CIO with the still more conservative and exclusionary American Federation of Labor in 1956, labor

institutions had become thoroughly bureaucratized and housebroken, even while past union victories provided a decent standard of living (and healthy pensions) for millions of workers. Millions more government workers joined unions in the next twenty years or so, but in most other respects, the ongoing stagnation only deepened. The emptying of the "rust bowl" during the 1970s and the resurgence of anti-union employer determination during the Reagan Era left unions bargaining to limit concessions while membership slipped steadily downward.

Austin, Minnesota, had been the epicenter of labor mobilization and community support for generations. During the 1930s, meatpackers and others had formed an Independent Union of All Workers, wholly independent of existing labor

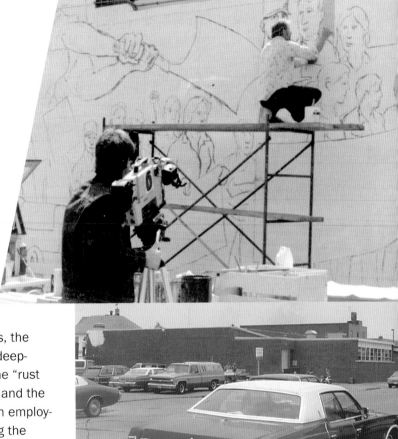

ABOVE: Worker volunteer beginning the mural. BELOW: The mural was located at the Austin Labor Center.

institutions. Horizontal in its egalitarian practices in contrast to the vertical military-style labor institutions with all the authority at the top, the IUAW reflected the traditions of the Industrial Workers of the World (indeed, the

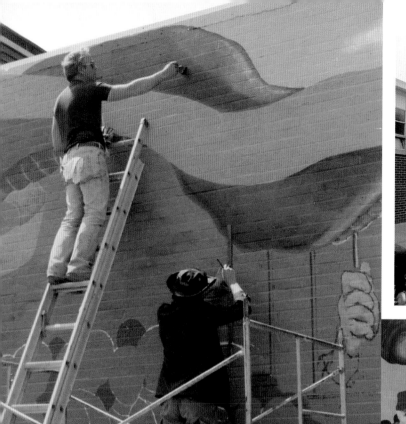

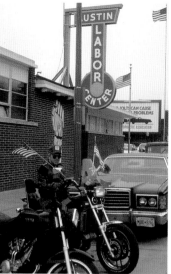

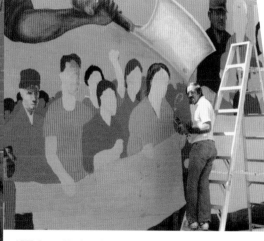

LEFT: Denny Mealy and Alex Ratner painting ABOVE: A union official from the Minneapolis Sign Painters Local.

merged with the CIO's packinghouse union in 1937. Never again did the former IUAW members operate so democratically, so freely in their own domain; the monuments to a generation of sharp struggle were quickly whittled down to size, even before the Cold War finished off the labor Left.

But the legacy survived. Still a center for Hormel's highly profitable production in the middle 1980s, Austin nevertheless saw a decline in working conditions simultaneous with a growth of a newer workforce influenced by the 1960s culture and the movement against the war in Vietnam. An earlier merger of the packinghouse workers with the United Food and Commercial Workers (UFCW) actually undercut the backstairs struggle against increasing dangers (due largely to a factory speed up and new, highly hazardous equipment) and prompted near-rebellion. Faced with the sorry consequences of corporate paternalism and compla-

IUAW's leading figure had been a prominent Wobbly activist) and the enthusiasm of local packinghouse workers. From 1933 until the end of the decade, the IUAW engaged Austin's leading employer, Hormel, in perpetual conflict while spreading out unionization to all manner of local working people. With astonishing energy, the

union dispatched "flying pickets" to nearby strikes, aided the region's farmers in militant actions, and created a rich community culture with a weekly paper, a library, and a drama troupe. Under intense pressure from employers and government alike, and with the encouragement of otherwise feuding left-wingers, the IUAW

"Look, these are the people who took on the Hormel company, the National Guard, and the Governor. Nobody is going to tell them they can't paint a mural."

—M. Alewitz

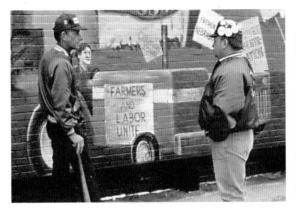

Union defense guards assigned to protect the mural from scab attacks. When rumors spread that an attack was possible, RVs were brought into the parking lot in front of the mural wall for an around-the-clock presence.

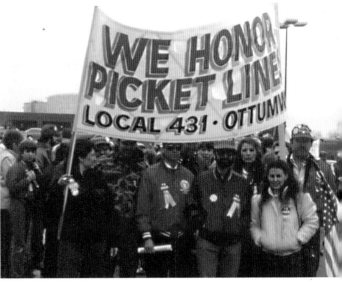

An Alewitz banner for workers from another Hormel plant in Ottumwa, Iowa, who honored the P-9 pickets in their own plant. These workers subsequently lost their jobs.

cent business unionism, the Austin leadership avowed union democracy and opposition to further concessions. In August 1984, shortly after a strike began and as the UFCW machine approached strategies to clamp down on restive unionists, a United Support Group began to revive IUAW traditions through public meetings of P-9 wives, an event that rapidly turned into a social movement. Within weeks, "P-9" buttons,

hats, and T-shirts could be seen everywhere in Austin. Labor and cultural activities of all kinds emerged as the community knitted itself back together.[1]

From a national standpoint, the resulting Austin strike was remarkable as a manifestation of resistance to the corporate drive for concessionary contracts. But it was also astounding as a place where mass meetings rose in applause for representatives of solidarity from Native American organizations, anti-apartheid groups, and other non-labor movements and where local women took the lead in many ways. The experiment in labor democracy yielded a new group of working-class visionaries, mostly traveling teams of Austin's own union members, most of them deeply involved for the first time as the spokespersons for a public fight. Fanning

out across the continent, from Puerto Rico to Alaska, appealing for support for their fight against takebacks, interacting with activists of all kinds and proselytizing for the rebirth of a militant CIO-style labor movement, they provided living proof that the labor movement could become a social movement once again.

A part of that activity involved preliminary mural work in advance of muralist Alewitz's visit. By the time Alewitz first arrived in Minnesota for a highly publicized "Shut Down Hormel" rally in April 1986, local union activists Denny Mealy and Ron Yokum had already produced, for the soup kitchen cafeteria headquarters in the Labor Center, a painted narrative history of labor. It was significantly dedicated to Norma Rae, the fictional labor heroine from the 1979 film of that name. By a

familiar coincidence, the film had been directed by Martin Ritt, an actor and labor activist of the 1940s who had been blacklisted and returned to movies as a director, restoring radical labor traditions in more ways than one.[2] Alex Ratner, a young cultural worker and the son of one of the union local's lawyers, had meanwhile led strikers in the creation of some inventive, mildly expressionist floats and effigies for protest marches.

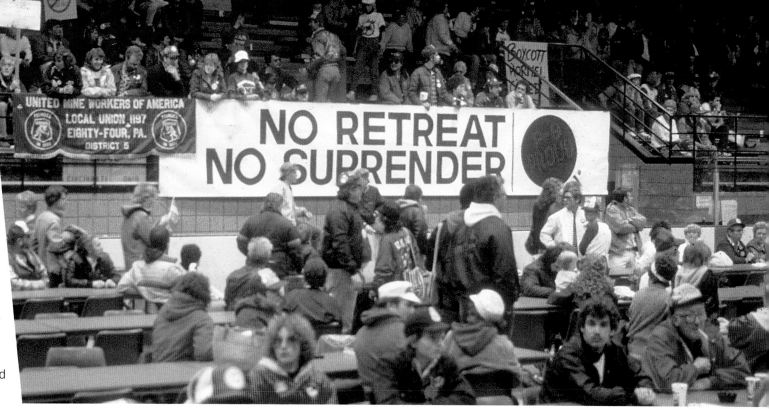

These initiatives prompted Alewitz, with the Nicaraguan experience under his belt, to suggest that he might assist the local activists in the creation of an outdoor mural later that spring. Mealy was enthusiastic and together they won the support of Local President Jim Guyette. A mural committee composed of Mealy, Yokum, Ratner and Guyette officially invited Alewitz to return to Austin in May 1986, to organize and oversee the project.

On the scene, Alewitz initiated a wide-ranging discussion of the mural's possible imagery and content, presenting a slide show of famed artworks associated with labor struggles in the modern era. Posters from the Industrial Workers of the World, photo stills from the fund-raising pageant for the Paterson, New Jersey, strike of 1913, scale drawings of Russian avant-garde plans for mass spectacles following the 1917 revolution, and a broad sampling of details from the work of Mexican muralists were all included. Alewitz brought

ABOVE: National support rally in Austin
LEFT: Mural work in progress.
CENTER: Disabled Hormel worker at the mural site.
RIGHT: Workers would gather at the mural site in the early evening to discuss the strike.

"The co-producer of the mural, Denny Mealy, was a leading activist in the local as well as a talented artist. My own experience as an artist and a worker has convinced me that the workplace is full of such creative people.

The dedication of the P-9 mural was one of the great moments in labor and art history—directly in the tradition of the Paterson Silk Strike Pageant. It was dedicated to Nelson Mandela when he was still branded a "terrorist" by the U.S. government. These workers were capable of engaging in a militant and selfless struggle—and the mural gave visual expresion to that struggle. Its destruction at the hands of UFCW bureaucrats was a crime against the working class. It will have to be repainted.

The mural site became the center of artistic activity—not just working on the mural, but making picket signs or just hanging around. Inside the building was the soup kitchen and organizing center for the strike and for P-9 activists crisscrossing the country to build support for the strike."

—M. Alewitz

Denny Mealy and Mike Alewitz toast the completion of the mural

materials documenting these examples, and P-9 members for their part provided more documentation of their work and aspirations. Committee members chewed on the possibilities raised by the various traditions, and an evocative set of concepts emerged.

A giant serpent at the center of the mural, squeezing the life out of the industrial city, unmistakably recalls a Russian poster from 1919 by Dimitri Moor. A face behind bars taken from a documentary photo of a union victim of state harassment in the packinghouse strike of 1936 reinstates images commonly employed by the International Labor Defense of the 1920s and 1930s. The Socialist Realist tradition of highlighting a monumental laborer, a vital tradition often abused with over-stylization, is here skillfully

Jim Guyette, the local president of P-9, with Alewitz's "Free Mandela" banner

inflected with Local P-9's high level of consciousness about the role of women in the fightback. A floating ribbon with the refrain of a Wobbly poem—"If blood be the price of your cursed wealth, good God we have paid in full"— provides unity to the various parts. While Alewitz clearly delighted in sampling details of imagery from various working-class and radical traditions, what pleased him most was the interplay between rank-and-file interest in those traditions and the desire of meatpackers to express, in more direct terms, their own recent experiences.

Alongside the sampling of iconic tradition stood, then, many strictly personal and local touches. One of the Minnesota hog farmers, a P-9er who expressed solidarity with the strike by refusing to sell pigs to Hormel, added a picture of his farm in the upper left of the wall. Alewitz poignantly recalled to reporters how another artist climbed up to place a small "For Sale" sign next to the

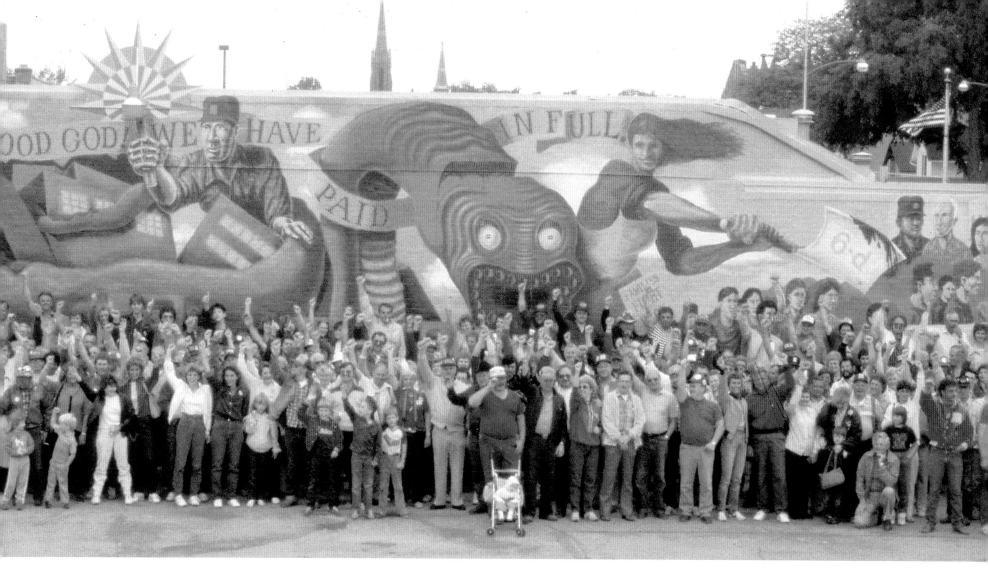

Dedication of the P-9 mural

image, evoking a larger symbol of the escalating tragedy of farm foreclosures that dovetailed with the 1980s corporate pursuit of concession contracts in labor. Another sign read "Ottumwa, Iowa" and referred to a sister Hormel plant where dozens of meatpackers, honoring P-9 pickets, shut down production in solidarity with Austin, and were all fired. Even at its most repor-

torial, the mural reflected the ever-broadening lens through which P-9ers viewed the world.

No less interesting were ways in which mural imagery became part of the culture of labor resistance nationwide. Folksinger Charley King incorporated it into his often-heard song, "We'll Take Our Stand in Austin." Meridel Le Sueur, local feminist legend and the leading

survivor of the "proletarian writers" movement of the 1930s, praised the mural as a rebirthing, "a Vesuvian release of energy...the only place where there's life...the only place where there are any kind of [rich cultural] images."[3] Larry Bastair, a member of St. Louis local UAW 325, took the initiative to find an artist to put the central image on a shirt that shortly began to

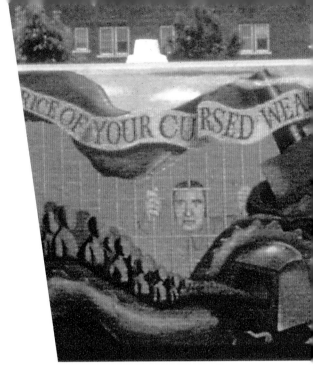

P-9 MURAL DEFACED

"One of the most shocking cases of cultural censorship in recent times is taking place on the wall of a labor center in Austin, Minnesota. A mural painted by and for members of a meatpackers union local has been sandblastedaway by the International union after it decertified the local and took over the building..."

—*Community Murals Magazine*
Berkeley, CA, Spring 1987

Beat the Devil
AFTER THE PRESS BUS LEFT

"As many in this sad world know, P-9 found an enemy as remorseless as Hormel in the form of its own international union, the U.F.C.W., which finally forced the local into trusteeship, signed a contract with the company, and then began a purge of the strike movement. Determined to extirpate the memory and culture of P-9's struggle, the U.F.C.W. ordered sandblasting of the mural..."

—Alexander Cockburn, *The Nation*
November 8, 1986

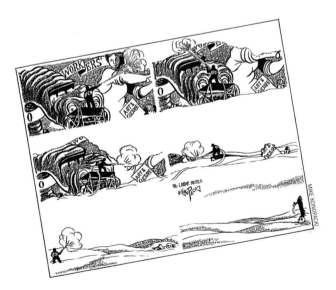

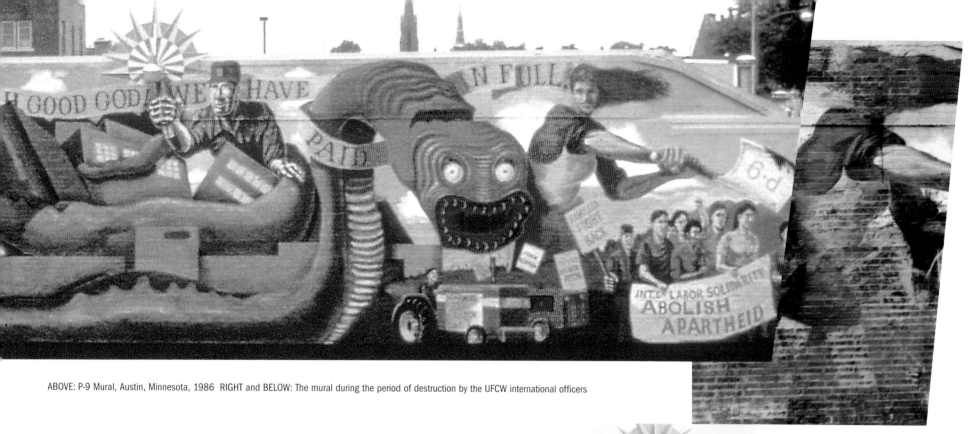

ABOVE: P-9 Mural, Austin, Minnesota, 1986 RIGHT and BELOW: The mural during the period of destruction by the UFCW international officers

turn up at picket lines in distant coal fields. Twin Cities supporters produced a postcard with the same image, utilized to raise funds and spread the word.

The participatory character of the project, made possible by the high level of P-9er mobilization and the enthusiastic response of Twin Cities activists, became central to the near instant lore of the mural. Twin Cities' Sign Arts and Display Local 880 donated forty gallons of paint, as well as brushes and pattern paper. Several officers of the sign painters' union put brush to wall, while strikers and supporters scoured basements and garages for old coatings to use as primers. Union members donated and assembled scaffolding, helped roller the brick surface with a sealer, and then prime the

wall. Volunteers recruited from appeals at union meetings plumbed the wall and helped transfer the gridded sketch to the building. Others gave the volunteers time to paint by stepping in to relieve them of their normal strike support assignments. Local P-9 member and plant carpenter Don Allen created a memorable wooden halo for a security light, transforming it into a torch that could be more easily incorporated into the overall design. Local members also provided floodlights so that work could go on at all hours. Thus an utterly unique mural created by Alewitz and about a hundred volunteers could take on its most stirring qualities. Painted at the invitation of local

members and dedicated to the jailed Nelson Mandela, it was toasted jocularly by Alewitz at an open-air rally with the presentation of a plaque with a dried brush attached:

Now, when Picasso was a young man, when he was fourteen years old, his father, who was an art teacher, handed him his brushes and he said, "I've taught you all I can and now it's up to you." So as an outside resource person on this project, I'd like to present a brush to Local P-9. We now have an excellent core of mural painters here, and as P-9 [inspired]

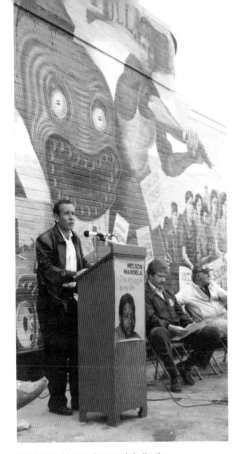

Alewitz speaking at the mural dedication

Three more features of the mural and its consequences merit extended discussion. First, the mural production at times assumed the festive atmosphere of a strike, even of a city general strike of the type known intermittently through the twentieth century. Traffic backed up as drivers slowed for a look. So many supporters dropped by with pizza and rhubarb pie and then stayed to socialize that the painters teasingly put up a bucket with a sign, "Twenty-five cents to watch." When rumors surfaced that the company was organizing scabs to vandalize the mural, a donated mobile home was quickly set up in the parking lot and staffed with local members assigned to defend the wall.

The dedication to Mandela, first proposed by Alewitz, was eagerly accepted by the strikers because of their experiences and developed sense of common oppression, their trips around the US, and their contact with thousands of supporters from union locals and other political organizations showing up in solidarity actions in Austin. At the time, it should be remembered, Mandela was still being vilified by the US government as a terrorist. Only a few weeks before

the dedication of the mural, the newly-formed Congress of South African Trade Unions (bitterly opposed by AFL-CIO leaders caught up in Cold War machinations, but later accepted as that nation's legitimate union federation) had sponsored May Day demonstrations of over two million workers under severely repressive conditions. The bravery of union leadership of the movement to abolish Apartheid sparked a new sense of international connection for many in Austin.

At the Austin dedication in which Alewitz

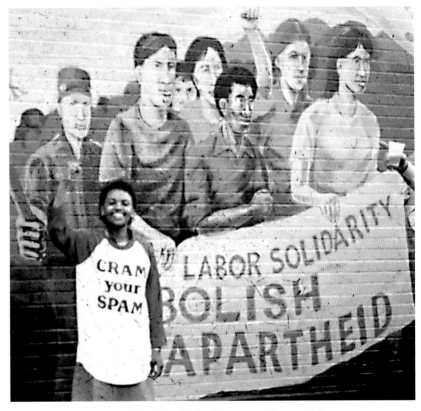

Babs Duma, the representative of the African National Congress, at the mural that was dedicated to the imprisoned Nelson Mandela

struggles take place throughout the country, which they will, people from P-9 will be able to go to other locals, those fortunate enough to have buildings, and help on projects there.

The sustained core of about fifteen had made it possible to complete the entire painting within several weeks. Most of those who worked on the mural had no experience at this sort of thing. Alewitz told newspaper reporters that such past limitations didn't matter: "Look, these are the people who took on the Hormel Company...the National Guard and...the Governor. Nobody is going to tell them they can't paint a mural."

offered an absent Mandela to "extend our hand in solidarity, as the hands of solidarity have been extended to us," Jim Guyette spoke movingly to the crowd of the "profound parallels" between the situation of Mandela and that of P-9. The imprisoned South African counterpart to America's Martin Luther King, Jr., could, that is, have signed away the ANC's principle and gained his own freedom, just as the P-9ers could bend the knee and return to work. Babs Duma, a representative of the African National Congress and Twin Cities Anti-Apartheid Coalition, similarly expressed the urgency of global solidarity. An officer of the parent UFCW, appointed to take over the local and end the strike, cynically quipped, "I see no correlation there between the struggle in black South Africa with the all-white population of Austin, Minnesota." Naturally he didn't. But many strikers had prepared to cross that line when they resolved not to cross another one.

As the mural became one of the emblems of P-9's idealism, it was naturally also the object of company and UFCW derision and even fear. When the Washington-based UFCW trustees snatched control of the local, their stooges shut off the security light so as to encourage vandalism, and sought to contract for a Twin Cities crew to sandblast the mural from the wall. No union sandblasters would accept the work, and despite a local judge's restraining order, the bureaucrats' flunkies proceeded with the sand-

T-shirt commentary

blasting themselves. Local unionists, members of the African National Congress, the Minnesota Public Interest Research Group, New York public art groups and librarians sent letters of protest, and Alexander Cockburn reported in the Nation that the effacement had begun symbolically with the word "Solidarity." Members of the local, including executive board member Kathy Buck, were arrested attempting to defend the mural. Nevertheless, it was destroyed.

A postscript took shape in Silver Spring, Maryland, home to the George Meany Center of the AFL-CIO educational apparatus. Ten years after the creation of the mural, Alewitz had a show there, as labor's leading contemporary muralist reviewing a decade's work. Meany Center administrator Bob Pleasure, soon to be a leading light of the Sweeney team, warned that the section recalling the P-9 mural violated the spirit of a historic show by injecting contemporary disputes. The P-9 detail was actually the oldest piece in the show, but the part of labor history still definitely in dispute. After protests by Alewitz and mural supporters, the Meany Center agreed to mediation by Joe Uehlein, who was not only a labor official but a musician with the band Bones of Contention, and eventually allowed the photos and text to remain in the exhibition. It was a small victory en route to a larger one for union members and working people more generally.

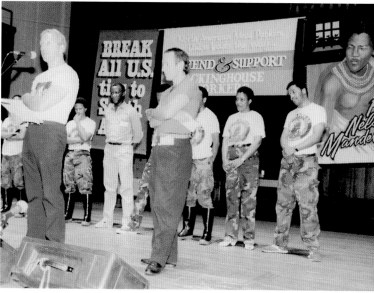

Denny Mealy, Alewitz, and a visiting ANC cultural troupe at a socialist gathering in Ohio

What had the mural meant, then? Like the Paterson pageant, publicizer for a heroic but defeated strike, the images in Austin stood out as symbols of bold resistance, solidarity, and generosity in an age of wholesale labor retreat and fearful individualism. In the muralist's own work, the experience crystallized a notion of possibility. Not only in Nicaragua or amidst a revolutionary situation, ordinary people, working people, had the capacity to rediscover common bonds and discover for themselves the value of artistic experiments alien alike to official Soviet styles and to the official American art world. Mural-making was a way of operating within the compass of labor resurgence, giving it resonance and the special meaning that only community participation in culture can give.

LABOR SOLIDARITY
(FOR ARTISTS TOO!)

PEOPLE'S ART
TEARS THROUGH
L.A. TINSEL

I

f you think that by hanging us you can stamp out the labor movement...the movement from which the downtrodden millions, the millions who toil in want and misery expect salvation—if that is your opinion, than hang us! Here you will tread upon a spark, but there and there, behind you and in front of you, and everywhere, flames blaze up. It is a subterranean fire. You cannot put it out."

—AUGUST SPIES (Executed November 11, 1887)

"To rebuild our movement we must relearn our traditions, like what a picket line is for, or how to stop production. We must also relearn our cultural traditions. The cultural and spiritual concerns of workers is a union issue.

That is what the Labor Art and Mural Project is about, the real tradition of a **singing and painting movement."** —M. Alewitz

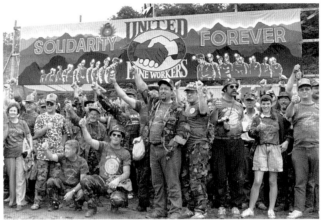

HISTORY CHOSE MIKE ALEWITZ or he chose history in the late 1980s. It was not the dead and distant past, but a history that came alive in a West Virginia Coal patch with the kick of a mule. The United Mine Workers (UMW) has an extraordinary story, as autocratic as any at the top but more democratic, with a longer history of real solidarity at the bottom than any other American union. Alewitz and his collaborators rose to the occasion of the famed Pittston strike of 1987 for the same reasons as many around labor did, but also because mineworkers' history had special meaning to them.

Going back to the latter decades of the nineteenth century, American coal miners had an extremely militant tradition from Pennsylvania and Appalachia to Indiana, Illinois, and Kansas. The causes are not difficult to locate. Not only was coal mining the most dangerous occupation worldwide (it continues to be so today), measured by the number of deaths and injuries, but internally, that is, among workers themselves, it is one of the most democratic. By a centuries' old tradition of Welsh and English miners, young workers still learning the trade and old workers in their last years shared the least skilled jobs; to begin was to see the end in sight, at least for those fortunate enough to escape death or maim-

ing in "the pits." Perhaps for these reasons, coal mining was also among the few racially integrated and unionized occupations of a century ago, although African Americans enjoyed fewer benefits and a constant threat of complete marginalization within the deeply racist American Federation of Labor.

But the UMW tended also, from its first decades, to be boss-ridden. The small coal-

ABOVE LEFT: New Jersey miners with *Justice For Miners* banner, 1989
ABOVE RIGHT: Camouflage is a uniform and sign of militancy for the miners, who have a unique history of struggle in the labor movement. Chris Gauvreau, Bob Allen and Alewitz painted the banner at Camp Solidarity
LEFT: Detail of John L. Lewis from the *History of the United Mine Workers Union*, 1990

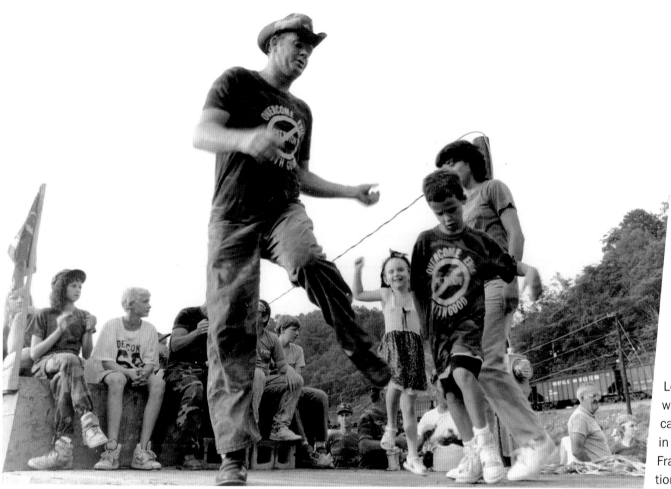

Clog dancing at Camp Solidarity

PHOTO: BOB ALLEN

patch towns were an ideal political base for union grafting and for lucrative political trading with Democrats (and, on many occasions, Republicans). Taking office shortly after the beginning of the new century, John Mitchell, the first UMW president of wide reputation, quickly became known for his high living, his socializing with big businessmen, and his autocratic behavior in office. John L. Lewis, arguably the greatest American labor orator after Eugene V. Debs, came to power in the same tradition of double-

dealing and frequent betrayal.

Lewis's career was marked by the acquisition of a personal fortune, but also by apparently wild swings against the Left, during which time he stuffed ballots and employed thugs to beat back radical threats to his power, alternating with swings toward the issues of the Left, as when he invited Communists into the new Congress of Industrial Organizations that he did much to bring into being. Lewis could also be more militant than the largest section of the

Left, as during wartime when he called out miners in 1941, over Franklin Roosevelt's threats of injunction and over Communist demands that labor cease strikes for the duration. His threat to form a Labor Party in 1940 (he eventually supported Republican Wendell Wilkie) was the closest approach to national, independent labor politics for generations; his shifts, from the AFL to the CIO and back to the AFL, marked his frustrations with labor leaders' unwillingness to live up to the potential of the movement.

Lewis grasped as few American union bosses that his strength depended upon membership mobilization more than upon political trading—which as a registered Republican he did

frequently, for his own purposes. From the early 1920s through the late 1940s, leading regional walkouts, he used his extraordinary vocal powers and capacity for organization to keep the union members and their families in struggle.

He fearlessly denounced all opposition alike (employers, police, and the state) as the enemies of the miners and of the working class. In his later decades before retirement in 1957, while mines shut and automation cut further into the workforce, he traded struggle for retirement and health benefits. His immediate successor, the thuggish Tony Boyle, had all Lewis's defects and none of his virtues; democratic challenger Jock Yablonsky was counted out at a union election in 1969, and then murdered along with his family, apparently by Boyle henchmen.

Arnold Miller, the reform candidate who came to power in 1972, brought the union real democracy but faced overwhelming odds. As the oil crisis of the 1970s brought

Hideous but True was Alewitz's cardboard mask caricature of Paul Douglas, CEO of the Pittston Coal Company. On Halloween, miners and supporters wore them in a demonstration past Douglas's house in Greenwich, Connecticut

Chris Gauvreau painting at Camp Solidarity

back coal production, Miller faced a petition campaign to recall him from office.

Disappointed with their president, miners nevertheless recognized the coal companies' deepest intentions: to weaken historic union control over work, and to strip away the health and safety benefits that kept coal towns alive. The strike that began in December 1977 awakened solidarity in a dormant labor movement. Even as leading AFL-CIO officials dithered, more concerned with increasing the defense budget

and pleasing a Democratic administration than with unions' steady decline, thousands of union members responded.

Heartened, UMW ranks turned down, at the bitter height of winter, a poor offer that Miller recommended for ratification. Even when the "pro-labor" Jimmy Carter ordered miners back under the Taft-Hartley Act that he'd promised to help repeal, and as welfare officials refused food stamps to strikers, the miners held steady. After more than a hundred days on the picket line, they had won labor's most significant victory in an era of defeats. Oscar-winning *Harlan County-USA* (1976), a film made by documentarist Barbara Kopple, recorded the faces and voices of Kentucky miners and their families for millions of labor's sympathizers.

This was the background for events of the later 1980s. Pittston Coal, subsidiary of a giant conglomerate and a major coal exporter to Japan, withdrew in 1986 from the industry-wide labor agreement, attacking insurance, pensions, widows' benefits and the historic prerogative of miners to refuse the compulsory overtime work particularly hazardous in the trade. It was also a test for new miners' president Richard Trumka, elected in 1982 after a ferocious red-baiting

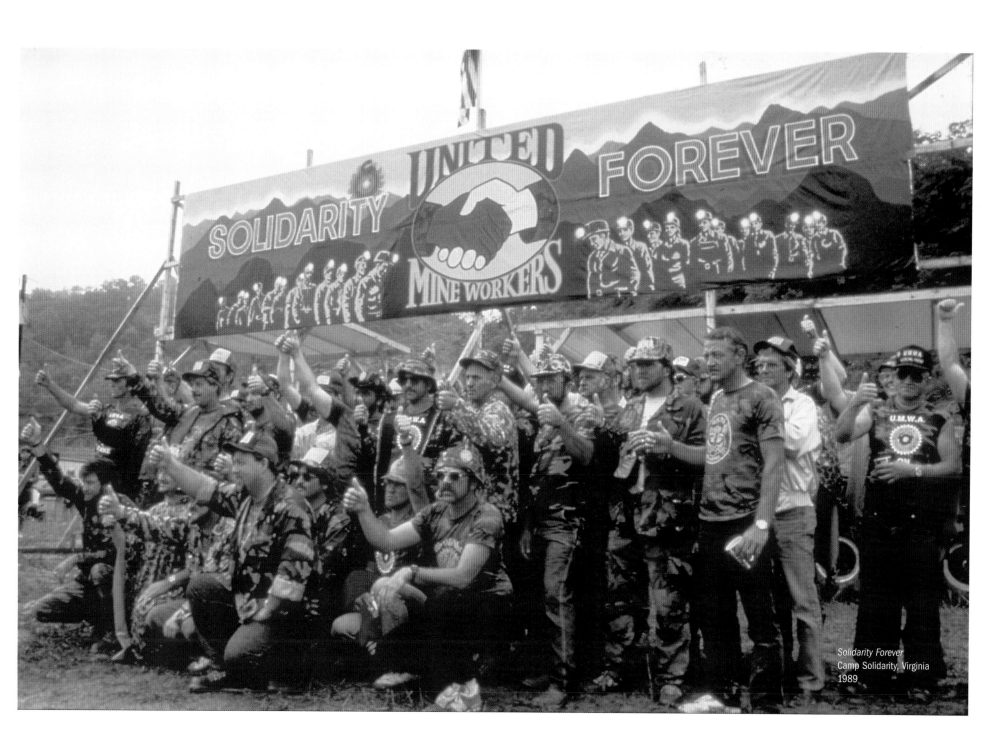

Solidarity Forever
Camp Solidarity, Virginia
1989

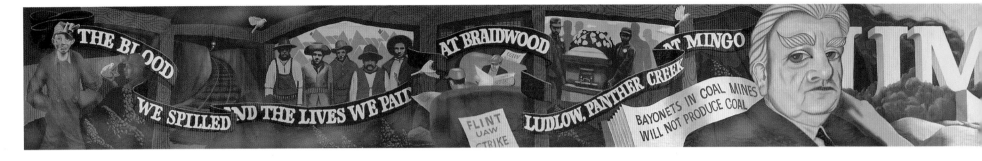

campaign, to hold strong against what would have been a crippling defeat to the union. Hold they did. As the miners "worked to rule" (the old Wobbly tactic of staying at work and obeying regulations to the letter, hence slowing production) and organized a "corporate campaign" against Pittston management, the conflict escalated and in spring 1989 led to an explosive strike. Miners organized their families, neighbors, and communities, dressed in camouflage clothes like guerilla warriors, peacefully blocked scab trucks with their bodies and appealed for a wider solidarity.

The summer of 1989 saw the emergence of "Camp Solidarity" and the formal reaffiliation of the UMW with the AFL-CIO. Thousands of unionists from across the country came to stay for days or weeks, living out of tents and trailers, taking part in picketing, rallies and informal discussions. At one point miners occupied a coal processing center, the first time this sit-in tactic had been successfully adopted in generations. It was, in all, a historic moment that only the paucity of national press coverage and the phlegmatic character of labor leadership pre-

vented from becoming a national cause célébré.[1]

Mike Alewitz had special reasons for enthusiasm and involvement in this struggle. Not only the UMW traditions of militancy and commitment to winning the current strike, but the example of the P-9 strike all suggested that Pittston could become a kind of turning point for a broader shift within labor. He also helped to make a genuine cultural

contribution, although his experience attempting to bring fellow artists to Austin had proved disappointing. Traveling to Nicaragua for the sake of workers and peasants obviously possessed more appeal than a trip to the midwest and its blue-collar (or rural) population, but Pittston might spark a collective artistic enthusiasm and insight. Besides, Alewitz's expulsion from the Socialist Workers Party intensified his determination to sink roots into New Jersey union activities. By dint of energy and good humor, he made himself the dean of the state's labor artists, the natural leader of an extended solidarity campaign with the prospect of raising strategic issues for the labor movement.

His political comrade of a decade (and an early collaborator on murals), Bob Allen, had been a miner for some years before settling in New Brunswick, and Allen maintained friends and contacts among the UMW. Alewitz, Allen, and Gauvreau traveled to Pittston in summer 1989, bringing with them most of the art supplies (paid for by Alewitz's sign

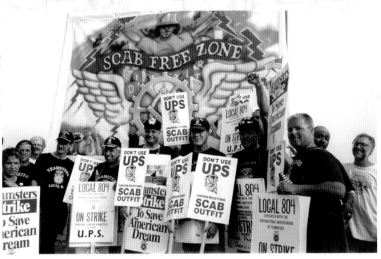

Scab Free Zone was originally painted for the International Association of Machinists (IAM) on site at a Seattle cultural festival. Here it is used in a rally for the Teamster strike against UPS.

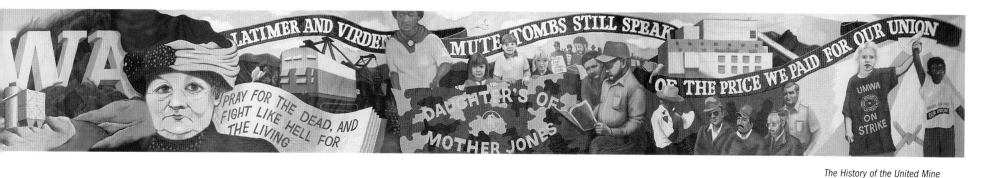

LATIMER AND VIRDEN • MUTE TOMBS STILL SPEAK OF THE PRICE WE PAID FOR OUR UNION • PRAY FOR THE DEAD, AND FIGHT LIKE HELL FOR THE LIVING • DAUGHTER'S OF MOTHER JONES

The History of the United Mine Workers Union, 1990

The one-hundred-foot *History of the United Mine Workers Union* was commissioned for the one hundredth convention of the union. The mural begins with children working in the mines and ends with them on the Pittston picket line.

painters' local) necessary for a camp banner.

Camp Solidarity quickly reminded the visitors that the mineworkers' union had in many unique ways retained its rich cultural traditions. Local union musicians exchanged songs with visitors around the country (and the world: Britain's Billy Bragg came to share music).

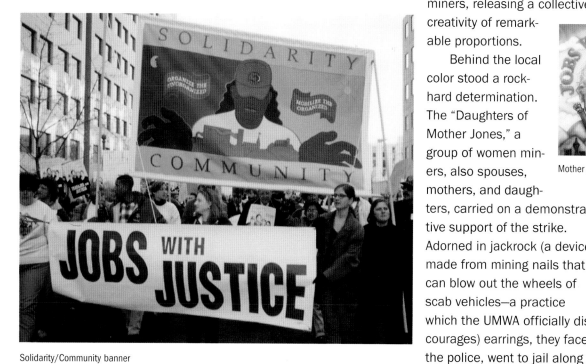

Solidarity/Community banner

Videos about the strike were quickly produced and widely shown in union locals elsewhere; camp dorms and trailers sprouted all sorts of popular art; and clog dancing broke out with amazing frequency. The mountain culture of the region could meld, as it had done so often in the past, with the contemporary struggles of the miners, releasing a collective creativity of remarkable proportions.

Behind the local color stood a rock-hard determination. The "Daughters of Mother Jones," a group of women miners, also spouses, mothers, and daughters, carried on a demonstrative support of the strike. Adorned in jackrock (a device made from mining nails that can blow out the wheels of scab vehicles—a practice which the UMWA officially discourages) earrings, they faced the police, went to jail along

Mother Jones

with others, but also traveled the country and spread the word ("jawsmithing").

The *Solidarity Forever* Camp banner was painted on site at Camp Solidarity in a day and a half, the design utilizing a drawing of miners that Allen had done in his miner's days for *The Mineworkers Journal*, showing a silhouetted line of miners with their hats aglow. The slogan is sufficient and expresses perfectly the favorite union song of the 1910s–1930s, a restatement of labor's creation of all value ("Now we stand outcast and starving midst the wonder we have made") and a deeply evocative rendition of the an-injury-to-one-is-an-injury-to-all Wobbly spirit. Allen remained in Virginia to paint walls and even a barn roof on behalf of the strikers.

Alewitz returned in the fall with a caravan of artists and unionists from the New Jersey Industrial Union Council. Traveling fourteen hours through a bitter winter storm and a highway strewn with disabled vehicles, they staggered into the camp to deliver toys to the

DAILY NEWS
FORWARD WITH LABOR
FREE
AUGUST 31, 1997
WORKERS STRIKE
FORCE FOR JUSTICE

ABOVE AND RIGHT: These banners were used in a number of different struggles—including the Eastern Airlines strike, the *Daily News* Strike, and the Yale strike

strikers' children. The miners had built a large drawing table for the artists to work, where they quickly and spontaneously designed and painted a banner commemorating the event. The camp was still a place to meet with strikers and fellow visitors, to share their experiences about labor solidarity and about the role of art and the artist.

In the end, the Pittston UMW, joined by the 47,000 miners from elsewhere, who traveled to the site to show solidarity, and the thousands of other supporters, outlasted the company. By spring, the strike was settled, with benefits that continued into negotiations with Pittston Coal thereafter. It had been a memorable moment for labor art work as well, in some ways the most memorable since the 1940s when mainstream giants like Ben Shahn still painted on invitation for labor solidarity.

The artistic result of all this was a seven-by-one-hundred-foot historical panorama banner of UMWA struggles, mine disasters, and union victories created for the union's centenary convention celebration. The panoramic narrative begins with a "breaker boy" releasing a canary that flies over the surface of the mural to alight on the hands of miners' children marching the Pittston picket line. The mural sees the history of the UMWA not simply as a struggle for rights for its members, but as a catalyst for the construction of the CIO, thus showing a scene of sit-down strikers in Flint, Michigan.

The centerpiece of the work is "Mother" Mary Jones—the most famous personality of women in American labor—and inevitably, John L. Lewis himself. The banner also boldly suggests, with its women workers, that solidarity has now outgrown the "manly" tradition (a verse of *Solidarity Forever* runs, "Union Men Be Strong") for something larger and better. Alewitz was assisted by Darlene Sanderson and numerous volunteers, with Bill Kane (president of the New Jersey IUC) personally painting the red tie on the visage of John L.

The imagery sparked some discussion. Young staffers and rank-and-file members of the UMWA objected to the inclusion of a scene of the union's international officers being arrested at a Pittston demonstration. Alewitz, who rarely uses living people in his murals, defended his decision. Union officers were, for once, doing the right thing by leading the union to victory—at a time when most labor officials were complicit in concessionary contracts. Throughout the strike, UMWA officers like Cecil Roberts supported the mobilization of the ranks, and through their militant (often anti-racist) speeches helped forge a movement with the confidence to take and occupy a key mine.

The banner was only shown for a single day in a poorly lit room at the miners' convention in Miami, then promptly buried in the UMW basement. Once the creative impulses generated by the mobilizations at Pittston ebbed, the commemorative mural was set aside. With the ranks back at work, DC staffers turned to other things. Alewitz was able to exhibit the mural at several

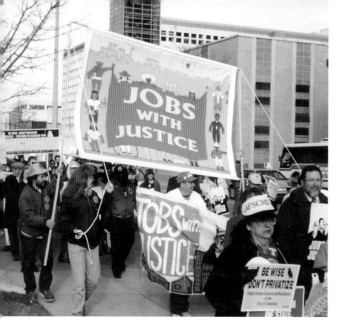
Jobs with Justice banner in Cleveland demonstration

ABOVE TOP AND MIDDLE: Alewitz presents banner donated by the painters union to Yale strikers ABOVE BOTTOM: Eastern Airlines strike banner LEFT: Mushroom Workers strike banner

nant of the CIO that (unlike every other equivalent state body) had never merged into the AFL-CIO, was in another way the remnant of a bygone era and which the old Industrial Union Councils were supposed to lead, organizing the unorganized by bringing members of assorted unions together for the task.

The New Jersey IUC did little of that; but it maintained a spirit of solidarity long abandoned by patronage-dominated central labor councils and the state AFL-CIO. The appointment of Alewitz, then, could be seen as a bone tossed to progressives. It was also a sincere effort to see a vigorous, youngish figure with considerable talent add some life to the flagging labor movement. A half-dozen years later, he had clearly added too much life. Like so many of the labor schools set up in the wake of the Second World War, the Rutgers school had been pressured to evolve into a management school for training and proper control of working people. Labor education and labor history in the Rutgers program were being increasingly marginalized by the 1980s–90s in favor of a strong management program. A parting of the ways became inevitable.

In the meantime, Alewitz turned out an impressive series of agitational strike banners and Labor Day floats for unions, including in this period auto workers, Eastern Airlines and New York *Daily News* strikers, machinists, International Brotherhood of Electrical Workers, Coalition of Labor Union Women, Newark Teachers, Yale University strikers, the IUC con-

gallery and political events where viewers could see the possibilities for art and struggle when working people are mobilized. Meanwhile, he began to prepare himself for something more systematic and lasting.

SOLIDARITY WORK

The successful conclusion of the Pittston mural gained Alewitz recognition as a coming figure in labor art. No previous work, neither his work in Nicaragua or on the walls of Pathfinder Press, nor even the P-9 mural (ignored or minimized by most official histories of the P-9 struggle, including Barbara Kopple's art film, *American Dream*) could have done that. In 1990, he became the unpaid artist-in-residence for the New Jersey Industrial Union Council, working at the Labor Education Center at Rutgers in New Brunswick. The IUC, a rem-

vention and conferences of *Labor Notes*. Simple in design, these works radiate notions of solidarity, historical accomplishment (*Equal Pay for Equal Work*, designed for the George Meany Center in Washington, was a recolored and superimposed emblem from the vanished Women's Trade Union League, a support organi-

zation of middle-and working-class women during the 1910s), dignity, and humor (*Organize Workers/Agonize Employers* for *Labor Notes* fundraising at the monthly magazine's annual convention of labor reformers offered a Zapata-style worker with mushrooms at the bottom).

Although little noted by viewers outside the labor movement, Alewitz's work not only raised historical and political points, but also reflected generational experience. His own sign painters local, with hundreds of members in New Jersey alone, was about to go out of existence. Craft mentality that had survived for generations was giving way to swift and final industrialization. Having learned assorted crafts, such as billboard painting, hand lettering, scenic painting, and so on, Alewitz carried forward a precious memory of skills slipping away.

LABOR SOLIDARITY HAS NO BORDERS

Alewitz extended himself in dramatically different directions by applying to the Social and Public Art Resource Center (SPARC) in Los Angeles for a unique mural commission. The City of Angels no more, Los Angeles had become by the middle 1980s the City of Murals, with hundreds of individual works and a Great Wall (designated by the city) of 2,435 feet directed by Judith Baca that illustrated the history of Los Angeles minorities. Some of the most popular left-wing muralists had resettled here by the later 1980s, and the Southern California Library for Social Studies and Research in Watts became a prime site for community art. The

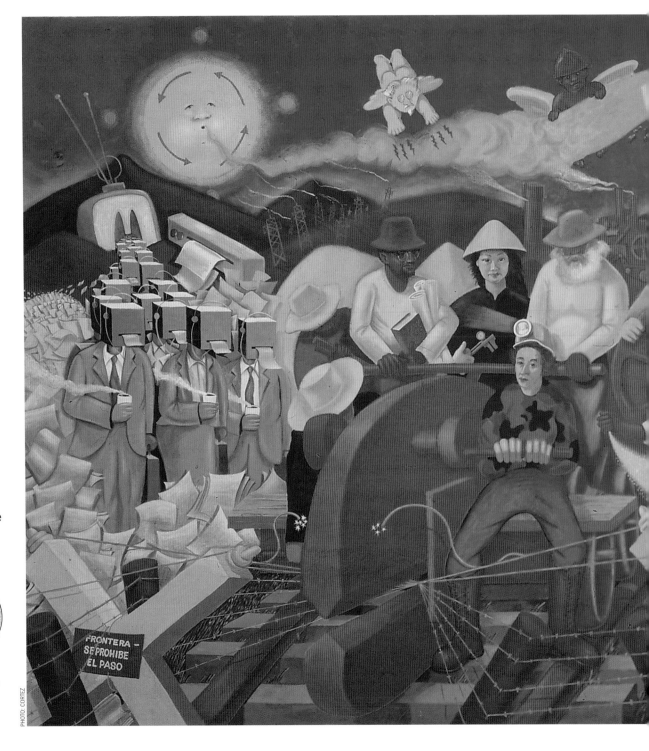

LABOR SOLIDARITY HAS NO BORDERS MURAL
The Library for Social Studies and Research
Los Angeles, CA

FRONTERA – SE PROHIBE EL PASO

PHOTO: CORTEZ

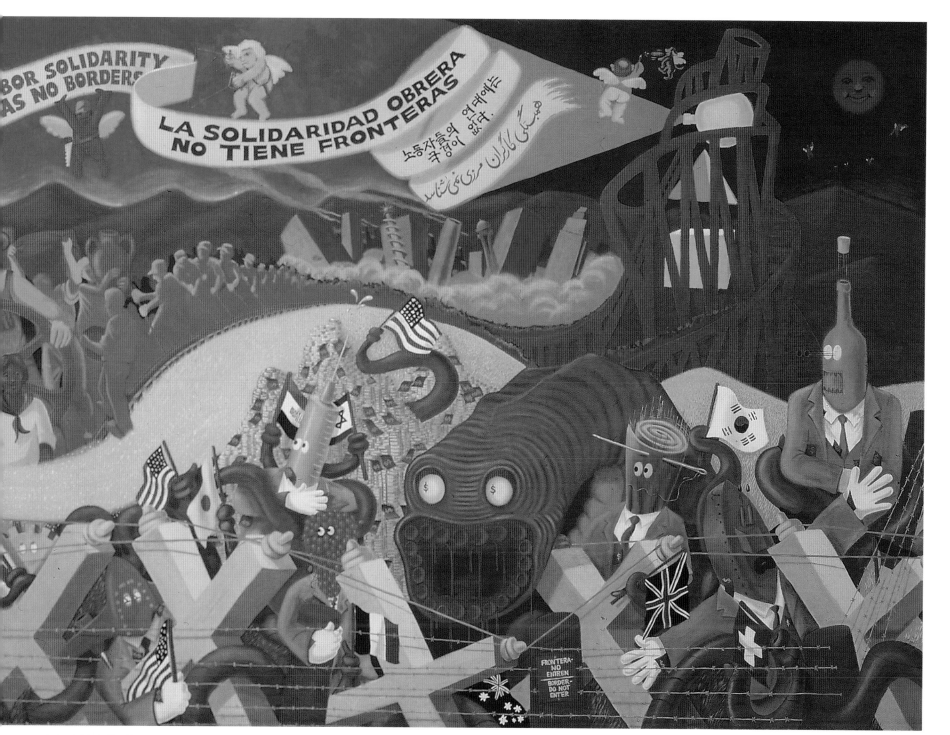

Labor Solidarity Has No Borders, Library for Social Studies and Research, Los Angeles, 1990

AN INJURY TO ONE IS AN INJURY TO ALL

"The underlying cause of the rebellion in Los Angeles was racism, unemployment, and poverty. Those conditions will continue to exist until we build a society that respects labor. It will continue until there is a recognition of the particular contributions of African-American labor, slave and black wage-worker, to the building of our society.

This mural came from the contributions of many, to say that we are in solidarity with the victims of racism, unemployment and police violence. I am dedicating this work to those victims. I do this with the confidence that the justified rage which fueled this explosion will find expression in a reborn, militant labor movement that will organize the unorganized to rebuild this city and the entire country."

—M. Alewitz
Dedication speech, August 26, 1993

SCL, founded in 1963 to preserve local progressive archives and to maintain through public events a spirit of people's history in the area, applied to SPARC for a mural showing the dual themes of international solidarity with undocumented workers and organizing to protect the interests of all workers. Alewitz's proposal got the job.

The dedication crowd for *An Injury to One is an Injury to All*

In April and May 1990, assisted by four area high-school students, Alewitz completed the twenty-three-by-forty-eight-foot surface. As lucidly described by Eric Gordon (a radical biographer of note, and later educational director at the Workmen's Circle of Los Angeles);

The mural depicts a mass of working people streaming toward the electrified, barbed-wire Mexican border from the distant, smog-shrouded city of Los Angeles. They wield a magnificent tool of their own creation, designed to cut through the frontier. On the right, the captains of local industry (grapes, wine, garment, pharmaceutical, machine tools, aeronautics, shipbuilding) look on in horror as their profits are threatened. Their mascot, the bloodsucking monster of imperialism, guards the pile of gold that has been created by labor. On the other

Mike Alewitz working on *An Injury to One Is an Injury to All*

side the legions of paper-shuffling bureaucrats, all of them plugged in to the middle class conformity emanating from the TV minority. Overhead, the sun that shines on all breathes out a banner held up by worker-angels, while a projector from the top of the tower spells out the title of the mural, "Labor Solidarity Has No Borders," in English, Spanish, Korean and Farsi.[2]

As Gordon acutely noted, the "sampling" on the margins includes a camouflaged woman whose uniform recalls the Pittston miners, a jug from ancient Egypt (reflecting the earliest representation of labor within art), Courbet's "Stone Breaker," a reference to Millet's famous painting *The Sowers*" (which, along with another Millet work, inspired a turn-of-the-last-century Los Angeles–area writer, Edwin Markham, to write one of the most internationally famous and most radical American poems, "The Man with the Hoe"), and so on.

At the dedication, the artist localized some of his favorite themes: that the city was a reflection of international developments, the massive shifting of people seeking (but often disappointed in) a better life, and the real lives lived among the poor, the "foreign" speaking (as if

English were the only appropriate language), the exploited. "When people are killed crossing a border...it isn't happening to those people," he insisted, "it's happening to us."[3] An old theme, but a good one. He especially enjoyed seeing labor officials at the podium, standing before a collective labor portrait that included images of Marx, Lenin, and Rosa Luxemburg.

AN INJURY TO ONE IS AN INJURY TO ALL

AN INJURY TO ONE IS AN INJURY TO ALL MURAL
Communication Workers of America Building
Los Angeles, CA

Alewitz returned to Los Angeles after the rebellion of May 1991 (during which the Southern California Library wall remained unscathed in the heart of one of the most riot-torn areas) to paint another mural. While many decried the violence and futility of the rebellion, Alewitz saw the willingness of people to respond to injustice, despite the failures of their leaders, as essentially positive. How different might the outcome of the struggle have been if the labor movement had taken the lead in mobilizing the population against the beating of fellow worker Rodney King. It had the potential to forge a powerful alliance between labor and the African-American and Latino communities not only in Los Angeles but throughout the country.

Chris Gauvreau and Alewitz decided to organize the mural project to raise this issue

ABOVE: John Connolly, actor and progressive leader of AFTRA, after speaking at the dedication ceremony

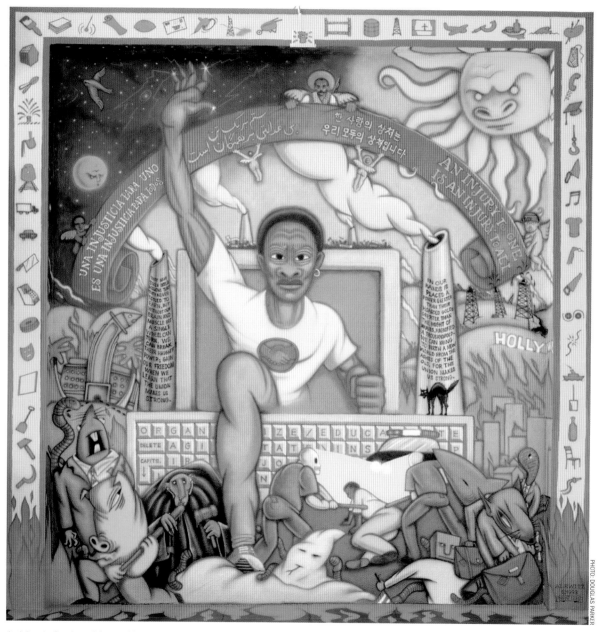

An Injury to One Is an Injury to All
Los Angeles, California, 1991

PHOTO: DOUGLAS PARKER

within the labor movement. They arranged for the initial support from the Industrial Union Council. They then approached the actors' union, AFTRA, and its first vice-president, the film, television, and theater actor John Connolly. Together the three organized support within AFTRA, and procured the endorsement of a number of Hollywood luminaries, including Charles Dutton, Debbie Allen, and Edward Asner. The Los Angeles Federation of Labor agreed to host the project, while the Labor Heritage Foundation acted as the fiscal sponsor. Throughout the project, Alewitz and his allies worked to promote the idea of independent political action, at a time when building a labor party was actively being discussed in the labor movement.

Created for the Communications Workers of America building in Los Angeles (and dedicated, most unusually for any AFL-CIO building, "to the victims of police violence") this mural instantly recalls the famed IWW banner for the Paterson Strike benefit in 1913, with the "advancing proletariat" stepping from a mill-town background into the scene, toward the viewer. This time it was a Third World worker with a background (and foreground) far more hideous, including Ku Klux Klansmen, cops slugging downed African Americans with clubs, fire in the hills alongside the famed "Hollywood" sign, and a weasly judge (like the

ABOVE: Chavez dedication BELOW LEFT: Martin Sheen, Paul Chavez, Mike Alewitz BELOW RIGHT: Children at the Cesar Chavez School

one who set the beaters of Rodney King off virtually scot-free), further revealed as a maggot crawls from under his robe. Most subtly, the keys of a computer keyboard have been rearranged so they spell out ORGANIZE, EDUCATE, AGITATE (after the old IWW clock that spells out "Time to Organize," this time with a Delete button hovering above CAPITS). Overhead, the angels include Mother Jones, Malcolm X, and Emilio Zapata, holding up the banner slogan "An Injury to One Is an Injury to All."

SI SE PUEDE

Two years further down the line, Alewitz's mural on the side of the Cesar Chavez High School in Oxnard caught the departed figure as a Chicano Martin Luther King, Jr. The project was spearheaded by Martin Sheen, an Alewitz supporter who has consistently put his celebrity status behind a variety of peace and justice campaigns.

The mural portrayed Chavez over an open book bearing a text of his own on faith and sacrifice. ("We must educate not only about the union, but about the idea of sacrifice and sharing....") Appropriate for a school of largely Mexican-American children, it bore the affirming slogan, "Si Se Puede! Yes! It Can Be Done!" In the background, along with the ag-business fields, a UFWA banner and strike sign ("*Huelga!*") could be found a Virgin de Guadeloupe (here a worker), and a definitive, mustachioed Mexican sun, winking. As Eric Gordon pointed out, more than a thousand attended the dedication program including UFWA president Arturo Rodriguez, Sheen, and Chavez's widow and son. The mural, like the program, offered historical depth to the ongoing political campaign for the rights of undocumented workers and against racist Proposition 187.[4]

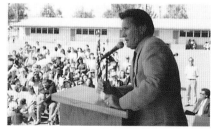

Martin Sheen speaking at the dedication ceremony

FOR THE CHILDREN WHO WORK IN THE FIELDS
FOR THE CHILDREN OF THE FARM WORKERS
FOR THE CHILDREN OF THE UNDOCUMENTED WORKERS
LABOR ART & MURAL PROJECT, 1993

Inscription on the base of *Si Se Puede* mural

SI SE PUEDE MURAL
Cesar Chavez High School
Oxnard, CA

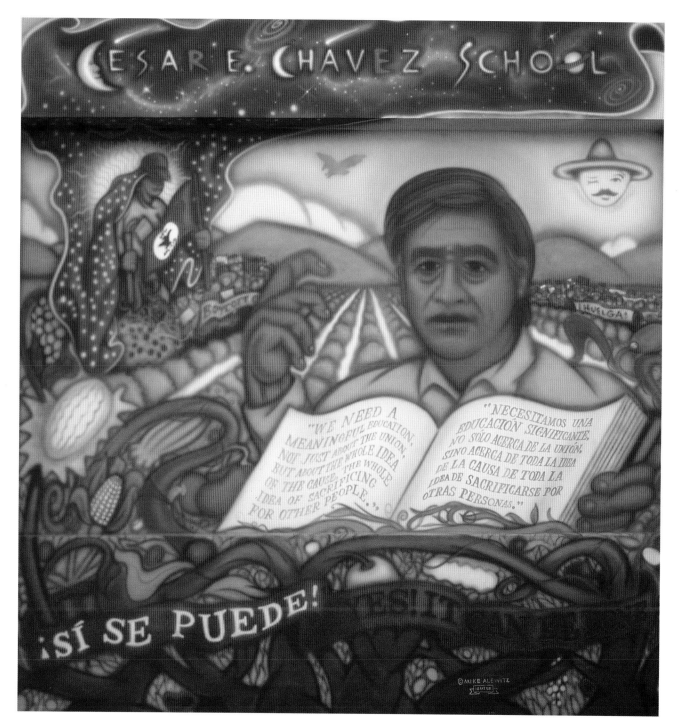

Si Se Puede, Oxnard, California, 1993

PROTEST PUPPETS

Closer to home and working in another medium, Alewitz made the same international-ist statement. In 1990, struck by the life-size puppets used in street festivals of Nicaragua and Mexico, Alewitz had helped lead a group of artists designing material for a pro-choice demonstration in Washington. The troupe contained drummers, a giant puppet of martyred German revolutionary Rosa Luxemburg, a two- headed monster of the two-party system, nine skeleton Supreme Court justices, and a giant red club labeled "Labor Power" on one side and "Women's Action" on the other. Now, in 1992, the desperately underpaid and non-unionized Latino mushroom workers in Kennett Square, the "mushroon capital" of Pennsylvania, had appealed for assistance. Working through the Philadelphia Area Coalition on Occupational Safety and Health (Philo-posh) and a grant from the Mid-Atlantic Arts Foundation, Alewitz returned to puppet-making. His pro-choice puppets became mushroom workers and the monster properly turned into their bosses.

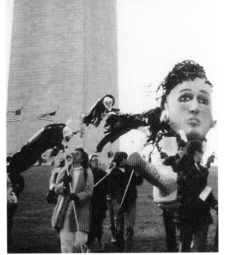

ART/WORK

The group Art/Work grew out of an emerging New York/New Jersey coalition that opposed the Gulf War. Chris Gauvreau, co-coordinator of the state-wide anti–Gulf war movement, and Mike, a co-coordinator of the affiliated New Brunswick coalition, had done much to bring this movement about, pulling together unions, political activists, and artists. Gauvreau herself had led an important effort in encouraging her own union, the Oil, Chemical and Atomic Workers, to adopt an antiwar position. In the tradition of the Manhattan-based PADD (Political Art Documentation/Distribution) created during the early 1980s for the anti-nuke movement, Art/Work tried hard to help artists understand themselves as workers, even while it urged them toward political art.[5]

Art/Work's basic pamphlet (1990) had an especially Alewitzian quality. It was revolutionarily eclectic, with Picasso, critic John Berger, Chinese and Cuban art alongside classics on Surrealism among suggested readings, and among the documents a true-blue midwestern communist Meridel Le Sueur and a forgotten declaration by Che Guevara on "Art and Culture in Revolutionary Society." But

Art/Work pamphlet

ABOVE AND TOP RIGHT: April, 1991: Art/Work created a series of puppets and organized a busload of artists, complete with marching band and banners, for a pro-choice demonstration in Washington. The puppets were later repainted and used in a mushroom workers strike.

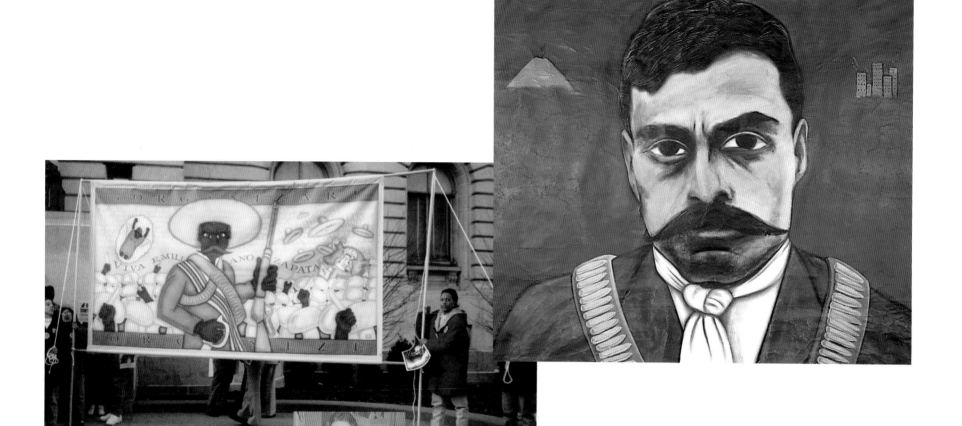

ABOVE: *Organize/Organizer*, 1995

These workers, immigrants from Mexico and Central America, self-organized and shut down the mushroom industry in eastern Pennsylvania.

RIGHT: Banners for striking mushroom workers

"The employers tried to stop our participation. When they threatened to remove any signs with words on them, we made signs without words."

ABOVE: *Zapata* banner

This *Viva Zapata* banner was carried by the Kaolin Workers Union in the 1995 Mushroom Day Parade. According to Alewitz, "The annual mushroom day parade was usually a self-congratulatory event for the owners, while the workers stayed on the job. We were able to help crash the event by creating banners and signs, along with providing instruments for a marching band. It was quite a scene."

it had the Marxist inner-sanctum quality as well. Alewitz's riposte for his expulsion over the Pathfinder mural can be set alongside the 1939 manifesto, "Towards a Free Revolutionary Art" by André Breton and Diego Rivera (for an unrealized revolutionary art movement of that era). While Alewitz was still smarting in ways that outsiders would find difficult to grasp, the manifesto itself was inescapable and revealing:

Art/Work supports all legitimate struggles of working people.

Art/Work recognizes that the class struggle is international and that between workers there must be no borders.

Art/Work rejects American chauvinism, racism, sexism, homophobia and any other ideology used to divide and conquer the working class.

Art/Work rejects any patronizing or romantic notions about working people and farmers in this or other countries.

Art/Work rejects the notion that North American workers are less capable of heroic struggle than other workers.

Art/Work supports the struggle of women for full equality.

Art/Work supports the struggles of Blacks, Latinos, Native Americans, and other oppressed minorities for political and cultural self-determination.

Art/Work supports the formation of an independent labor party and rejects supporting Democratic and Republican candidates.

Art/Work is opposed to bourgeois censorship.

Art/Work is opposed to censorship by workers' organizations.

Art/Work welcomes debates.

Art/Work is open to artists and workers using ay medium or styles.

Art/Work favors the objective over the subjective, the monumental over the private.

Art/Work places content before form.

Art/Work is not for artists who flap their jaws about political art but never walk a picket line.

Art/Work is not for artists whose paint adorns only the homes of the upper classes, but not the banners of workers.

Art/Work rejects the gallery system which exploits and dehumanizes artists.

Art/Work rejects the distinctions between professional, primitive, commercial, and fine art, and strives for the highest quality of work.

The work of several hands (or minds), it was clearly a personal credo, surely enough to set off the militant temper of the radical artist. But the manifesto also included these thundering phrases, which might have come out of Russia in the 1920s or the United States in the 1930s:

Art/Work is for those who want to use their art as a weapon.

Art/Work is for those who want to study the propaganda arts.

Art/Work is for those who understand that the struggles of artists and workers are inseparable.

LEFT: *Malcolm X* banner created for an exhibition by Artmakers, a New York City muralist collective.
RIGHT: *Art/Work* banner

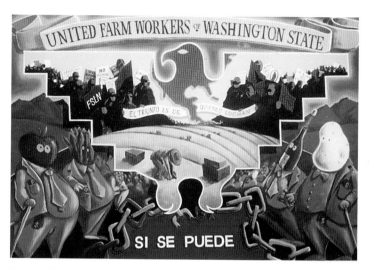

This portable mural, dedicated to the farm workers of Nicaragua, was painted for farm workers in the Yakima Valley of Washington. The workers brought it to the fields to use as a backdrop for their meetings

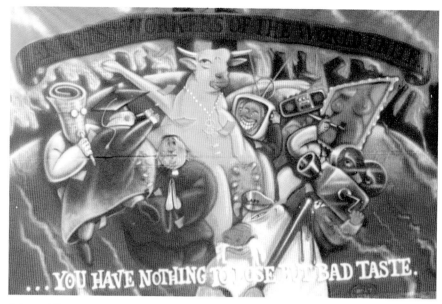

Artists and Workers of the World Unite, portable mural painted in two days for a meeting of the Southwest Labor Studies Association, Redlands, California

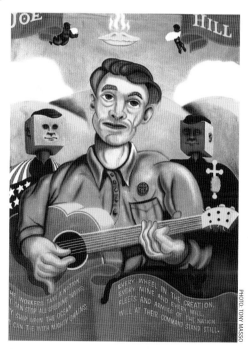

Joe Hill banner, painted during the Great Labor Arts Exchange

PHOTO: TONY MASSO

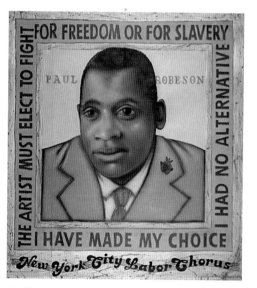

Paul Robeson banner painted for the New York City Labor Chorus

The document reads as if Alewitz had been saving up and developing the thoughts for twenty years before spilling them out. But the polemics also spoke to the sentiment of artists at that moment. Facing attacks in Congress on the National Endowment for the Arts, grant recipients and big coalitions formed in New York to defend artists. Alewitz and his friends wanted to go further than defending the rights of relatively privileged artists to receive grants, and they weren't alone. The idea that artists' groups would be willing to stage another fight, this one around censorship of the Pathfinder and P-9 murals, seemed a stretch, but not an impossible one. Unfortunately (and not so different from PADD, which faded by the middle 1980s), the political and perhaps also the artistic moment was not right to keep the thought alive organizationally. But this mini-movement left a mark.

The cover of *Art/Work: Documents and Manifestos* was itself a manifestation, designed by Alewitz's friend Bob Allen after Vladimir Tatin's proposed building for the Third International, planned as a massive transparent Petrograd structure three times higher than the Empire State Building. The sculpture was planned to consist of two concentric conical spirals with a transparent cylinder emerging from

the head, the structure hung on a dynamic forward thrust, representing the social organization of the new world state. The three suspended buildings would embody different levels of decision making and broadcast qualities, and the

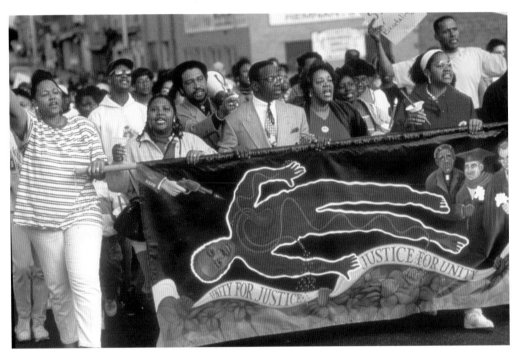

The Murder of Shaun "Unity" Potts by Sgt. Zane Grey of the New Brunswick Police carried in a 1991 demonstration

buildings would be made completely of glass—so that workers could always see what their leaders were doing. Like the Russian socialism envisioned somewhere after the revolution, the building was never constructed. At least its key image survived—as the emblem of Art/Work.

Such visions were all too centralized for the artists and cultural workers of post-Bolshevism, surely, and yet the very fantastic quality reminded the reader of the utopianism of Alewitz's lat-

est venture. He dreamed (if he could place the vision only in a static and one-dimensional mural) of projectors beaming images on clouds floating by, the kind of conceptions that had once been so strong in real-life Moscow that workers actually made little models of the building and carried them along to demonstrations.

GEORGE MEANY CENTER

Had reality been capable of bringing him down fully to the mundane level of the labor movement's constant (and often corrupt) horse trading, Alewitz might have drawn different lessons from his own experiences at labor's counterpart to the old Kremlin, the George Meany Center. There, the Labor Heritage Foundation and the Labor Arts Exchange garnered meager official support and patronage of the federation, a connection which opened doors at least part way for the artist. Thanks to his growing reputation and the fondness for Alewitz's work by some younger, up-and-coming functionaries (especially Joe Uehlein, foremost figure of the AFL-CIO's Industrial Union Department), he executed in 1993 a dreamy Joe Hill at the annual exchange event, with blockheads (as in the IWW song, but here one is pseudo-patriotic and the other pseudo-religious) in the background with a pie ("You'll get pie in

Free Mumia banner, 1998

the sky when you die") and Hill's own worker-empowerment lyric in the foreground. So far so good, almost amazingly so in a regime dominated by intelligence agency "assets" and Lane Kirkland's personal courtiers.

Alewitz was later invited to design a backdrop/banner for the Meany Center. He took his text from Mother Jones, "Sit down and read: Prepare yourself for the conflicts to come," showing an African-American youth, hat backwards, reading about labor history, with live characters jumping off the page. The sketch was accepted only after the second half of the phrase, "Prepare yourself for the conflicts to come," had been removed.

Conference banner at the George Meany Center

The next few years raised more bureaucratic hackles. A gallery showing of the artist's outstanding works was threatened with unabashed censorship. Perhaps the reflection upon the eighteenth-century artisan motto, "By Hammer and Hand / All Arts Do Stand: The Banners and Murals of Mike Alewitz," had in itself been off-putting: too much history, too much thought for men in pricey office suites seeking rather urgently to escape the record of their own failures. The present and future remained one at best of passive solidarity, the only kind promoted (or perhaps permitted) by the Kirkland regime in a moment of extreme cutbacks, defeats, and union downsizing.

In 1995, Alewitz was invited to create a sketch for a backdrop for the historic October convention where the Kirkland clique would be ousted by the "New Voices" team. After submitting a design, Alewitz did not hear back from the federation's public relations agency. Later he was anonymously faxed an article from the *Wall Street Journal,* which had obtained an internal memo from the AFL-CIO's Labor Institute for Public Affairs. The document warned, "The viewer should feel a sense of solidarity and determination in the future without resorting to militancy," especially because "raised fists or angry expressions are...too militant."[6]

All this was far from unexpected for a revolu-

Sit Down and Read banner

tionary socialist entering the labor mainstream, but Alewitz was taken aback by the utter triviality of the AFL-CIO's strictures. The collapsing labor bureaucracy, faced with falling membership and more rapidly declining faith in their competence, had staked all upon the expectation that a post-communist eastern Europe would fall into their lap as a bonanza for international business unionism. The new employers of eastern Europe did not, however, particularly want unions of any kind, and the ordinary folk whose living standards plummeted did not feel uplifted by promises of future privatizations or threatened by dire warnings of the effects of strikes. Instead of accepting meekly the fate decreed from the AFL-CIO executive suites, unionists moving from state-directed organizations to class-conscious ones simply shunned the imported Western bodies.

Thus unabashedly class-collaborationist unions died, not only in eastern Europe but also very nearly in the United States as well. When the October 1995 AFL-CIO convention accepted challenges from the floor (reversing familiar procedures of shutting off the power for floor microphones when objections became too embarrassing), the floodgates had seemingly opened. But the revolution only went partway. It remained to unionists and labor allies to make the most of the situation. Mike Alewitz intended to do so.

LIT BY
L A M P

ORGANIZE
EDUCATE
AGITATE
INSPIRE

CULTURAL WORKERS
& ARTISTS CAUCUS *of*
the LABOR PARTY

The Labor Party will oppose censorship in all its forms, including censorship of new technologies like the internet. We reject attempts at censorship whether they arise from government halls, corporate boardrooms, or within the labor movement itself. If we are to win artists to our cause, we must stand— absolutely and without faltering—for total artistic and intellectual freedom."

—CWAC RESOLUTION PROPOSAL TO THE LABOR PARTY.

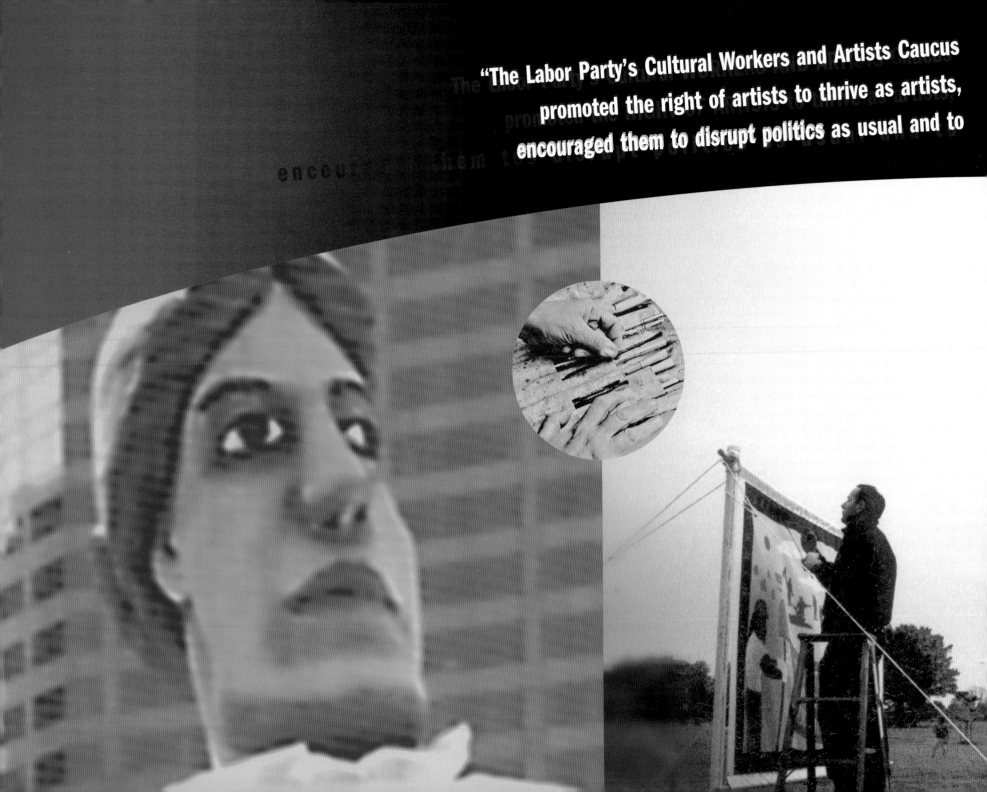

"The Labor Party's Cultural Workers and Artists Caucus promoted the right of artists to thrive as artists, encouraged them to disrupt politics as usual and to

open people's imaginations **to new**
political **possibilities.** "

M. Alewitz

ACTUAL PHOTO OF
ABACHAS
HANDS

!DAR
WITH
N WOR

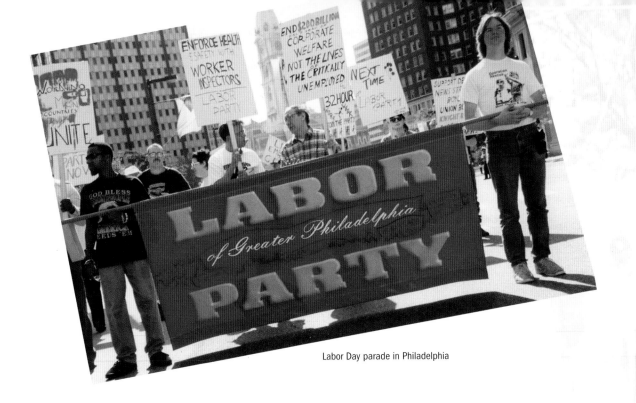
Labor Day parade in Philadelphia

HE LABOR ART & MURAL PROJECT (LAMP) and the Cultural Workers Action Committee (CWAC) soon took the place of Art/Work in Mike Alewitz's life. The story is more complex, but in the time-honored style of dynamic but short-lived radical (and radical artists') movements in the United States, the fading of one era's institutions bespoke the emergence of new ones. Alewitz's art work, with a dossier steadily growing, reflected these commitments even as it stretched beyond them.

The Labor Art & Mural Project (LAMP), initially organized in the early-1990s, was in one sense a broadened political project of the kind that Wobblies (following the lore of lone miners looking for gold) called "singlejacking," going off into agitation on their own. LAMP was more or less a writ-large version of Alewitz himself, an activist promoting a movement. His stint as Artist-in-Residence for the New Jersey Industrial Union Council had taught him the value of letterheads and sponsors. He had no trouble, by this time, landing the official sponsorship of the unions for which he'd begun or completed work: the Oil, Chemical and Atomic Workers (OCAW) including its president, Robert Wages, the United Farm Workers, New Jersey Coalition of Labor Union Women (CLUW) and the Graduate Labor Association of Rutgers, the state's Industrial Union Council (IUC), the Industrial Union Department of the AFL-CIO (and its leader, Labor Heritage president and rock 'n' roll musician Joe Uehlein), along with such

LaBOR aRT
&
MURaL PROjECT

individuals as actor Martin Sheen, John Connolly of AFTRA, and assorted labor educators like Tom Juravich of the University of Pennsylvania and Elaine Bernard of the Harvard Trade Union Project. Christine Gauvreau served as director of LAMP, Alewitz as his own artistic director. At the beginning, LAMP was no bigger than the two of them; but it represented the return of labor muralism in America, with Alewitz's involvement in or encouragement of more projects than he could possibly paint in a lifetime.[1]

THE REBIRTH OF THE LABOR PARTY

CWAC was another story that belongs, properly, to the rebirth of the Labor Party idea. An old, old tale (by US standards) going back to the urban labor parties of New York and Philadelphia during the 1820s and 1830s, this political and cultural movement grew out of the decades of artisans' parades (often bearing on printed banners the slogan that Alewitz took as his own: "By Hammer and Hand All Arts Do Stand"), a tribute to the tradesmen's key role in the Revolution.[1] Especially in New York, radicals and women's rights advocates (including the famed Frances "Fanny" Wright) heavily influenced the labor party milieu. After early success, New York's Workingman's Party was ferociously red-baited by mainstream politics and finally driven down,

GARY HUCK

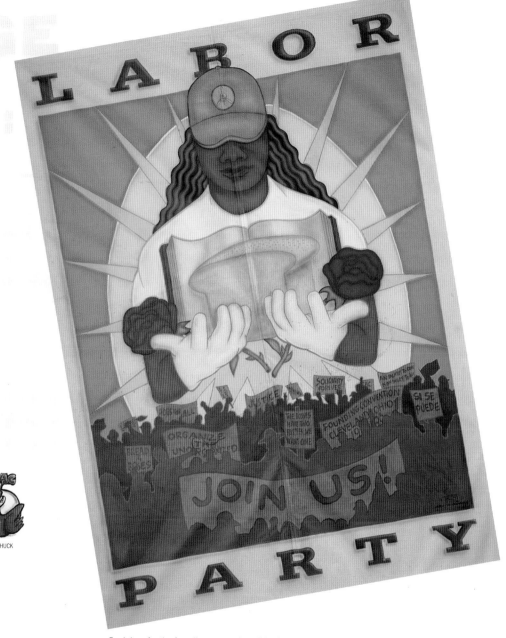

Backdrop for the founding convention of the Labor Party

"Why purple people? Agitprop artists need to experiment and develop a visual language to express the diversity of the living labor movement without having to rely on cliched images of 'diverse looking' groups of people. I have often used androgynous looking people painted in purples, greens and blues. Besides, its much more fun to paint purple people."—Mike Alewitz.

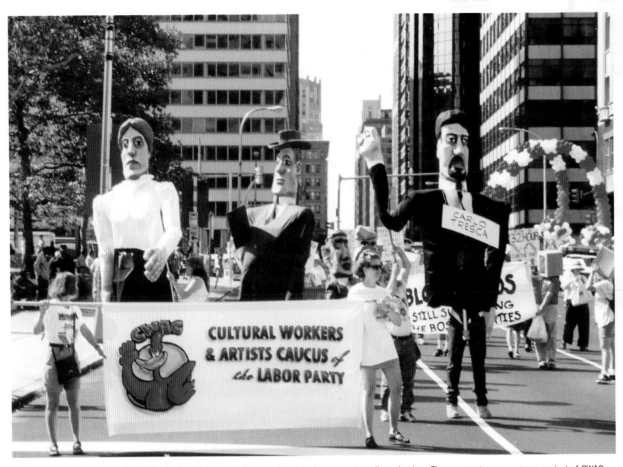

Carlo Tresca, Big Bill Haywood, and Elizabeth Gurly Flynn: ordinary workers who became extraordinary leaders. These puppets were a group project of CWAC.

it's remnants swallowed by a corrupt and avidly racist Democratic Party. Despite the failure to create a lasting political organization representing workers, the early labor party movement had both successfully demanded the spread of free, public education, and had dramatized through artisanal enthusiasm the widespread wish for another and better kind of society.

The post–Civil War generation of unionists, sprinkled with immigrant (mostly German) socialists repeatedly sought to launch labor parties, sometimes in alliance with farmers' groups. Because labor's champions of the day stressed the dignity (often, admittedly, the "manliness") of the oppressed but unbeaten worker, newer labor parties rhetorically sought to recall republican government from its takeover by the financial swindlers and "shabby aristocracy" of America's new rich. During 1886, in the backwash of the national eight-hour movement for a shorter workday, local labor parties ran dozens of strong municipal election campaigns—then disintegrated once more, into the Democratic Party's ethnic appeals and its patronage for local labor officials.

Not until the Socialist Party had been crushed by government officials for opposing

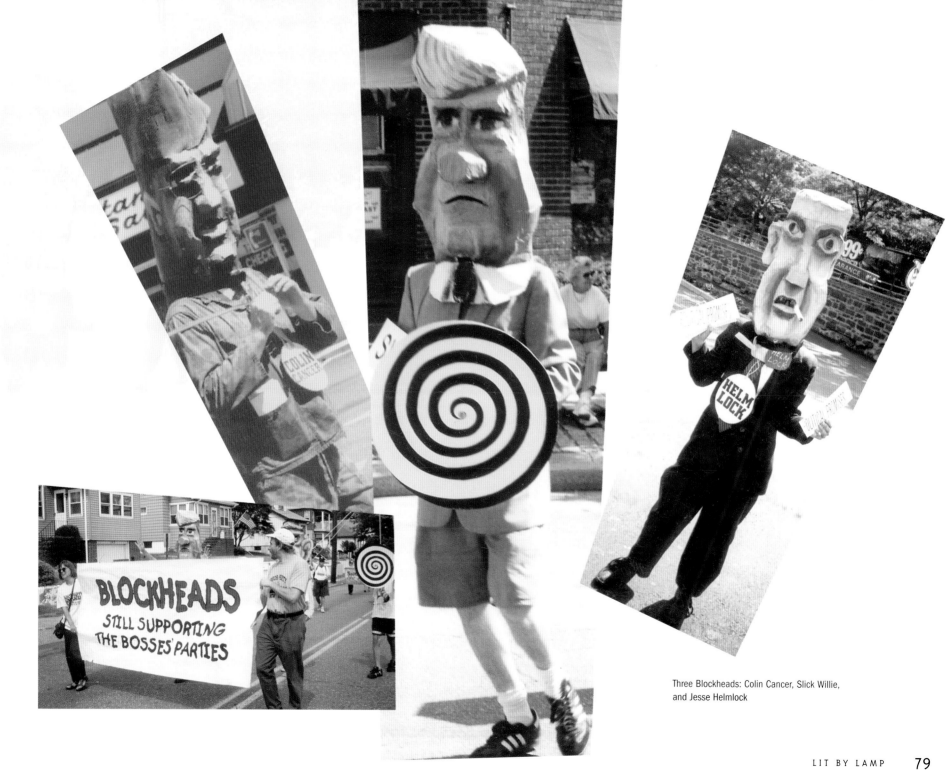

BLOCKHEADS
STILL SUPPORTING
THE BOSSES' PARTIES

Three Blockheads: Colin Cancer, Slick Willie, and Jesse Helmlock

United States entry into the First World War did the labor party notion reappear, in the presidential race of 1920. The AFL formally backed Wisconsin labor-farmer Progressive candidate Robert La Follette four years later, but virtually abandoned the veteran reformer during the home stretch. Again the impulse faltered when La Follette died shortly after the election. It revived during the Depression and became a favored cause of many local unionists. But by the time sentiment peaked, in 1936, Franklin Roosevelt's overwhelming popularity buried the idea of a national third-party movement again. In the end, the labor party dream survived only as a regional movement, in New York State, the northern Midwest, and the Northwest especially, taking assorted names and holding statewide offices until red-baited and crushed by the Cold War, its remnants swallowed yet once more by the Democrats.[2]

GARY HUCK

"It's Party Time for Labor," a CWAC production staged in New Jersey and Manhattan. Among the featured performers were Michael Moore (above), comedian Betsy Salkind (left), and actors John Connolly and J.R. Horne.

The Labor Party Advocates (LPA) of the early 1990s formed in the shadow of these earlier failures. LPA's undoubted leader, sometime OCAW official Tony Mazzocchi, had come out of the 1948 anti–Cold War Progressive Party campaign of former vice-president Henry Wallace. He bore proudly the OCAW tradition, not only in his progressive politics, but with also in his serious commitment to culture that included the-

ater pieces commissioned for every OCAW convention, something almost unimaginable for the great majority of unions. Mazzocchi based himself in New Jersey and admired Alewitz's work; Alewitz returned the favor, even as he remained uncertain (like many of the Labor Party enthusiasts) whether Mazzocchi really wanted a third party or merely an organized lobby of real radicals among left-leaning labor officials. The "Cultural Action Committee" (CAC) of the New Jersey IUC grew up as Alewitz and a circle of friends organized public participation in the state Labor Day parade for several years, with hilarious and empowering floats and signs that ridiculed the two-party swindle while calling

labor to higher purposes. With Mazzocchi's support, the Cultural Action Committee (CAC) of the IUC was succeeded by the Cultural Workers and Artists Caucus (CWAC) of the Labor Party.

A proto-CWAC issued an "Artists' Appeal for a Labor Party" in 1996, timed to coincide with a major Labor Party Advocates' convention in Cleveland. The appeal, signed by noted avant-garde painter Rudolf Baranik, Pete Seeger, Noam Chomsky, labor cartoonists Gary Huck and Mike Konopaki, art critic Lucy Lippard, stand-up comic Betsy Salkind, and television

star Brett Butler, as well as officials from AFTRA and other unions, bore the Alewitzian stamp. It read in part:

A historic opportunity is opening for artists concerned with the future of art and labor...

Our goal is a party which will challenge the employers' two parties in the streets, in the workplace and at the ballot box.

The formation of a labor party would mark a watershed for the progressive forces of this country. It would provide a vehicle to address the struggles for international solidarity, for women's rights, for the rights of oppressed peoples, immigrant workers and others marginalized or demonized by the capitalist class. It would mark the rebirth of class-consciousness and a rekindling of the vision of a world of peace and justice.

As artists and cultural workers we have a special responsibility to help illuminate that future. The formation of a labor party would provide an opportunity for the organic linking of the struggles of workers and artists in a way not seen in decades. It would mark an impetus for lively and critical art-making.

We issue this appeal to all painters, writers, poets, designers, architects, musicians, sculptors, film and video makers, actors, critics... to all artists and cultural activists without exception. Join us for a special convening of artists in Cleveland, to help shape

Bob Allen, former miner and rail worker, working as a puppet maker

a cultural generation... Perhaps we can initiate actions which will inspire new generations of artists to use their art as a weapon for the transformation of society...

Alewitz designed the official poster for the convention, a by-now emblematic minority worker of ambiguous race and gender (his/her skin colored a glowing and equally ambiguous purple), wearing a green cap and holding a loaf of bread, roses, and an open book. Concerned about class as well as diversity issues, the artist blazed a path that avoided either becoming exclusionary or simply offering a Coca Cola (or for that matter, Benetton) image of smiling pseudo-diversity. As before in Alewitz's work but more vividly here, "bread and roses"—the icon of the 1912 IWW-led strike in Lawrence, Massachusetts—had been updated and refigured around the need for knowledge. Beneath this central image on the poster, delegates hold signs: "Jobs for All," "Organize the Unorganized," and largest of all, "Join Us!"

The founding convention proved to be a combination boost and let down. The Labor Party idea had suc-

ABOVE: *Just Health Care* banner for the Labor Party campaign for national healthcare BELOW: Labor Party founding convention delegate pass, June 1996

cessfully caught on in districts where long traditions of left activity deposited a residue of veteran activists (many of them former members of assorted Marxist organizations) to urge the LP as the latest promising development. The Labor Party failed to make much headway within the AFL-CIO mainstream, despite endorsements from the traditional labor left consisting of the United Electrical Workers and the Longshoremen, plus the mainstream United Mine Workers, the American Federation of Government Employees, and the California Nurses Association along with OCAW, one railroad brotherhood (Mike's old union, the BMWE), and a scattering of assorted union locals. Most union leaders held back, not so much out of

fear of the consequences as from labor's historic commitment to the Democrats and the personal prestige or financial benefits that leaders got out of the deal.

The problem was worst at the top. The AFL-CIO of the 1990s, its supportive rhetoric about the welfare state and minimum wage aside, had abandoned any serious progressive role within the Democratic Party decades earlier. Indeed, so hostile were George Meany, Lane Kirkland, and their circle to the social movements from the middle 1960s onward, that the defeat of peaceniks, feminists, environmentalists and "New Politics" types associated with George McGovern had been the major item on their personal agendas. Globalism, the familiar Cold War issues of American wars, and United States control over the world's agenda continued much the same for them even after the Cold War ended. If they changed sides of the aisle between elections, it was to work with Ronald Reagan's State Department and facilitate the repression of increasingly illegal operations against stubbornly rebellious social movements abroad.

The "palace revolution" of 1995, rudely tossing out the morally bankrupt and stumbling AFL-CIO leaders, also cleared out most of the CIA crew. But the change at the top had only a limited effect upon labor's domestic politics or its official aesthetics. Rich Trumka, who spoke most often about the need for labor's own party, was widely assumed to be new president John Sweeney's ultimate successor; in the meantime,

Malcolm X banner

the Irish-American president of the Service Employees International Union, assuming leadership of the federation, made his own choices clear. Sweeney intelligently sought to take labor's left in hand—unlike his predecessors who sought to crush all opposition to conservative business unionism. At least as much as a revival of labor activity, however, Sweeney wanted a Democrat in the White House.

The new regime quickly moved to encourage better organizing drives—broadening the dues base if not empowering ordinary union members—and a more idealistic public image. But it definitely did not intend the abandonment of the Democrats, who now garnered more of labor's financial support than ever. At the state level particularly, AFL-CIO leaders had long since become mere cogs of the Democratic machine (occasionally crossing over to a friendly Republican) as their membership fell but their personal prestige remained politically useful. Even past bureaucratic threats (however insincere and empty) from the likes of AFL-CIO president George Meany to launch a labor party had become heresy in these quarters;

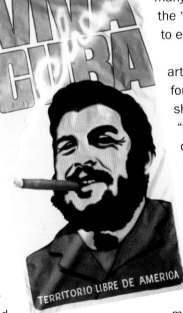

Che Guevara banner

no matter how far rightward on welfare, trade and other policies, the business-first Clinton-style "New Democrats" drifted, such disloyalty remained for the moment, and perhaps for a long moment, out of the question.[3]

The CWAC consequently operated within a rather narrow frame. The cultural resolutions passed at the 1996 Labor Party convention, drafted by Alewitz, nevertheless reflected a vital effort. He sought to bring into the Labor Party artists of every kind, and to bring the radical movement outside labor back to the unresolved issues of class. Most especially, Alewitz the erstwhile billboard artist and graphics craft worker wanted to bring the cultural worker and consumer up to speed with the effects of recent technological changes, wiping out many a venerable trade but also placing the "artist" and "worker" logically closer to each other.

Urging the Labor Party to support arts funding and accessible culture for all, promising to oppose censorship of every variety by standing for "total artistic and intellectual freedom," the Labor Party proposal avowed that "international artistic and cultural exchanges" across all boundaries could open new vistas, and that the efforts of artists to form unions, organize campaigns and strikes for their own benefit and for others would help shape a new labor movement. The Labor Party for its part would therefore "establish a national

network of artists interested" in the project, reaching out especially to "young workers, artists and activists."[4]

One could readily see behind the phrases the repeated historic efforts, often successful but always problematic, of radical artists to work with the political movements of labor and the left. "Culture and the Crisis," a manifesto issued by the "League of Professional Groups" supporting communist candidates in 1932,

rang with some of the same ideas if not the same phrases; the same year John Reed Clubs sprang up in many parts of the country, enlisting writers like Richard Wright, Nelson Algren, and Meridel LeSeuer to the task of finding the new

writers from among working people. The American Writers Congress, the Congress of American Artists, and, during the early 1940s, the Hollywood Writers Mobilization all convened national meetings, featuring many of the nation's important painters, sculptors, photographers, playwrights, novelists, poets, actors, producers,

Banner commemorating the 150th anniversary of the *Communist Manifesto*. Detail figures are of Zapata, Trotsky, Mother Jones, Che Gueverra, Harriet Tubman, and Malcolm X.

and screenwriters, coming together to talk about organizing their crafts for higher artistic purpose of democratic and creative control as well as support for progressive causes. CWAC had in a sense reinvented a wheel that had been lost and badly needed reinventing.

Indeed, more than a dozen local groups of artists did respond vigorously to CWAC's initiative. In Seattle and Olympia, Washington, in Portland, San Francisco, and Los Angeles especially, discussions drew together working artists with those amateurs who (as in the 1930s–40s movements) saw themselves becoming artists in the framework of a vital radical movement. Lee Ballanger, an editor at *Rock and Rap Confidential*, urged and helped to lead the LA effort, insisting "Today there is a huge layer of artist and activists...who can be drawn around the Labor Party by cultural events," attuned to the rapid technological changes and even more rapid capital shifts of the multi-billion-dollar American entertainment business and leading export industry. As the entertainment giants continued their monopolization and (from the standpoint of club players, especially) used cable television to wipe out long-standing arenas of work for comedians, singers, and musicians, employment with health benefits became ever-more elusive, even for many whose faces could be seen intermittently on network television. These kinds of issues, raised by AFTRA activists John Connolly and Betsy Salkind within the entertainment unions, demonstrated the LP points even if they

did not manage to widen the LP base.

In short, the Labor Party movement might be shaky or merely ahead of its time, but Alewitz's proposals had touched a chord with his ideas of artists organizing themselves. Or so it seemed. Then, after awhile, CWAC seemed ahead of its time as well, no matter how badly needed. Local events continued at lower levels, until participants drifted into other activities or away from politically-connected efforts entirely.

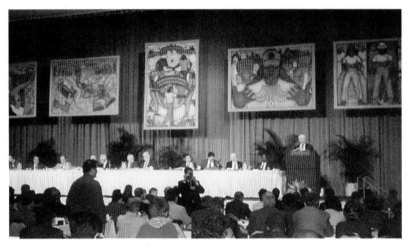
ICEM convention

No final judgment could be registered on the lasting value of these efforts. But the great art and cultural movements of sixty years before had been organized, it might be remembered, when public faith in capitalism had been badly shaken, and when the threat of fascism loomed over the political landscape. That the earlier movement had drawn upon large numbers of working-class or lower, middle-class Jewish Americans who grew up steeped in socialistic ideas (and often, the

ideals of art as well) marked another important difference. Could those young people whom cartoonist R. Crumb once called "tract house Isadora Duncans," children of the suburbs urgently seeking to realize themselves in culture, as well as those artists from inner-city surroundings or from distant parts of the globe, perceive the need for collective action and the means to do it? That remained a serious and unresolved question that CWAC addressed only part way. Perhaps confidence in capitalism needed to be shaken in a large way again for more to become clear.

LABOR ART AND MURAL PROJECT

LAMP meanwhile continued to light a way forward. Alewitz's accomplishments and growing reputation brought him three important commissions of multiple murals or posters during the 1990s, each remarkable in its own fashion.

His first truly international labor work was commissioned in 1995 for the merger of the International Federation of Chemical, Energy and General Workers Union (IFCE) and the Miners International Federation (MIF). Global affiliations of the OCAW and connected with it, the new IFCE and MIF called for five seven-by-ten-foot murals —*Competition, Bureaucracy, Production, Unity,* and *International Solidarity*—comprising together *The Worker in the New World Order*. *Competition*, as might be expected, showed a dog-eat- dog, worker-against-worker (the potential murderer even wearing a peace sign on his/her chest) image,

ICEM BANNERS
Washington, D.C.

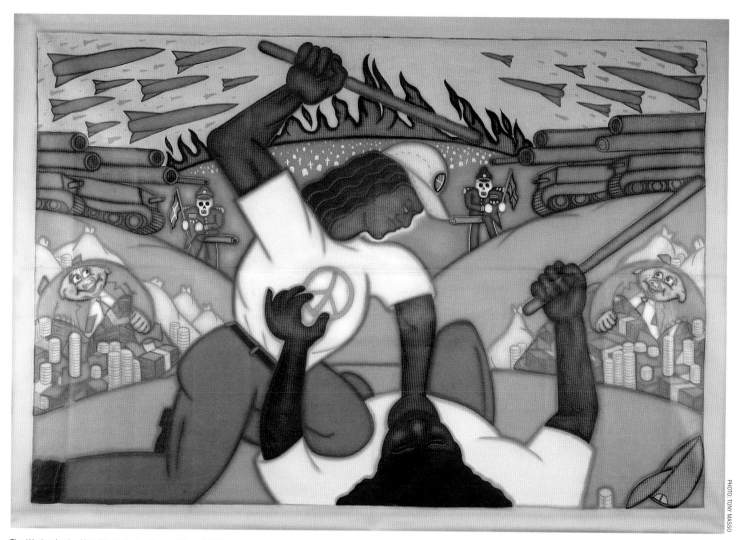

The Worker in the New World Order: Competition, 1995

"The 1994 strike in Nigeria, led by oil workers, was an inspiration for working people throughout the world. This struggle for power and justice was met with harsh repression by the Nigerian government. I am dedicating this work to those brothers and sisters victimized for their participation in this movement, and still being held in prison..."

—M. Alewitz, November 1995

with tanks, missiles and skeleton generals looming in the background as piggy capitalists with their piles of money watched gleefully. *Bureaucracy* depicted an androgynous worker bound by union bureaucrats. This hero(ine) was tied up in reams of paper, spit out perhaps by the printer-headed robots who stood on each side of a White House. With his/her golden scissors s/he could cut her way out, but will s/he? *Production* would be familiar indeed if the worker was the burly male of old-time radical iconographics. Instead we again have the purple wo/man, her fingers streaming beams of light toward a telecommunications tower. S/he is clearly the worker of present and future. Behind him/her stands the occasional house, factory, and earth-moving crane, but now joined to a beaker evidently used for chemical reformulation, and other modern scientific devices. On the worker's cap this time we find a light brown and darker hand clasped. *Unity* depicts three workers: the computer operator on the left, the traditional miner in the center, and the agricultural worker (hoe at the ready) on the right. Each represents a continent or place; but the

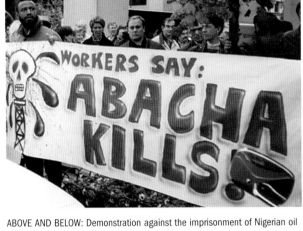

ABOVE AND BELOW: Demonstration against the imprisonment of Nigerian oil workers at the founding convention of the ICEM

faithful sabot-tabby also hovers, its back up, promising unrest. The final panel, *International Solidarity*, is the near-literal logo for the merged union, radicalized through Alewitz's imagination. Angels hover above the union banner. The image includes two Amazonian bare-breasted women, five variegated workers around an organizing globe that reads (in Spanish) "Solidarity of Workers, No Frontiers," and beneath all of this, on repugnant display, are the capitalists, financial wolves, robots and generals. These are the players in the Big Game.

But the new leadership of the AFL-CIO was not entirely sure that it wanted to play. Intended to be displayed at the AFL-CIO headquarters building after the chemical unions' international merger talks, the panels were dedicated to imprisoned oil workers in Nigeria as a focus of international solidarity. Alewitz's work was shortly removed. Officials explained that the panels had proved offensive to some viewers (two banners contained a penis, albeit so subtly as to escape casual notice). Alewitz commented, in an open letter to Rich Trumka, that

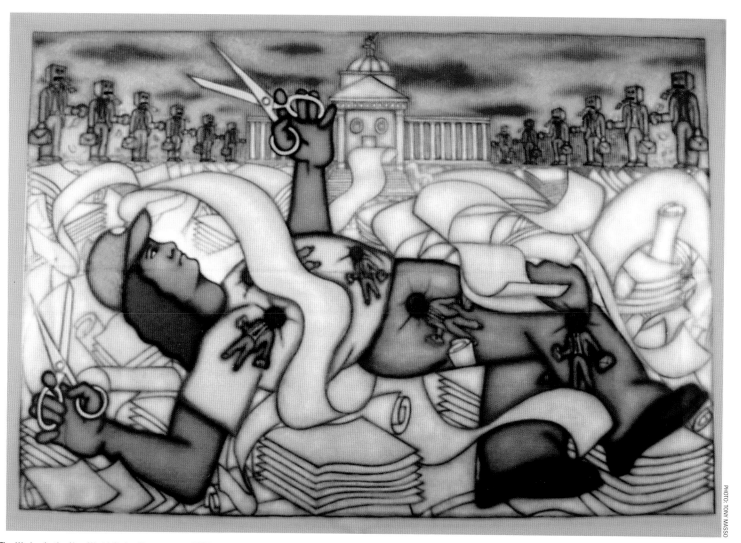

The Worker in the New World Order: Bureaucracy, 1995

The Worker in the New World Order: International Solidarity, 1995

One of the images that apparently offended AFL-CIO officials

the labor movement should not practice censorship in any case, but

In the first image the "penises" are cannons in the pants of generals forcing workers to wage war against each other. In the final panel, the same general, now vanquished to hell, is in a flaccid state as workers dance around the globe. Is this not clearly an antiwar cartoon? Have these censors not been to see any movies or art shows in the last decade or two?

Of course, it was very likely to be the ridicule of the generals rather than symbolic penises that offended the old hands at the AFL-CIO headquarters. War and the constant threat of war had been awfully good to labor's top leaders, and the changeover at the leadership level had not budged the permanent Cold Warriors and seasoned intelligence operatives from influential unions like the American Federation of Teachers. Winning the first,

Alewitz had lost the second anti-censorship appeal directed at the AFL-CIO.

A second series issued for the OCAW featured Karen Silkwood, the martyred union activist apparently assassinated by corporate agents. Made into labor's famed martyr by the award-winning film *Silkwood* (with Meryl Streep in the title role), the real Silkwood stood with the fictional Norma Rae as a heroine in two of the best union-oriented American feminist films of recent decades. In Panel four of a five-part series, Silkwood holds a nuclear power plant in her arms, below her is the slogan around OCAW, "A Woman's Place is in her Union." She is surrounded by signs ranging from "*Huelga*" to "Hometowns Against Shutdown" and "Break the Lockout," while a labor martyr of another era, Tom Mooney (arrested in 1916 on trumped-up charges, released in

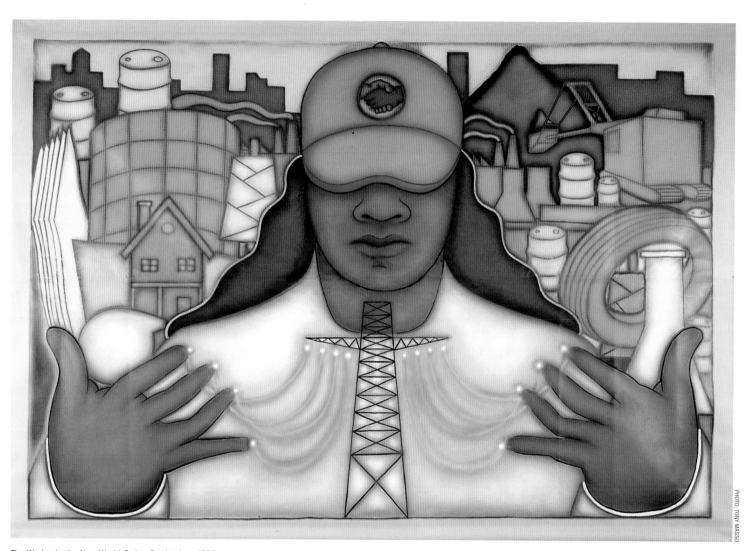

The Worker in the New World Order: Production, 1995

"Karen Silkwood was a great heroine. Not because she was murdered. The atomic industry has murdered many people. It's not an industry known for its respect for the sanctity of life. This is an industry that conducted tests on retarded children, giving them radiated milk and telling them they were members of a science club. They've murdered many.

It wasn't dying that made Karen Silkwood great; it was how she lived that made her important for us and for the rest of labor. She made a conscious decision to place the needs of humanity and of her fellow workers above the interests of her job, and that is something that workers alone can do. No politician, no union official can change the world today—only workers can do that.

So I dedicate this mural to Karen Silkwood because she showed us how to live and how to extend solidarity in real life by building her union.

I present this mural to you, the elected delegates of the Oil, Chemical, and Atomic Workers Union, who represent the great rank and file of this union, and those who, in the future, you will organize into its ranks.

The bosses killed Karen Silkwood, but they can't kill the union, they can't kill our movement. Karen Silkwood will rise again. Others will fill her shoes, new battles will unfold, labor will march forward."

—M. Alewitz
OCAW banner dedication ceremony
Aug 29, 1994

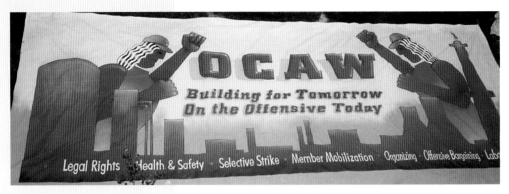

Backdrop for a convention of the OCAW

1938), looks on. As Alewitz commented, Karen Silkwood was killed, "but her spirit shall be reborn a hundred times over, wherever oil, chemical and atomic workers struggle anew for their rights and their future," for "history is made by working people, in both their collective action and their individual heroism."

The first panel, *Organize the Unorganized*, hailed back to earlier organizing days, with Eugene Debs' "prisoner-for-president" button from the 1920 election (when he gained nearly a million votes while in the Atlanta Federal Penitentiary), also oil derricks, Wobbly and atomic emblems, and the burning hills of history. That was a match for Panel Two, *Union Democracy and Diversity*, with Martin Luther King, Jr. (and police assassinating a black worker), John L. Lewis, and mementoes of the 1937 Memorial Day steel strike (in which police charged unarmed workers, killing ten and wounding more than a hundred). The civil rights movement and the role of women workers in

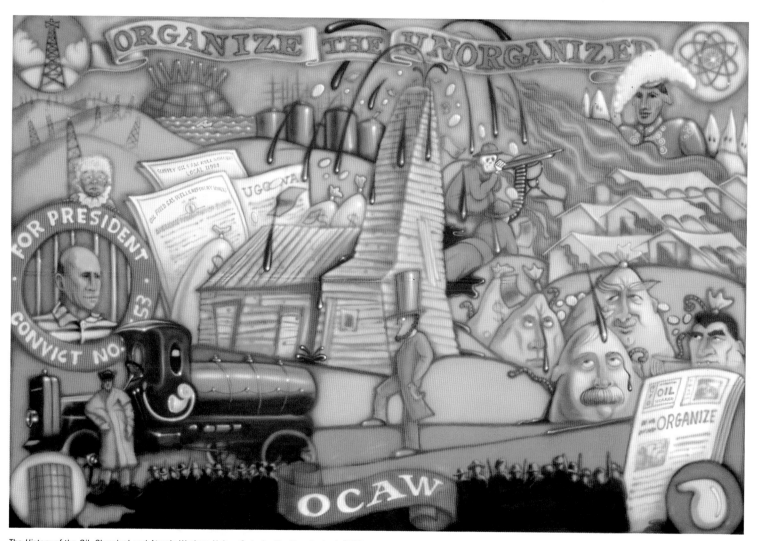

The History of the Oil, Chemical and Atomic Workers Union: Organize the Unorganized, 1994

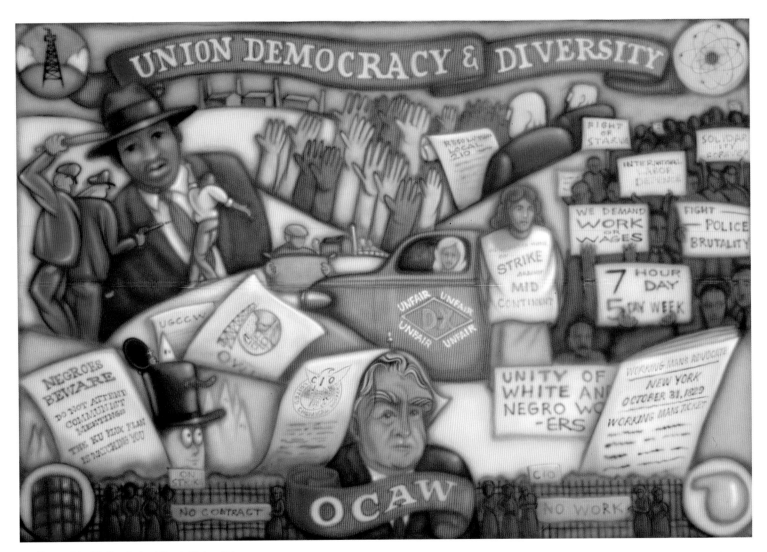

The History of the Oil, Chemical and Atomic Workers Union:
Democracy and Diversity, 1994

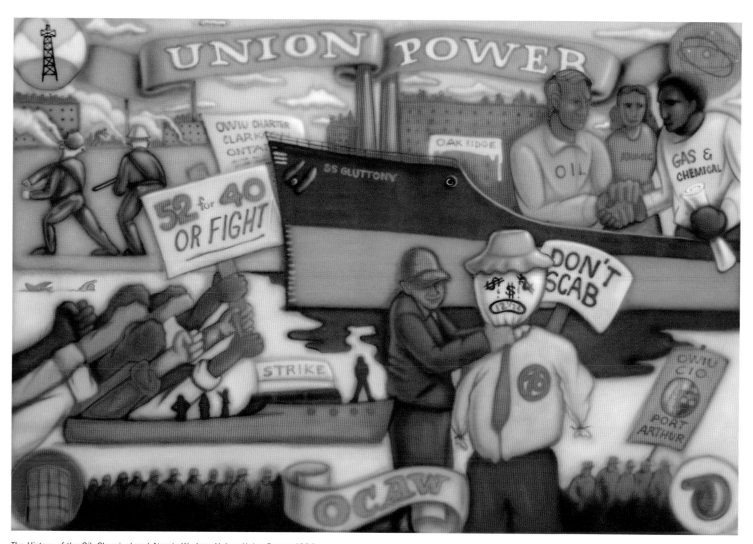

The History of the Oil, Chemical and Atomic Workers Union: Union Power, 1994

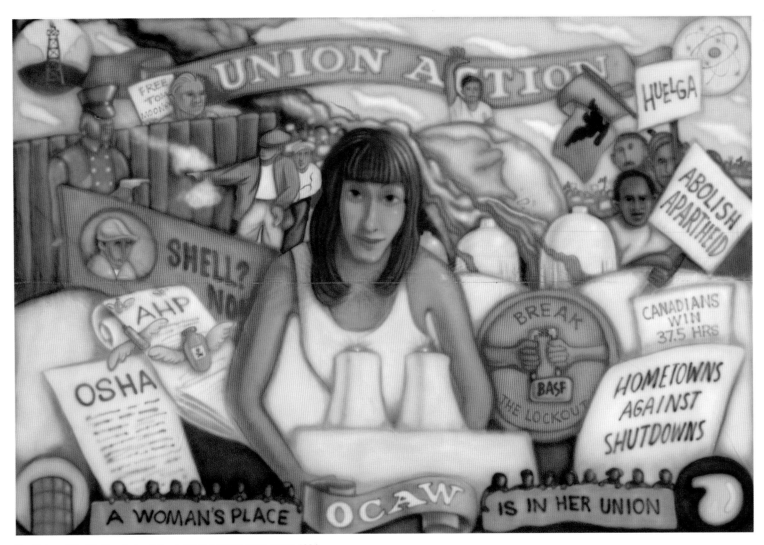

The History of the Oil, Chemical and Atomic Workers Union: Union Action, 1994

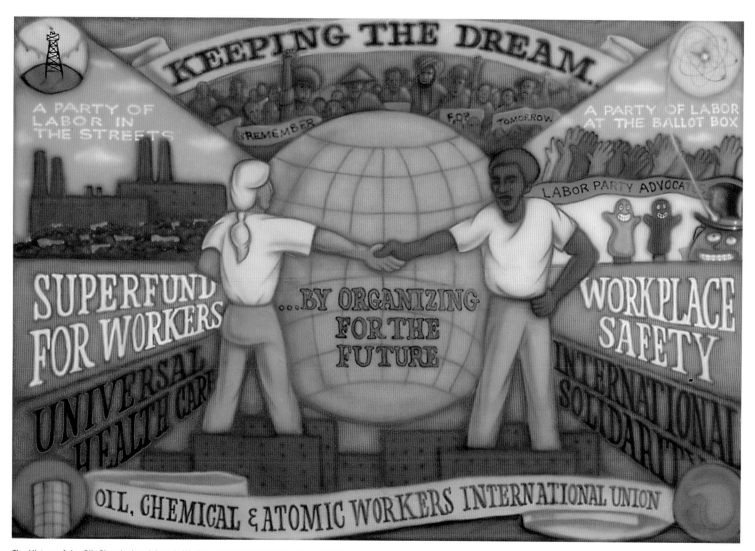

The History of the Oil, Chemical and Atomic Workers Union: Keeping the Dream, 1994

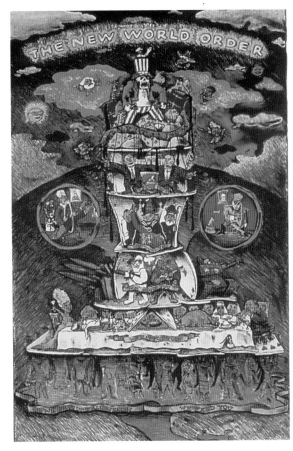

Lithograph of *The New Order*, an updated version of an IWW image

historic strikes suggest the changes that unions have belatedly begun to make and need to understand better.

The third panel, *Union Power,* depicted the rise of the OCAW from the 1930s to the 1950s, when the fledgling union (early on known as the Gas, Coke and Chemical Workers, later the Oil Workers) struggled for life, then led the "52 for 40 Strike" of unions at large in 1945, fighting for and gaining a return to the forty-hour week in the postwar world without losing the higher pay made during wartime of fifty-odd-hour weeks. A picket boat symbolizes President Harry Truman's use of the navy to break the 1945 strike. The union eventually won out, setting standards for other CIO bodies. Over in the right corner, a worker chokes a stuffed dummy, dramatizing a 1948 strike defying the presidential decree of the Taft-Hartley act.

After Silkwood, a final panel, *Keeping the Dream*, urges a labor party, a superfund for workers, universal health care, international solidarity, and workplace safety. Working people of all kinds clasp hands or stand side by side, obviously ignoring the capitalist who holds up two (undoubtedly warring) puppets, preparing for his latest manipulative strategy to set worker against worker.[5] Never had Alewitz performed so brilliantly for his friends in labor and

never had his work been so determinedly distributed by labor as it was in OCAW booklets and the poster series on hand at meetings of all kinds.

THE ARTIST FORMERLY KNOWN AS ORGANIZING DIRECTOR

As these murals met the approval and interest of unionists, Alweitz approached a more curious milestone. In early 1997, he was suddenly if not unexpectedly terminated from his job as organizing director of the United Scenic Artists Union. He recalled in a letter (ironically headed from "The Artist Formerly Known as Organizing Director") that he had accepted the job a few months earlier at a distinct loss of income "as the responsible thing to do."

The sign and display division of his painters union was going out of existence technologically,

Joe Uehlein and Alewitz organized a 1995 commemoration of the Kent Massacre on the Mall in Washington D.C.

and he had studiously re-educated himself in the kinds of scenic painting done for movies, theater, and associated display advertising of various kinds. Since the nineteenth century, painters' Local 829, working largely in theater, had been affiliated with the International Brotherhood of Painters and Allied Trades. The local has since affiliated with the International Alliance of Theatrical and Stage Employees (IATSE), the stagehands' union best

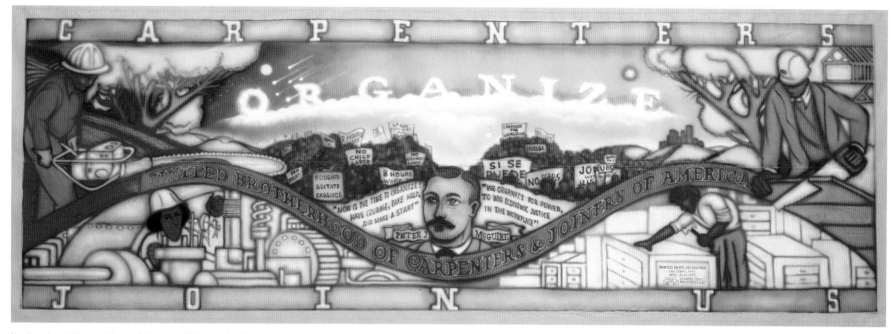

Alewitz painted this portable mural from a scaffold over the Carpenters convention in Las Vegas

known historically for its company-friendly leaders and their mob connections. Local 829's members, exacting craftsmen, sometimes worked for extremely high wages; but they, too, faced the various threats and dilemmas of automation and non-union competition. Alewitz quickly joined a new leadership group, which asked him to head up organizing, and he agreed to his first union staff position, on condition that the work would be part-time and not stop him from continuing with the craft; and that he be paid at scale, no more. The palace revolution in the AFL-CIO

UE convention banner

nationally, and talk about organizing in the painters union as well as unions at large, emboldened his dreams of labor mobilization.

Within a matter of months in 1996, he had managed to launch a series of discussions for an organizing strategy, including a program for member-organizers, discussions with other unions and with academics, and had generally prepared a major political discussion to lead a membership-driven organizing campaign.

Unfortunately, the international union was at the same time offering employers voluntary

wage reductions to assist in the search for larger market shares. Leading international officers now attacked Alewitz as a danger to the union. Proffered a full-time organizing job under the direction of the international—and simultaneously receiving implied threats—Alewitz refused the offer and resigned his position. He remained eager to work on union projects and was not burning his bridges. But perhaps they had been burned for him.

VISIONS OF A
DIFFERENT F U T U R E

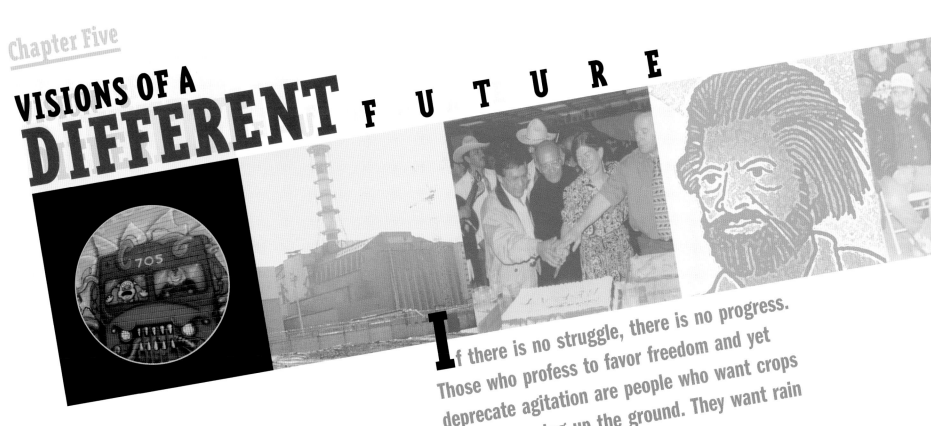

"If there is no struggle, there is no progress. Those who profess to favor freedom and yet deprecate agitation are people who want crops without plowing up the ground. They want rain without thunder and lightning."

—FREDERICK DOUGLASS

"I don't paint murals that are easily understood.

Art must be challenging. And the labor movement must be challenged. And we must be **challenged.**"

—M. Alewitz

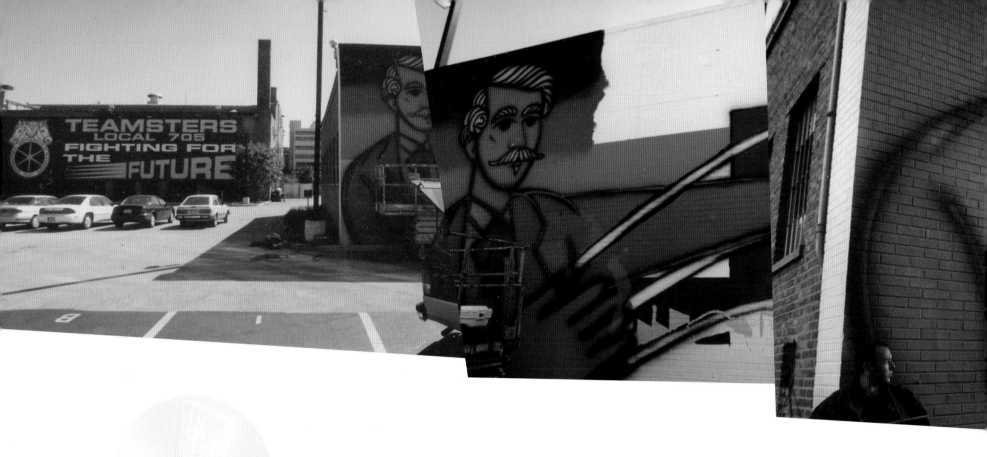

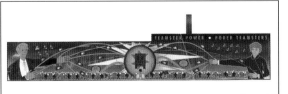

I N AN ADDRESS TO THE NEW JERSEY Industrial Union Council in 1999, LAMP director Christine Gauvreau recalled the historic labor figure Albert Parsons, martyred a century earlier. A Texas-born, Confederate veteran married to African-American militant Lucy Parsons, Albert had become leader of the 1880s Chicago radical movement—until placed on trial with seven other outspoken revolutionaries for the bomb thrown at Chicago police in Haymarket Square on Mayday, 1886. No evidence was presented of their participation in the bombing. Instead, their rhetoric and known leadership of the movement was judged conspiratorial: they were convicted for their ideas. Four, including Parsons, went to the gallows, one committed suicide, the other two were later pardoned by Illinois governor John P. Altgeld, apologizing for the blatant miscarriage of justice. Parsons's fellow defendant August Spies, also facing execution, spoke for the condemned men when he declared that the "labor movement—the movement from which the downtrodden millions" arose, remained a "subterranean fire" that would surely rise again.

The pregnant phrase "subterranean fire" floated atop the Teamster mural that, more than any other Alewitz had done, celebrated a current victory and apparent moment of revival for a

Preparation for *Teamster Power* mural LEFT: Wall before the painting began RIGHT: Mural design

The mural commemorated the Teamster strike against UPS. It was part of a series of murals painted by Alewitz and Daniel Manrique in Chicago and Mexico City.

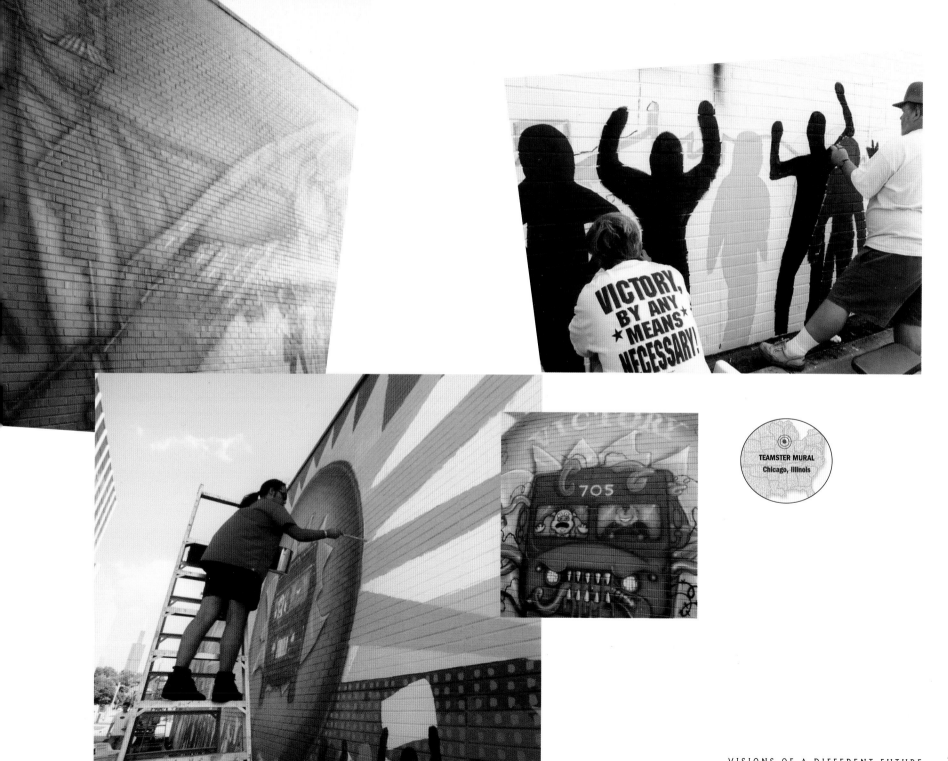

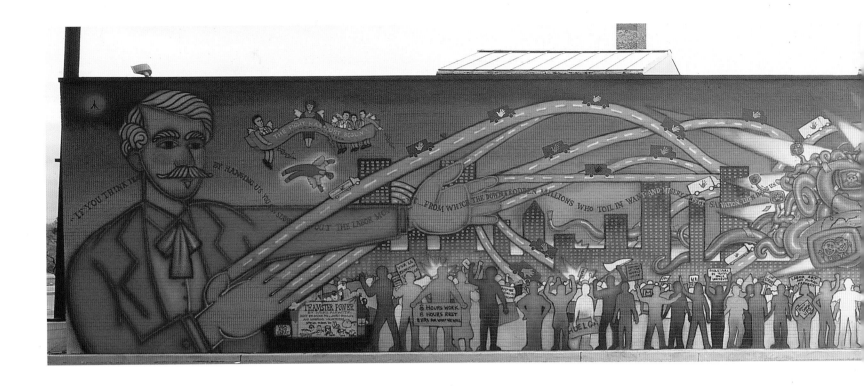

hard-pressed labor movement at large. The victory properly belonged, of course, to the Teamsters. During the late summer and early fall of 1997, the International Brotherhood of Teamsters (IBT) had taken on the United Parcel Service (UPS), one of the world's most powerful shipping corporations, and through its members' solidarity and public support had won a smashing, precedent-setting victory. The battle had been a test for the new, reform leadership of the union, headed by Ron Carey, after decades of scandals (and an open-ended phase of government supervision) had precipitated a victory by the reform forces. Carey's leadership, in turn, had made the 1995 AFL-CIO convention victory over labor's conservatives possible, ironically for the old guard because president Lane Kirkland, desperate for some success amid encircling failure, had personally invited the IBT back into the AFL-CIO a few years earlier.

Carey's early victory for IBT president had itself been sweet for Alewitz. Backed decisively by the group around *Labor Notes* (the publication and its surrounding political milieu launched two decades earlier by another branch of Trotskyists, whose practical temperament and sense of humor was, however, more in

A banner Alewitz presented to striking UPS drivers at a New Jersey rally. Bill Kane, president of the New Jersey Industrial Union Council (IUC), is speaking. Holding the banner is LAMP activist Jessica Ripton.

keeping with the artist's own), Carey had challenged UPS to make real full-time jobs with benefits for part-timers rather than reducing the union ranks by attrition as most unions from the 1970s onward casually allowed employers a free hand to do. Rather than the ongoing global race to the bottom, Carey promised a race—more properly, a collective struggle—to the top, very much in the union spirit of the 1910s and the 1930s and 1940s fighting

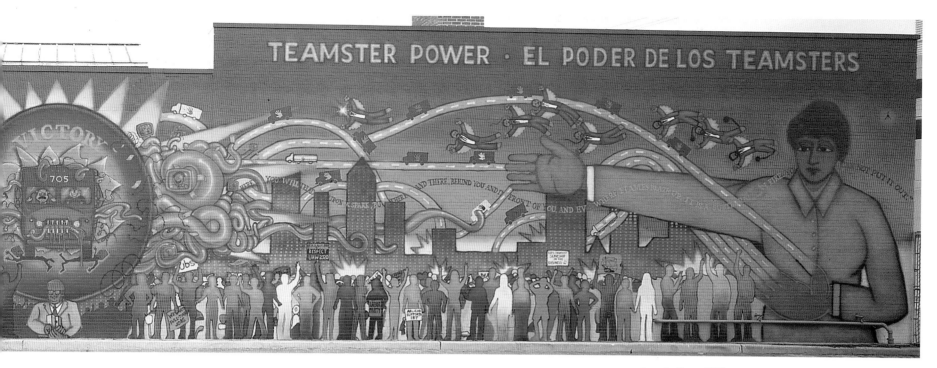

TEAMSTER POWER · EL PODER DE LOS TEAMSTERS

Teamster Power, 1998

days. Despite some hesitation on Carey's part once the struggle had began, this was clearly the way forward. It marked, in a larger sense, a solidarity strategy deserving the supportive scrutiny of every unionist, every friend of labor and the poor, and also every artist with labor sympathies.

Disappointment followed shortly. As various observers predicted, promises made by UPS but not sealed by the contract were quickly broken. More crushing, a desperate Carey had financed his own election victory against the well-healed junior Hoffa through a check-trading scheme involving many players including the Democratic National Committee and worse, AFL-CIO vice president Rich Trumka, whose position was badly weakened in the resulting scandal. When

PHOTO: STEVE DALBER

Carey left office and James Hoffa, Jr., routed his would-be successor-reformers in late 1998, a brightened national labor picture turned suddenly gloomy again.

Not that all had been lost, by any means:

ordinary Teamsters had seen and experienced what it meant to win, and how. But as Alewitz knew well from his own experience, any bureaucratic advance like Carey's could easily be reversed, because nothing but regular rank-and-file participation in decision making meant real democracy in the unions. Anything less meant deals cut with politicians at workers' expense, one way or another, in the United States and across the global scene.

Mike had originally come to Chicago to assist and collaborate with Mexican artist Daniel Manrique Arias, who was creating a mural at United Electrical Union headquarters that would be a sister mural to one that Alewitz had done (with the help and collaboration of Arias) in Mexico City. He made a dramatic

Volunteers from Chicago Jobs with Justice and the Chicago Public Art Group. Steve Dalber, on left, produced a video on the project for *Labor Beat*

Mona Fox—UPS striker, single mom, and artist—was assigned by the local to assist in the project

change of course in the aftermath of the UPS events. As Gauvreau commented to the IUC convention:

> Though the (Teamster) mural was done quickly and without much planning, almost a spontaneous response to the thrilling unfolding of the Teamsters' victory, I think you can say that it is a joyous and exuberant visual testament to the truths that can no longer be ignored: The truth that strikes have an economic impact and can be won. The truth that rank-and-file workers are not complacent, but are ready to fight when they sense their leadership is prepared to go the whole nine yards. The truth that service workers and part-time workers can be organized. That international organizing can have an effect on the outcome of an industrial dispute. That we can reach the unorganized and

middle-class public, and that they can come to see our struggle as their struggle. The basic truth, often buried in the last two decades in an avalanche of corporate newspeak and sometimes, unfortunately, by the theorizing of our own union strategists... the truth that we do indeed have the power to press our demands for justice.

Alewitz worked with the ardent support of the Teamster local, which organized assistance. Mona Fox, the key assistant, was a UPS worker and single mom. Big (at 20 feet by 130 feet) and beautiful, the work immediately inspired a widely viewed video of its production by *Labor Beat*, boasting interviews with Teamsters, passersby, amateur artists working with Alewitz, and the lead artist himself.

On the left-hand side of the mural could be found, wearing

Alewitz airbrushing the mural

his old-fashioned flowing tie, none other than Albert Parsons, the editor-orator of the English-language paper *Alarm,* who had offered a great voice in what was then widely called "Little Paris" (after the Paris Commune of 1870), the Chicago movement for an eight-hour day. Out of Parsons's hands flows the highways where teamsters drive their load and through him the slogan that promised victory over the death given him by the state. Above him stands a banner ("The fight has just begun") held by the Minneapolis Teamster leaders from 1934, the famed Trotskyist Dunne brothers, Marvel Sholl, the leader of the women's auxiliary, Henry Ness, a worker killed in the 1934 strike, and the working Teamsters of truck, factory, and office; below, outlines of working people with signs ranging from "8 Hours Work, 8 Hours Rest, 8 Hours for What We Will" (an 1886 favorite demanding leisure time for working people) to "UPS: Tightest Slaveship in the Business." To the far right of the mural, Lucy Parsons could be seen receiving the highways in her hands, the slogan completing itself around her. Behind them both stands a modern Chicago of swarming and towering skyscrapers, but superimposed in the middle, a Teamster-driven bus smashing through monster-monitors toward victory (and

over the bodies of two "blockheads," the classic anti-union workers). It all made for an eloquent message and an eloquent mural. In Chicago's Teamster City headquarters, the mural was a lasting monument, a historic recollection of early Chicago labor battles that no other artistic form could so successfully represent—and no less a promise for another day ahead.

LEFT: mural detail
CENTER/RIGHT: Local 705 Secretary-Treasurer Jerry Zero addresses the press
RIGHT: Teamster activist Lynda Zero at the mural site
BOTTOM: Mike Alewitz at work

LABOR AND "INTERNATIONALISM"

The Mexican mural project was a major cross-border collaboration with a counterpart artist, Daniel Manrique Arias. They and their work, ardently supported by Chicago UE, concretely demonstrated a new era of labor internationalism.

Chicago Socialists had quite naturally proclaimed labor's struggle an international one, for many Chicago Socialists themselves had come from Germany or Bohemia in the latter-day Czech Republic (along with a scattering of early arrivals from Jewish shtetls of eastern Europe). They were followed in many parts of the United States by "birds of flight," workers from southern Europe who moved with the seasons or labor conditions back and forth across the ocean: Filipinos, Mexicans, and latter-day Caribbeans who followed their own paths back and forth. Until the passage of the 1924 immigration quota and a generation beyond, the heart of working-class radicalism in the United States often beat in the immigrant breast, the tongues speaking Yiddish, Lithuanian, Italian, Polish, Hungarian, Chinese, Filipino and other languages.

America's labor bureaucrats had a very different version of "internationalism" in mind. AFL president Samuel Gompers had created, before his death, a supine Latin American labor federation

Mexico City union members contributing to *Sindicalismo Sin Fronteras* mural

SINDICALISMO SIN FRONTERAS/ TRADE UNIONISM WITHOUT FRONTIERS
Mexico City, Mexico

devoted to the interests of U.S. investors. After the Second World War, his AFL successors turned the federation's policies further to the right—directly into the hands of the new Central Intelligence Agency, collaborating in massive payoffs for compliant foreign union leaders, deals with European mobsters against radical unionists, and blatant vote buying in elections, political and labor, affecting U.S. interests.

During the Kennedy years, with the AFL-CIO recently merged into a single body, secret funding skyrocketed and agencies like the American Institute for Free Labor Development along with sister regional bodies for Africa and Asia devoted tens of millions to corrupting Third World labor leaders, meanwhile fingering dissident unionists to be threatened, sometimes beaten, kidnapped, or murdered. In events across Vietnam, Indonesia, Chile and throughout Central America, American labor leaders had been at the very least compliant in mass assassination plots, and often more directly involved. After the Cold War, the AFL-CIO and individual

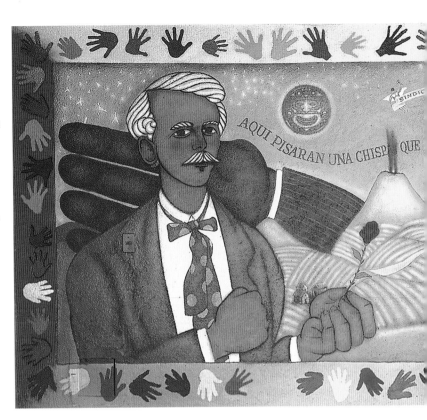

unions like the AFT continued building United States–funded business unions in eastern Europe, supporting privatization of industry at giveaway prices and attacking unions that opposed the United States–friendly governments or the notorious "vampire capitalism" of swindle-minded investors.

Labor progressives had striven, all along, to find a better way. Seattle Wobblies famously struck a ship in 1919 loaded with weapons for the feared anti-Semitic "White" forces seeking to overthrow the new Russian government. CIO leaders had refused AFL demands to set up a compliant Mexican labor federation in 1938 to oppose the government nationalization of U.S.-

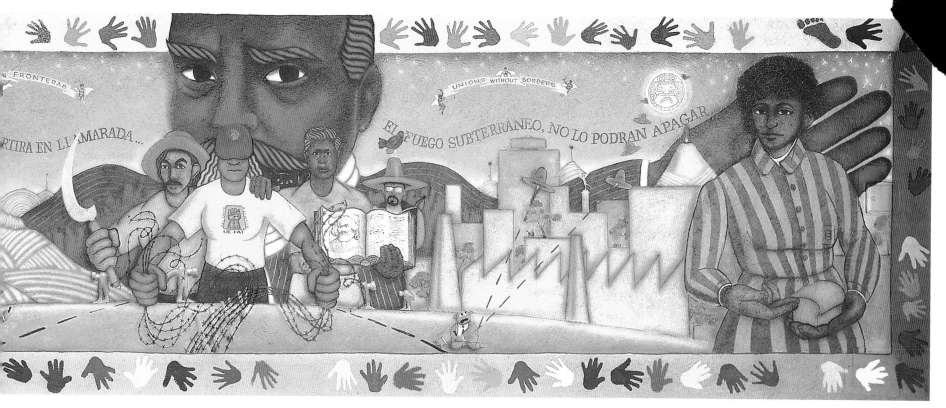

Sindicalismo Sin Fronteras/Trade Unionism Without Frontiers, Mexico City, April 1997

Mexico City mural dedication ceremony. From left to right: Benedicto Martinez of FAT, Daniel Manrique, Robin Alexander of UE, Mike Alewitz

FAR LEFT AND RIGHT: Daniel Manrique was Alewitz's Mexican counterpart in the cross-border mural project. Both painted this banner for a May Day demonstration

owned oil companies stealing Mexican petroleum. Left-wing unionists had gone down fighting the Cold War, or in some cases survived with their badly weakened unions (such as the United Electrical Workers) through terribly tough times.

Now, in the face of NAFTA and the creation of sweat-shop *maquiladoras* just across the United States/Mexican borders, at once stealing jobs and poisoning the environment (not to speak of the families living within it) with massive toxic dumping, the old business unionism "internationalism" looked out of date. The collapsing Kirkland AFL-CIO administration, in its last years, conducted a popgun war against NAFTA, albeit consisting mostly of hot and polluted air behind which Kirkland's henchmen backed the very same politicians who supported NAFTA (Kirkland himself, tainted and forced out of office, became a U.S. trade representative) and declared the consequences not so bad after all. But not everyone had gone along.

Indeed, unionists who had supported Nicaraguans seeking self-determination and Salvadorean unionists against thuggish United States–guided federations reset themselves even before the fall of Kirkland to encourage new relations to their south. The Resource Center for the Americas (based in Minneapolis), reformers based in the Southwest, and a first wave of campus protests against Central

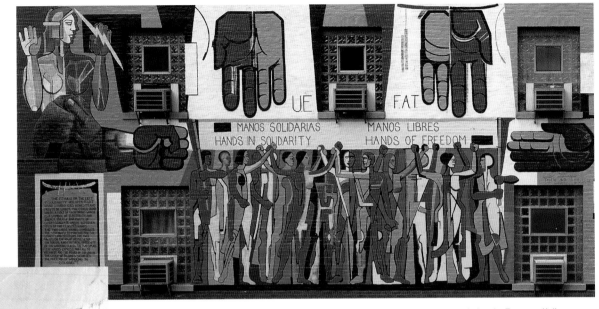

Manrique painted this mural on the side of the UE building in Chicago while Alewitz was painting the Teamster Hall

American sweatshops took shape in the middle 1990s. The United Electrical Workers (UE), rebounding from the beating they took in the McCarthy era and from the downsizing of electrical parts plants, was the first union to establish close relations with the sister union reformers of the Authentic Labor Front (FAT), a reform-minded Mexican labor organization founded in 1960, an alternative to the government-controlled "official" Mexican labor federation. As the campus efforts against sweatshops heated up and the UE established an electronic newspaper for a Mexican-American exchange of labor information, Alewitz embarked on his new ambitious project, which began with Christine Gauvreau writing a letter to Robin Alexander, director of

international relations for UE, and engaging UE with LAMP.

A Mexico City newspaper explained the results to its readers very simply: "two muralists, the same ideal: free trade unionism." The resulting Mexican mural, entitled "Sindicalismo Sin Fronteras/Trade Unionism Without Frontiers," showed workers tearing up borders imposed by bosses. Emiliano Zapata stood at the center, with Albert and Lucy Parsons on either side. Alewitz had originally paired Che and Malcolm in these spaces, but FAT members had requested the change and Alewitz was happy to accommodate their sense of labor history in which anarchist and other movements had lifted the Haymarket victims into martyrs for generations of labor demonstrators. The mural also depicts two historical FAT heroes: a founder of the new

federation killed in a tragic accident; and another leader, tortured and murdered for organizing unions free from the bossism of the Mexican labor mainstream. A volcano symbolizes the stress and oppression ultimately prompting eruption of working-class struggle.

This mural was opened for viewing at FAT's annual convention in 1997, with UE members from the United States and Canada on hand along with FAT delegates. In remarks to this meeting, Alewitz spoke about the "humbling experience to come to Mexico to paint." Unlike the usual (and rarely modest) labor banquet speaker, he was not exaggerating. "Here is where the [artists] Rivera, Orozco, and Siqueiros were inspired by millions of peasants and workers to illustrate the historic conquests of the Revolution." He continued:

We are using this cultural project to illustrate our collective union vision, unfortunately, too often our unions resemble exclusive clubs, or worse, criminal gangs. Even unions that pride themselves on being progressive are often bureaucratic and autocratic. Without the full and active participation of the membership, all the weaknesses of our organizations emerge. As workers we often must not only battle the employers, but our own conservative leaderships as well. This is a particular problem in the United States....Today we dedicate this mural to those who have been victimized in the struggle for union democracy. This mural is the product of not only artists, but the thousands of workers who built our unions. This is their mural.

He went on with a statement that inevitably made his message more controversial back home:

Finally, I would like to take this opportunity to denounce the criminal policies of the United States government. In particular, I denounce the economic sabotage of Mexico and the criminal embargo of Cuba. The gang in Washington does not speak for me or millions of other American workers. They are waging war upon our class. They are my enemy and your enemy. They represent the past, we are the future.

ABOVE LEFT: Alewitz at Pripiat

"**After the Chernobyl disaster the city of Pripiat had to be completely and permanently evacuated. It was an eerie feeling to visit an empty city; an amusement park with no children. Much more was destroyed than lives of the thousands who died. The nuclear industry—and its parent the nuclear arms industry—are a horrible plague on the earth.**"—Mike Alewitz

BELOW: Planting a rose during the annual commemoration of the meltdown

ABOVE: The Chernobyl nuclear power plant, still in operation when Alewitz visited

CHERNOBYL

In 1996, marking the tenth anniversary of the Chernobyl disaster that flooded the Ukraine with nuclear poisons and spread deadly fallout across Europe, Alewitz traveled to Slavutich, a "model city" built to house the surviving and newly imported workers. Dedicated to those workers who perished in their attempts to prevent a worse disaster, the mural was sponsored by the International Federation of Chemical, Energy, Mine and General Workers' Unions along with local energy workers.

The result was like nothing else he had done before. A technician wearing a protective face mask, with hair ambiguously flowing behind a head that could be either male or female, holds out

hands clutching a wire (strung in turn to a transmitter or generator) with sparking ends, representing the martyred workers who had given their lives to save others. An alternative transportable, canvas mural depicts the same worker with a saying overhead: "We shall bring to birth a new world from the ashes of the old," favorite lines of the venerable IWW song, "Solidarity Forever," obviously relevant now in new ways.

CHERNOBYL MURAL
Slavutich, Ukraine

Not surprisingly, given the nuclear industry's record for denial, the mural had a rocky course of creation. Originally proposed by the International Chemical Workers' Union (ICEM) to raise the popular discussion of nuclear power, and embracing the progressive position that nuclear workers should be trained to decommission the industry out of existence, the mural project arrived at a troubled and badly divided labor scene. City officials in the new, post-meltdown district near Chernobyl greeted Alewitz so cheerily, wined and dined him so continuously that he became suspicious. Sure enough, they were hoping to distract him by using up all of his time in the Ukraine because of their concern that his drawing (of workers in protective

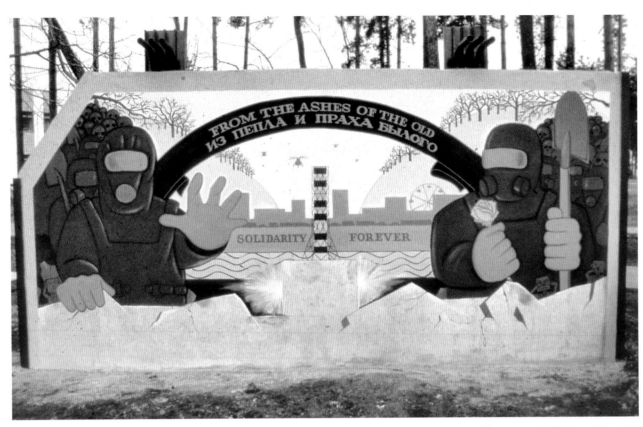

Monument to the Workers of Chernobyl,
left panel, 1996

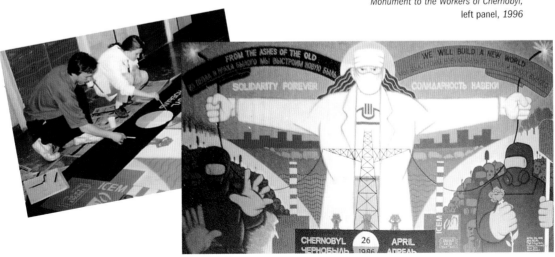

ABOVE LEFT: Volunteers painting ABOVE: Portable mural

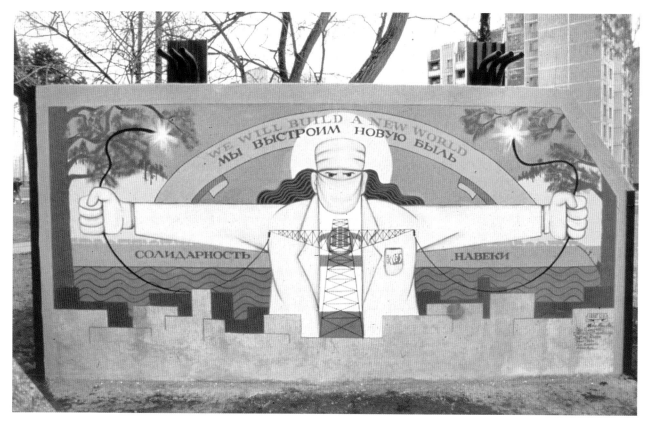

Monument to the Workers of Chernobyl, right panel, *1996*

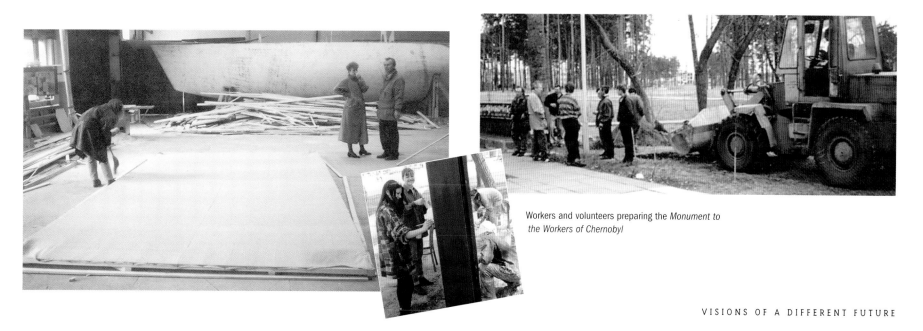

Workers and volunteers preparing the *Monument to the Workers of Chernobyl*

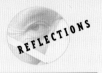

"A few of the leaders of the union aligned themselves with the government in attempting to stop the project. They lured me away from Slavutich to Kiev. After I met up with ICEM leaders, they attempted to keep us in Kiev. What followed was a series of events including the sudden disappearance of our car, commandeering a cab, a madcap trip down the highway chased by a car full of pronuke officials, and a negotiating session at the side of the freeway.

Eventually, workers from the Atomic Workers Union went to a cement factory, made two huge slabs, brought them to the center of square in town, back-hoed the ground and installed the slabs. There was about two weeks left on my trip. We jumped on it—agitprop artists often have to work fast.

Finally it was agreed that there would be a city-wide referendum, conducted by the union, on the future of the murals. I considered it a complete victory. Chernobyl has now been shut down, but the murals remain."

—Mike Alewitz

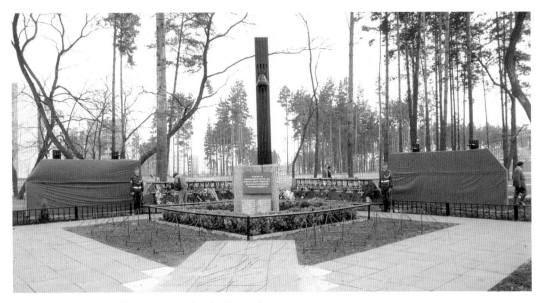

Monument to the Workers of Chernobyl, covered and under guard

gear) actually suggested that nuclear power had safety problems! Approaching the end of his stay, he threatened to hold a press conference on the tenth anniversary of the tragedy, and quietly created an alternative, transportable canvas mural that he presented to unionists still working at Chernobyl.

Meanwhile, local unionists joined by local residents simply built two concrete walls in the new town center and told him to proceed with the murals. The city covered up the murals shortly before completion and put out armed guards to prevent their unveiling for

the international press—then relented and agreed to a union-run referendum on the murals' survival. As time went on, they remained on display, albeit under threat. Alewitz and the Chernobyl survivors, and labor art in general, had won a small victory (the portable mural also remained on hand in Chernobyl). It was also a reminder that, as with the Pathfinder mural and Rivera's 1930s murals, public art remains dangerous to authorities who tend to patronize art that is comfortable to them, and do not permit visual symbols of opposition.

ICEM representative Vic Thorpe presents the permanent mural to the union of liquidators in the devastated town of Chernobyl

IRAQ

Alewitz took a new tack in 1998, as the calamitous results of the United States clampdown on Iraqi oil sales and consequently on food and medicine for Iraqi civilians became better known. He boldly joined a humanitarian delegation that included Detroit Catholic bishop Thomas Gumbleton and former U.S. attorney general Ramsey Clark, along with peace activists, traveling to ascertain conditions and, on his part, to arrange the creation of a mural dedicated to the victims of bombing and of starvation policies. Funded by private unionists' support (no official body dared, even after the fall of Kirkland, to venture into such humanitarian territory), the "sanctions challenge" defied U.S. law by bringing medicine and food, and by bringing what Alewitz called "a different message to the people of Iraq: a message of peace and solidarity." Crowds of Iraqis, conducting lively political discussions about the form and meaning of the mural, flocked to Alewitz's talks and slide shows given on the labor movement today. Perhaps they appreciated that he, too, in the days of the Vietnam War, had been labeled "terrorist," when the state was the real terrorist.

ONE WORLD
WITHOUT BORDERS
Baghdad, Iraq

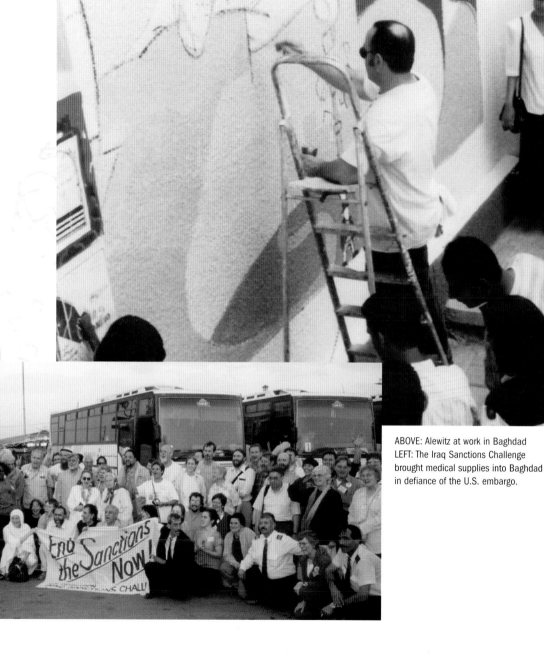

ABOVE: Alewitz at work in Baghdad
LEFT: The Iraq Sanctions Challenge brought medical supplies into Baghdad in defiance of the U.S. embargo.

VIEWSPEAK

The following is an excerpt from LAMP's (Labor Art Mural Project) call for the Iraq Mural Project support.

AN URGENT APPEAL FOR INTERNATIONAL SOLIDARITY

"U.S./UN sanctions against Iraq are a crime

against humanity. Hundreds of thousands of innocent working people and their children have been killed. Millions more are endangered by the lack of adequate food, medicine, water and sewage treatment, and other necessities of life.

The sanctions, the most pervasive blockade of any country in modern history, remain in place today due to the insistence of the United States government.

U.S. policy in the Middle East is designed to keep Saddam Hussein in power, by preventing the growth of any genuine opposition movements. Only the oil corporations and other multi-nationals, the same employers who wage war on us, are the beneficiaries of this cruel and inhuman policy.

We must not only speak out in protest, we must take action to end the sanctions now."

—M. Alewitz

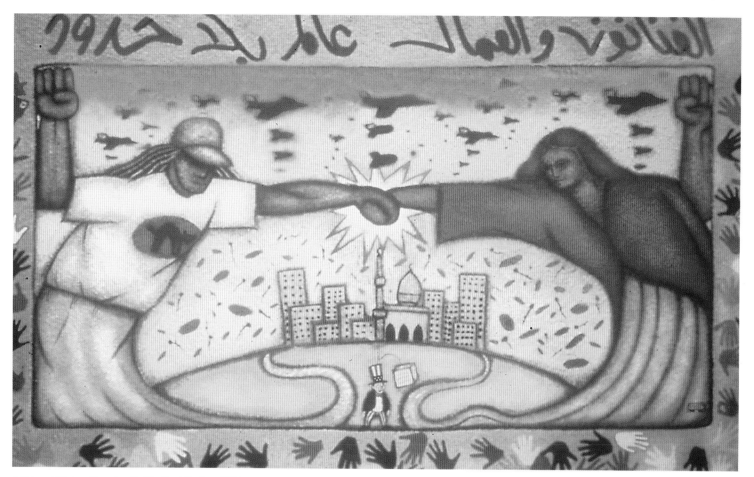

Artists and Workers Form One World without Borders, 1998

Assistant Fatin Musa with
Alewitz

Alewitz at the dedication. Behind him
is former Attorney General Ramsey Clark
with students

Mural process observed

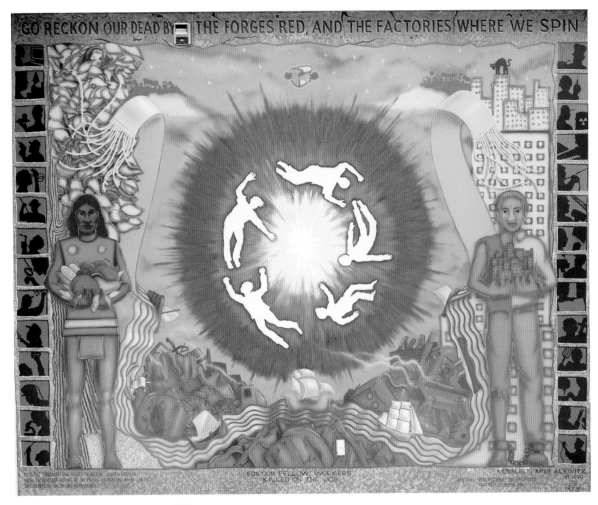

GO RECKON OUR DEAD BY THE FORGES RED, AND THE FACTORIES WHERE WE SPIN

FOR OUR FELLOW WORKERS
KILLED ON THE JOB

MURALIST: MIKE ALEWITZ

Explosion, Lodi Library, Lodi, New Jersey 1999

A memorial to the five workers killed in the Knapp chemical explosion

and employer repression. Mike Alewitz worked with the musuem on a number of projects during the 1990s. From children's art festivals to a re enactment of the Paterson pageant (done with the help of local high school students) to a series of CAC projects including commemoration of the formation of the CIO, the creation of life-size puppets for the museum's entry in the state's Labor Day Parade (all accomplished with the collaboration of the CWAC activists), to the encouragement of new artwork by students on the subjects of "Workers and Immigrants" to other artworks by local senior citizens, Alewitz almost personally embodied Botto House's aspirations as a historical and public institution. In the old industrial town of Lodi, across the state, Alewitz fashioned a mural of a different kind, commemorating a chemical disaster that needlessly martyred five workers, seen in a circle of glowing red light and surrounded by other Lodi pasts, of Native Americans, African-American workers, woodlands and cities.

THE AMERICAN LABOR MUSEUM

All politics, even global labor politics, is finally local, and even while roaming far afield, Alewitz brought the issues home again. The American Labor Museum, Botto House, is located in Haledon, New Jersey, where a socialist ran the mayor's office in 1913, and IWWs leading the Paterson strikes could plan events in safety from police

THE AMERICAN LABOR
MUSEUM
Haledon, New Jersey

Mike Alewitz, Christine Gauvreau, Sam and Beatrice Alewitz at the dedication of the explosion mural

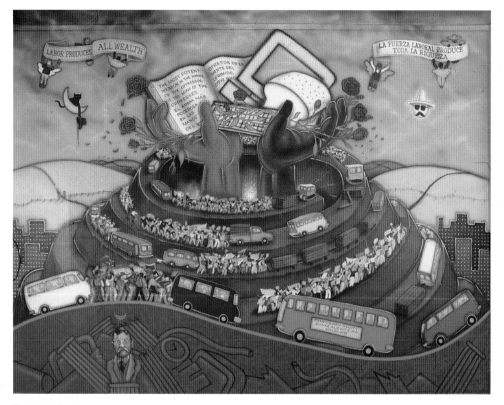

Temporary Sanity

Alewitz with students at Roosevelt School in New Brunswick, New Jersey

Student work for
Temporary Sanity

VIEWSPEAK

TEMPORARY SANITY
Roosevelt School, New Brunswick, NJ
The following remarks were prepared for the recent dedication of a mural at the Roosevelt School in New Brunswick, NJ, by Mike Alewitz of the Labor Art & Mural Project.

"This mural is the result

of a grant from the Mid-Atlantic Arts Foundation. But when we went off to look for a site, the city of New Brunswick refused us a wall. Churches refused us a wall. The Labor Education Center at Rutgers refused.

Why? Because I wanted to paint about temporary workers...immigrant workers who make up the working poor of this city. In this mural you will see the vans that come every morning to take workers to the warehouses and factories of this area. There are so many vans in the morning that the city council passed a law against honking before 8 am.

It is these workers who produce the wealth of the state and the nation. And yet they are invisible. But the poor are not invisible to us. They are our parents, brothers and sisters, our children, our neighbors. And the work that they do is important. They make our clothes. They build our homes. They grow and prepare our food. In fact, they create everything..."

CENTRALIA UNION MURAL PROJECT

Centralia, Washington, halfway between Seattle and Portland, Oregon, was once infamous but is now only a struggling woodland community almost forgotten by labor historians. According to longtime Olympia trades council president Helen Lee, the Centralia Union Mural project began in 1996 with John Regan—one of the first antiwar GIs—who had become a small businessman in Centralia offering a building downtown where the famed Centralia Massacre of 1919 could be commemorated. Regan contacted the Labor Party committee of Seattle and CWAC activist John Ruhland contacted Alewitz. A site was organized and local union and community groups were involved, including the Evergreen State College Labor Education Center, also headed by Helen Lee.

John Regan painting on the mural

CENTRALIA UNION
MURAL PROJECT
Centralia, Washington

An intensely political and politicizing process followed, even more intense perhaps than Alewitz had anticipated, although so much to his liking that it could be called downright Alewitzian. A committee, mostly union members, discussed everything, from content and thematic treatment to color. They contacted groups interested for good reasons, including local progressives, and for less than good reasons, a local American Legion branch whose predecessors had been involved in the brutal attacks on the Wobblies. Following a local showing of Alewitz's art and two lengthy conference calls,

the committee was ready.

Mike arrived in Centralia after months of planning, talked to the press, gave lectures at the local community college, and lived in the heart of the community. He thereby built up trust sufficient to allow him to make the connections between labor history, community history, and current issues Centralia was facing (the prospect of an environmentally dangerous, minimum-wage chicken factory poised to move into Centralia with full approval of local, development-crazy businessmen). The connection clicked.

The Centralia events of 1919 offered no comfortable memory. That year, an IWW lumber workers' strike near Centralia had pressed a booming wood-supply industry, whose executives raised a cool half-million dollars to break the Wobblies. The War Department, claiming neutrality between workers and capital for the duration, had nevertheless dispatched officers of the Signal Corps to organize a Loyal Legion of Loggers and Lumbermen as a repressive arm of the state. Proclaiming an eight-hour day (for which the IWW, long putting forth the demand, now properly took credit), the LLLL promised to stamp out anarchy and sabotage, rallying support for mob violence against the Wobs.

Armistice brought armed vigilante attacks on IWW offices by uniformed servicemen and others in many parts of the country, but none

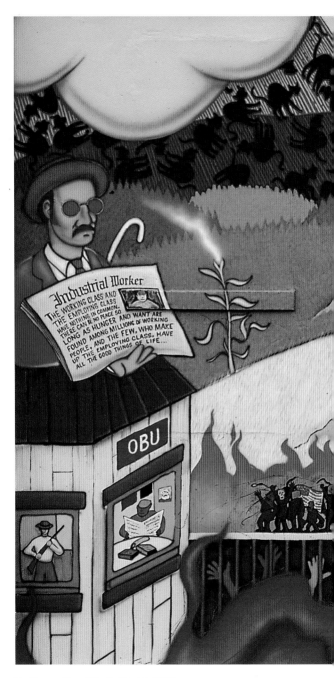

The Resurrection of Wesley Everest, 1997

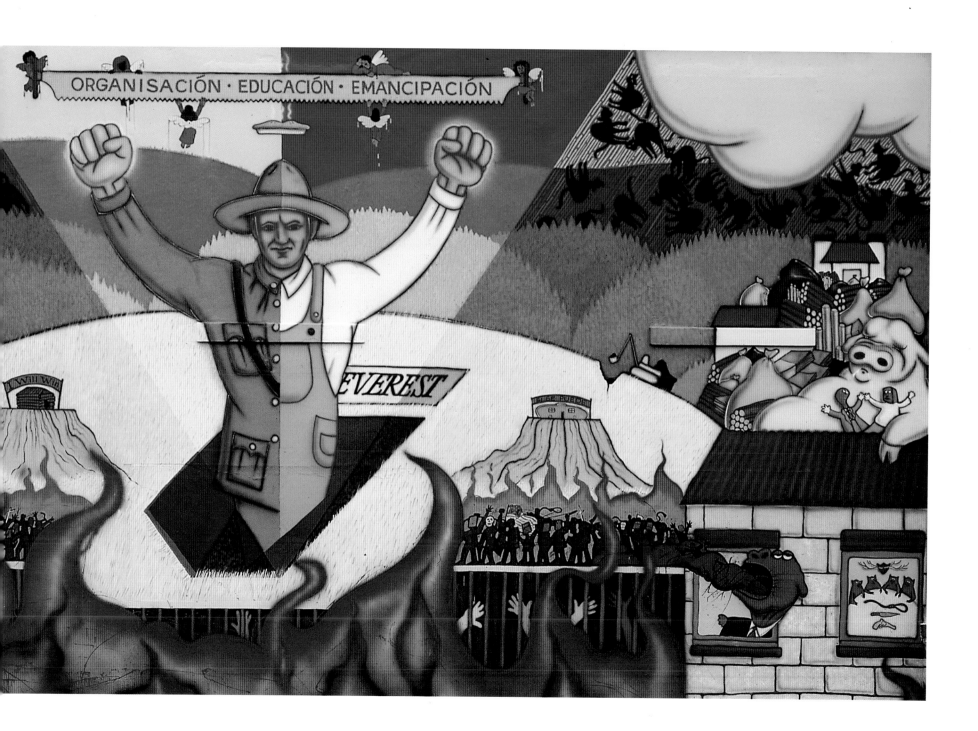

ORGANISACIÓN · EDUCACIÓN · EMANCIPACIÓN

EVEREST

THANKS TO MURAL, NO BRUSHING ASIDE CENTRALIA CONFLICT

"Centralia—For decades, the statue, known as *The Sentinel*, was the only evidence of what became known as the Centralia Massacre. People in town wouldn't talk about the events of 1919, the library carried no information on it and the schools didn't teach it...

That silence will end tomorrow, when a brightly colored mural of the event is dedicated. Its centerpiece is Wesley Everest, the Wobbly lynched that night, rising from his grave."

—*Seattle Post-Intelligencer*
OCTOBER 1997

CENTRALIA UNION MURAL PROJECT

"...Pat Underhill, member of the Carpenters' union and mural project, said at a recent CUMP meeting. "For many working people in Centralia, the average wage is $6 or $7 an hour."

...Jon Regan, owner of the former Elks Lodge building on which the mural will be painted, added, "All of us are looking for answers, but we haven't found the solutions that will help us advance our community economically. One reason is that all elements of the community are not involved in the dialogue. The mural provides an opportunity for that dialogue."

—*Labor Center News*
The Evergreen State College, Olympia, Washington
Fall 1997

more violent than in Centralia. An IWW office had already been wrecked in Centralia on Memorial Day, 1918, and the newsstand of a blind Wobbly sympathizer ripped apart, its owner kidnapped and dumped in a ditch outside town. On Armistice Day, 1919, word leaked out of an impending right-wing conspiracy, and Wobblies circulated leaflets asking for aid and support. Paraders used the cover of local festivities to break into the hall. Wobblies inside shot until their guns became too hot, killing three vigilante Legionnaires including the Legion commander at the head of the invaders. Those few Wobblies hidden in the hall were set upon by the mob.

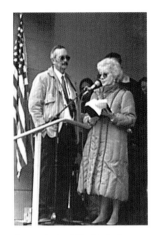

Descendants of the Centralia victims speaking at rally

Wesley Everest, a war veteran and Wobbly, was knocked unconscious, dragged to jail by a strap around the neck; that night he was seized from jail, castrated, and hung on a railroad trestle to be seen by touring vigilantes shining their car lights upon the body. The four surviving Wobblies were then compelled to bury the body in an unmarked grave so that no photos could be taken. Centralia had become an American Legion dictatorship, and members of the Bar Association were warned they would be disbarred for even defending the victims. Months later, not the vigilantes, but seven Wobblies

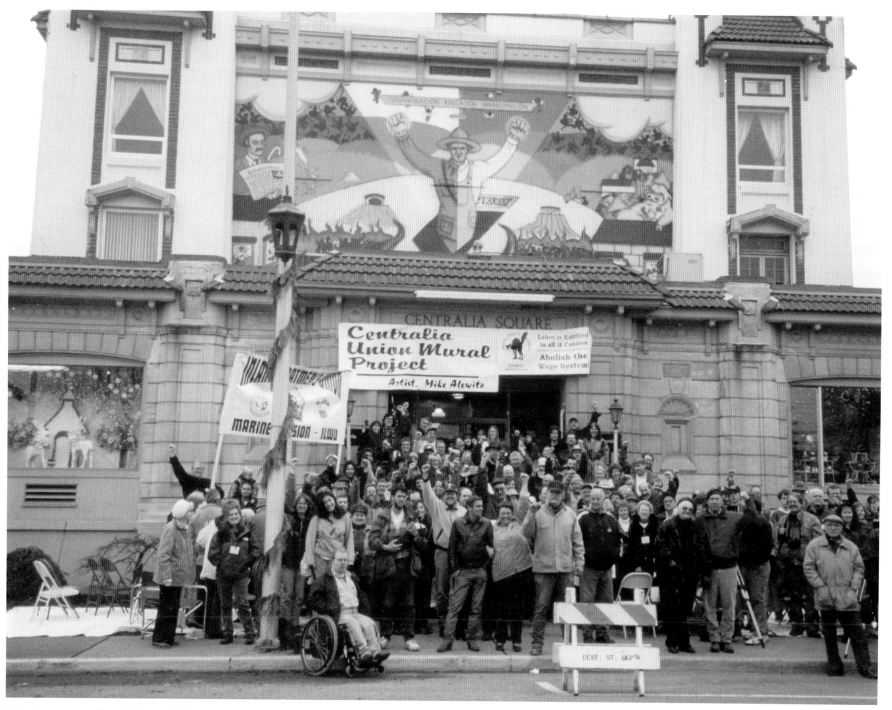

Dedication ceremony at Centralia Square, 1997

were declared guilty of second-degree murder, and the judge sentenced them to maximum terms in prison. Six of the jurors later declared, in an affidavit, that they would have voted to acquit if they had known the full story of the conspiracy in the Legionnaires' raid on the hall. It made no difference.

Wesley Everest and the events in Centralia had once been captured in Wobbly poems and songs, but even these had been lost over the generations by a forgetful labor movement. The mural,

The capitalist, the porkchopper, and the block-head—time-honored Wobbly iconography

dedicated December 13, 1997, brought Everest and his comrades back to life. On the left side, the blind newsdealer offers the IWW's *Industrial Worker*; on the right side the hog of capital hogs the good things of semi-rural life, the money, crops, and houses. In front of him dances a pork-chop-headed union official and a blockhead-ed worker. Below we see imprisoned Wobblies and above, from the clouds, fall a veritable rain of black cats, Sabo Tabbies, the IWW symbol for resistance to blind wage slavery.

Wesley Everest himself naturally takes up the center of the mural, half of him dressed like a soldier, the other like a lumberjack. Both hands are up in fists, and above him, a Spanish

"Organización-Educación-Emancipación" banner is held up by angels. The same organization, education, and emancipation were desperately needed now, in the 1990s, to reach out to newer immigrant workers who live in "Little Tijuana," a sprawling trailer camp. Thus a little log cabin on a tree stump, the old Wobbly housing, is seen and above it "We Will Win," and on the other side a mobile home, with the same slogan in Spanish.

Alewitz and the mural finally overcame most of the local opposition, including that by descendants of Legionnaires. A more ironic episode involved a few members of the current (and badly reduced) Industrial Workers of the World, who objected to the artist "appropriating" an exclusive Wobbly memory. As this controversy died away, it could be said that the mural became one of the most notable features in the little town of Centralia, and along with Joe Hill one of the most vivid visualized memories of the Wobblies anywhere.

The Sentinel monument to the lynch mob that killed Wesley Everest

Thanks to the Centralia Mural Committee, it now overshadowed by the image of Wesley Everest rising from the grave.

HIGHLANDER MURAL

The story only pauses here. For that reason, perhaps it is best to end this narrative with a mural particularly evocative of the best of American radicalism: "Without Action There Is No Knowledge," sited at the Highlander Center in New Market, Tennessee.

HIGHLANDER MURAL
New Market, Tennessee

Highlander opened in Monteagle, November 1932, as a residential adult-education center. Along with Commonwealth College of Mena, it was one of two radical "labor schools" in the South. Southerners who had met at the Union Theological Seminary in New York founded Highlander, supported by socialists, unionists, and assorted sympathizers to counteract failures of public education, especially acute in the region, and to train new social leadership. Founding father Myles Horton, seen as an angel in the upper left corner of the mural, was there from the beginning and remained until his death in 1990, an affable, hardworking, dedicated southern radical. By the time the school celebrated its fiftieth anniversary in 1982, he and his colleagues had been beaten, repeatedly arrested, called reds, snubbed, attacked by union bureaucrats, and spied on by the FBI. Highlander itself had been bombed, its building seized by the state, the school driven out of the Knoxville region by a phony urban

Dancing Cattle.
During the redbaiting of the 1950's, the Highlander was rumored to harbor nude dancing.

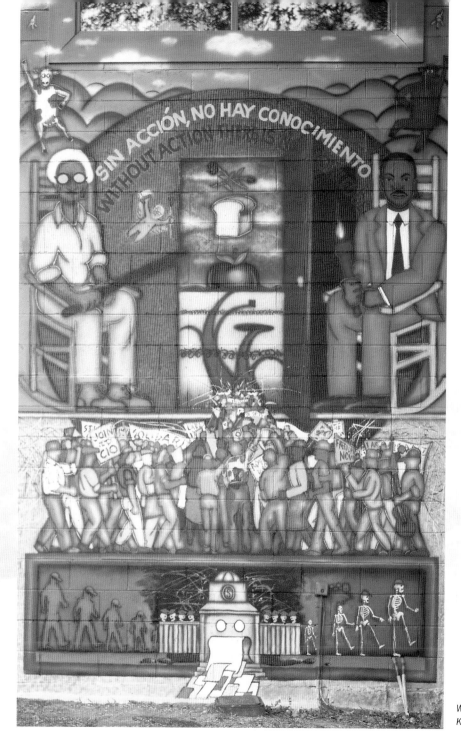

Without Action There is No Knowledge, Highlander Center, 1998

RIGHT: The view from the Highlander Center LEFT: Volunteer working on the mural

renewal scheme. Nothing stopped Highlanders from conducting classes, holding interracial social and cultural events, ceaselessly urging unionism and brotherhood.

Highlander has subtly reshaped southern labor history (and continues to do so today), but grew most famous for its struggles against segregation and institutionalized racism. Fanny Lou Hamer and Rosa Parks both attended Highlander, as did Stokely Carmichael; Martin Luther King, Jr., was a frequent visitor (his presence there considered "proof" of communist influences, according to southern lawmen and J. Edgar Hoover's operatives). On completing the mural, Alewitz proclaimed that—as Highlander had proved—action was the true basis of education, and art's role properly among the educational tools. He had "chosen to dedicate this mural to those educators and activists who have taken liter-

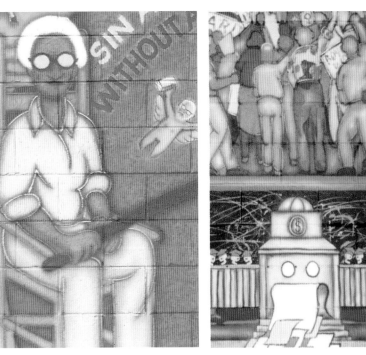

Without Action There is No Knowledge mural details

acy and popular education throughout the world, and who have died in that effort," adding that "whether it be the jungles of Nicaragua, the towns of Chile or the mountains of Appalachia, they are all part of one movement." On one side of the mural can be seen workers from the earlier attempts to organize the CIO in the south,

represented, in part, by a portrait of Tennessee labor organizer Lucille Thornburgh, and on the other side, Martin Luther King Junior and the civil rights movement. The two movements march past barbed-wire, signs in hand, toward bread, roses, and a beautiful apple, at once homage to the agricultural activities of Highlander's residents and also a historic symbol of knowledge. These two movements of what has now become the last century represent the best of our past and the possibilities for the future.

As the monster machines of capital continue turning working people into skeletons, some of them wearing scholars' hats, life and struggle go on. And surely they will, brightened and lightened by the pictures that Alewitz has wrought, a brainy and talented branch of them trained directly or indirectly by Alewitz for a new century of work ahead.

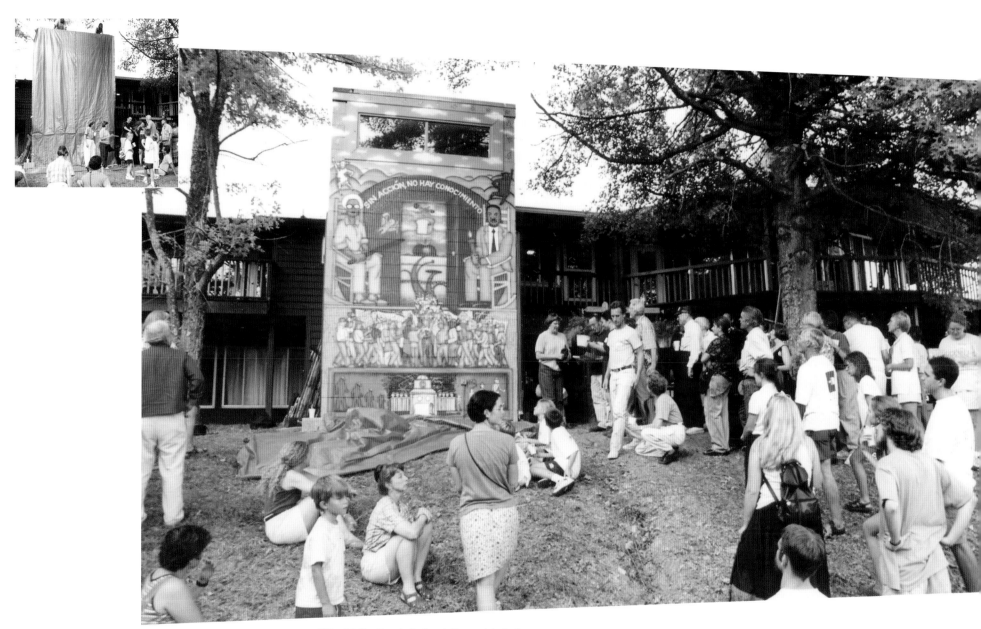

Without Action There is No Knowledge mural dedication,
Highlander Center, 1998

POSTSCRIPT

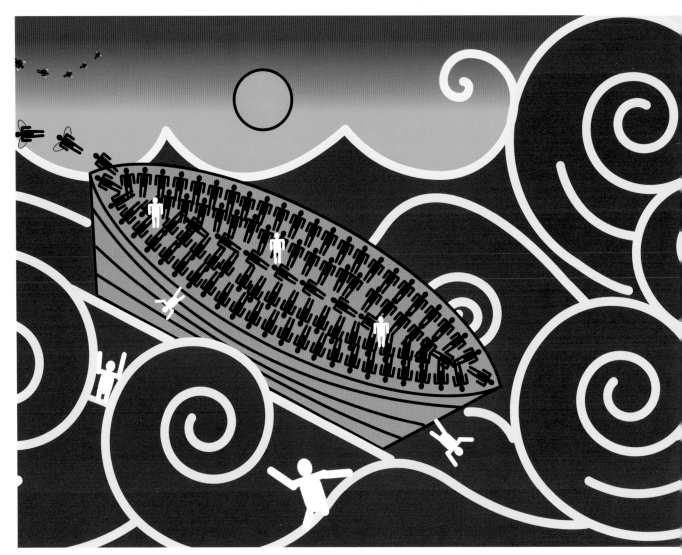

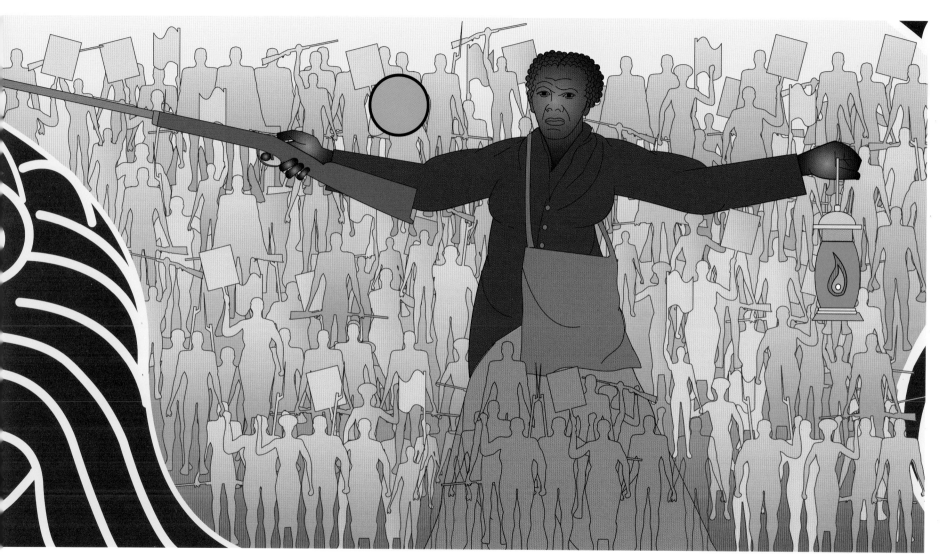

Detail, sketch for *The Dreams of Harriet Tubman*

THE DREAMS OF HARRIET TUBMAN

THE DREAMS OF HARRIET
TUBMAN MURALS
Baltimore, Maryland

In 1999, Alewitz was one of 50 "Millennium Artists" named by the White House Millennium Council, the Mid-Atlantic Arts Foundation, and the National Endowment for the Arts, and invited by Baltimore Clayworks to do a project in Maryland. Through discussions with them, and activists in the Underground Railroad Movement, he developed an idea for a piece of artwork—a series of murals call "The Dreams of Harriet Tubman."

As he began to create the murals, Alewitz ran into problems. *Education for All*, a mural highlighting Tubman's role as an educator, which was painted at a middle school in Harford County, was vandalized with racist graffiti and swastikas.

More seriously, the main mural that was to be painted in Baltimore was rejected by the group for whom it was designed. It showed Harriet Tubman as Moses—armed, militant, parting the seas of reaction. She is overturning a slave ship on one side, and a modern day slave ship—a sweatshop—on the other side. When the mural was declined, Alewitz was asked by the press if he would remove the gun. He refused to do so.

"I don't want a kinder, gentler Harriet Tubman. She was a tough woman who lived in scary times. I don't want to make Harriet Tubman a meaningless icon that hangs in McDonalds to try to get you to buy hamburgers. She was a freedom fighter—and that is how she should be painted."

Monument to Harriet Tubman, back

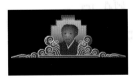

Mural design

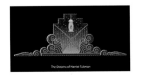

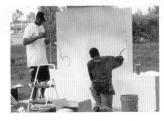

Assistants working on the mural

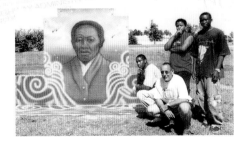

The walls in the Harriet Tubman Park in Cambridge, MD, were built by Baltimore Clayworks and painted by Alewitz

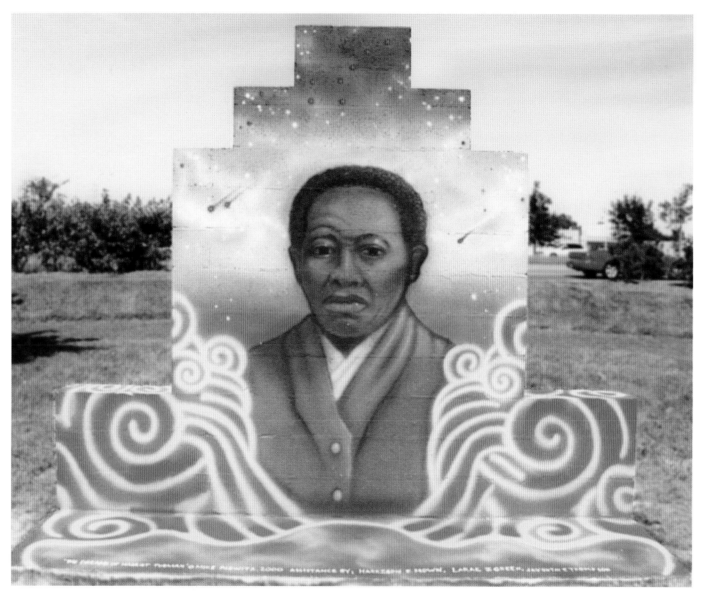

Monument to Harriet Tubman

The following is an excerpt from the talk given at the Magnolia Middle School, Baltimore, Maryland.

MAGNOLIA MIDDLE SCHOOL MURAL

"**Harriet Tubman** was an educator of the first order. She educated thousands about racism and the evils of slavery. She educated about the rights of women. She taught about the rights of working people and the elderly. Education was an important component of her amazing life.

And yet she was illiterate. The slave system from which she escaped was based on keeping African-Americans ignorant of their own great culture and history.

Here at the Magnolia Middle School, the workers, administration and faculty are dedicated to continuing the educational traditions of Harriet Tubman. I am here to give visual expression to that effort. This mural, part of a series of murals called The Dreams of Harriet Tubman, is entitled "Education for All." It is an effort of many individuals and groups, including the Mid-Atlantic Art Foundation and Baltimore Clayworks.

Slavers and northern industrialists alike feared Harriet. She waged an uncompromising struggle against slavery, racism and social injustice. The slave catchers and northern racists could not stop her, and she will certainly not be stopped by misspelled graffiti from a handful of cowards.

The destruction that you see here cannot be blamed solely on a few racists. They are products of growing up in a society that too often tolerates racism—that celebrates the execution of poor black people—that condones inequality in education and employment.

When these criminals are found, it is my fervent hope they will be sentenced to join me on the scaffold to help paint this mural. There, we will discuss and learn about Harriet Tubman, John Brown and Frederick Douglass. We will examine the great civilizations of Africa that gave so much to the modern world, and the history of African-Americans here. We will look at how the wealth of this country was based on slave labor. And we will discuss the inequality that exists in society today, what that means for working people, and how we can organize to change it.

We are going to repair the damage. We are going to complete *The Dreams of Harriet Tubman*. We will continue to paint murals that illuminate the historic events of the past and the problems that facing working people today. We will continue to create a public art and public dialogue that will inspire the young people of today to follow the example of Harriet Tubman."

—M. Alewitz, July 18, 2000

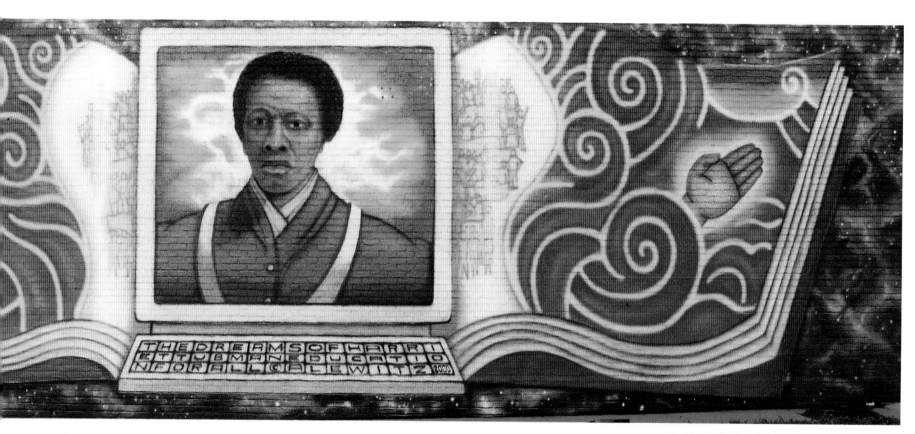

Education for All, Magnolia Middle School, Baltimore, Maryland

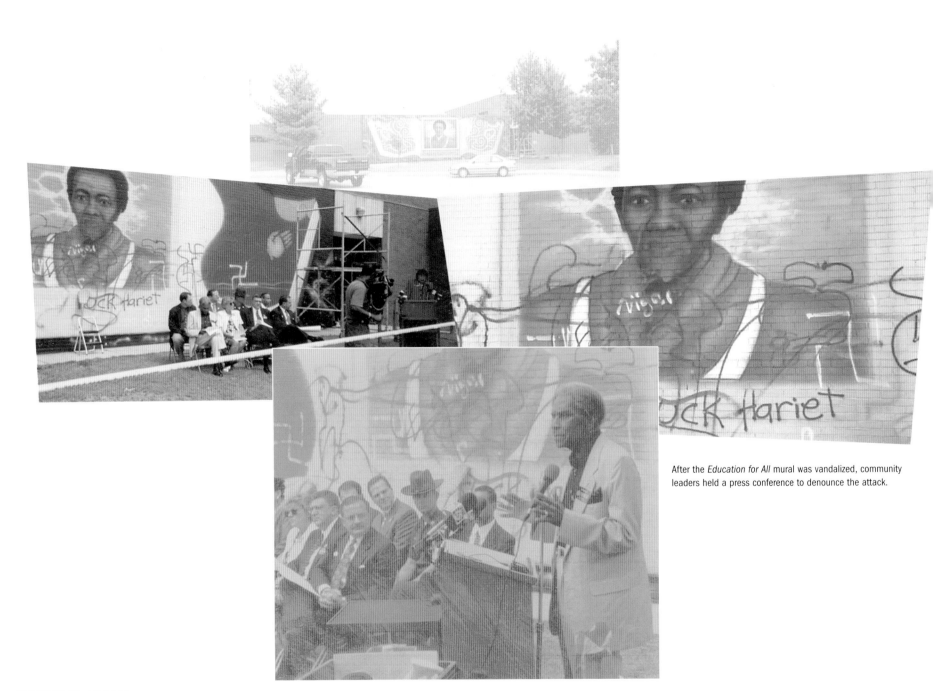

After the *Education for All* mural was vandalized, community leaders held a press conference to denounce the attack.

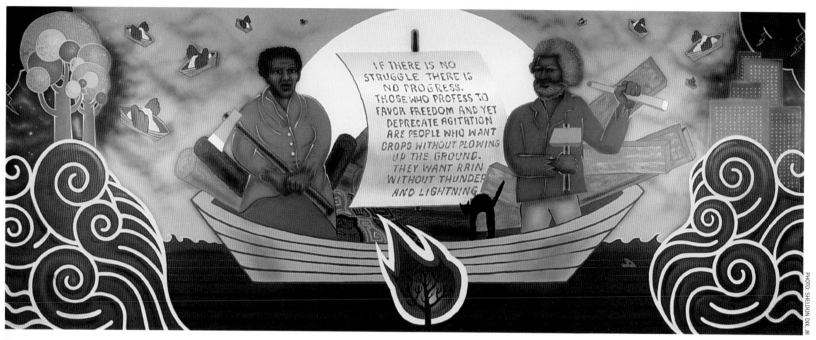

The mural in the Frederick Douglass Library at the University of MD, Eastern Shore. **While Tubman worked as a slave felling trees in the forest, Douglass worked as a ship's caulker.**

Assistants preparing
the mural

Alewitz with mural supporters at the dedication

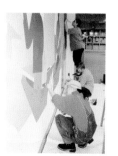

Assistants working on
the mural

MARYLAND
THE SUN

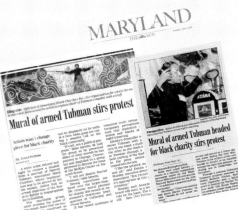

Opinion:
BALTIMORE: GIVE A WALL

"There will be no justice and there will be no peace in this country until the United States faces up to this truth: The great wealth of this country was built on the backs of slave labor."

—Mike Alewitz

The Maryland Sun
July 2000

HE SEES THE BIG PICTURE

"Often splashed across 50-foot walls in brilliant, hard-to-miss hues, the paintings of Mike Alewitz are hard to ignore...But he wasn't quite expecting the attention his Harriet Tubman projects have garnered in Maryland.

The first mural, proposed for the headquarters of the Associated Black Charities in downtown Baltimore, was rejected by the group last month because Tubman was depicted with a musket. The second, at a Hartford County middle school, was nearly complete when vandals painted over it last week with swastikas and racial slurs."

The Maryland Sun
July 2000

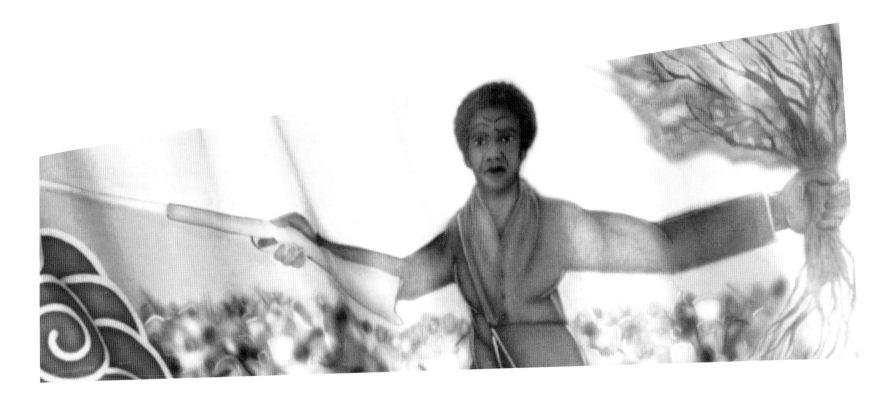

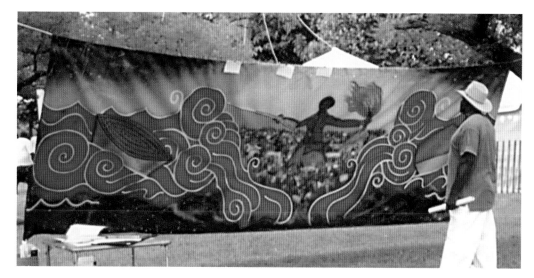

When Alewitz was unable to use a wall in Baltimore, he painted a portable mural with the same image. This mural was unveiled at the AME Zion national convention and has been displayed throughout the country.

UNITE MURAL
Fall River, Massachusetts

The following are edited remarks by Mike Alewitz, LAMP Artistic Director at the dedication of the labor mural in Fall River, MA. They were delivered to a crowd of trade unionists at the building of the Union of Needletrades, Industrial and Textile Employees (UNITE,) on July 30, 2001.

UNITE MURAL

"Some of you probably don't know who Carlo Giuliana is. He was a young Italian activist shot down by a cop while demonstrating in Genoa. After they shot him down they ran over him with their jeep. He was the first to be killed on one of these demonstrations—but he probably won't be the last. There is no important struggle that has not been won at the cost of our blood. In addition to murdering Carlo, many others were beaten and jailed.

Millions of dollars were spent to isolate the government representatives from the peoples demonstrations—but it didn't work. Wherever they go they are met with protesters.

The officials announced at the end of the meetings that they had been traumatized by the demonstrators. They were victims—not Carlo.

They are going to hold their next meeting out in a remote area of Alberta, Canada to try to avoid protests. The WTO is going to meet in Qatar for the same reason.

Of course they can go hide out—but the demonstrations will continue. What we are seeing is the birth of an important new movement. It's made up of trade unionists, environmentalists, anarchists, socialists, indigenous people, human rights activists and many others. It is a movement for global economic justice. What does that have to with a mural in Fall River? Everything. When you drive into this city and look at those stone mill buildings sitting empty, it is a scene repeated in hundreds of cities and towns across the country. You cannot begin to deal with the question of the de-capitalization of this town without confronting the realities of the new global economy. They took the industry and left. They went somewhere else because their profits are more important than the welfare of the workers.

There are two kinds of people in this world: those who work and create the wealth, and those who don't work and take the wealth. That is what we show in the mural. And that is a very frightening idea to some people.

Why did the Mayor of this city try to stop this mural? It's not only the specific image—it's that we are saying we have our own voice. We are workers—we aren't supposed to be telling our story on the walls. We're supposed to shut up and work.

But whenever workers begin to get in motion, they immediately turn to the arts. When the Industrial Workers of the World (IWW) knew they might be getting arrested, they would learn different poems to recite to each other in jail. When the sit-down strikes took place in Buffalo, workers formed an orchestra to serenade the masses from the factory rooftops. When textile workers struck in Paterson, NJ, John Reed organized New York artists to create a great pageant of the strike performed in Madison Square Garden.

We have created this mural in that tradition, because we are looking to the future, to a revitalized labor movement that extends the hands of solidarity to our brothers and sisters—wherever they may be. We are part of a movement that that demands that the obscene profits of the rich—which get greater every day—be used instead for the betterment of humanity.

The protestors in Genoa and Seattle are fighting for such a world. I am therefore dedicating this mural to Carlo Giuliani and the new movement for global economic justice. They represent the future."

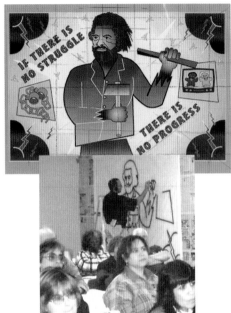

TOP: Portable mural design
CENTER: Creating a portable mural on site

Union members helping to prepare the mural

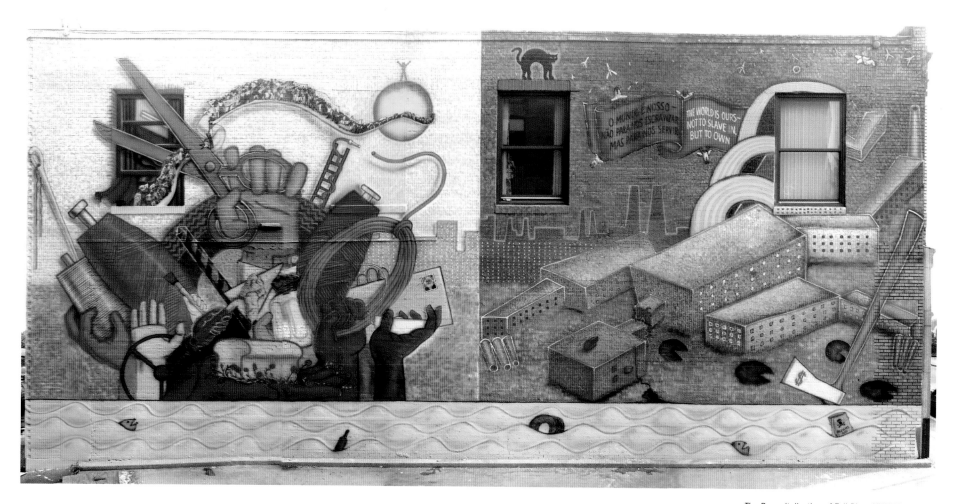

The Decapitalization of Fall River, UNITE Building,
Fall River, MA

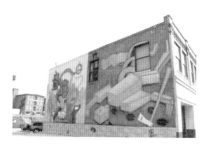

INTRODUCTION

1. Bertram D. Wolfe, *Portrait of America by Diego Rivera* (New York: Covici-Friede, 1934), 11.

2. See for instance Eric Breitbart, "Diego Rivera," in *Encyclopedia of the American Left* (New York: Oxford University Press, second edition, 1998), edited by Mari Jo Buhle, Paul Buhle and Dan Georgakas, 699.

3. The New Workers School originated in an expelled faction of the Communist Party led by Jay Lovestone and Bertram Wolfe; Lovestone later became a key figure in the labor movement's CIA operations, and Wolfe, the biographer of Rivera, a right-wing ideologue at the Hoover Institution. Their group had, however, for a time in the thirties been eclectic in cultural matters and supportive of artistic independence, thus eager for Rivera's mural. The group officially dissolved in 1940, and former members "borrowed" sections of the mural, never reassembled.

4. See *Posada: Messenger of Mortality* (Mt. Kisco, New York: Moyer Bell Limited, 1989), edited by Julian Rothenstein.

5. See Franklin Rosemont, "A Short Treatise on Wobbly Cartoons," in Joyce L. Kornbluh, ed., *Rebel Voices: An IWW Anthology* (Chicago: Charles H. Kerr Co, 1998 edition), 425–44.

6. See Rebecca Zurier, Robert W. Snyder, and Virginia M. Mecklenburg, *Metropolitan Lives: The Ashcan Artists and Their New York* (New York: Metropolitan Museum and W.W. Norton, 1996).

7. Unpublished interview with Hugo Gellert, 1982, by Paul Buhle, archived in the Oral History of the American Left collection, Tamiment Library, New York University. Extremely elderly at the time of the interview, and even after a near lifetime of evolution toward more socialist-realist styles, Gellert remembered his early past and his bohemian circles vividly.

8. See Barbara Melosh, *Engendering Culture: Manhood and Womanhood in New Deal Public Art and Theater* (Washington: Smithsonian Institution Press, 1991), for a sweeping interpretation of the ways in which Works Progress Administration projects tended to reinforce gender stereotypes, nostalgically recalling earlier and presumably simpler days.

9. See "Harvey Kurtzman," interviewed by Paul Buhle on some of these political points, in *Shmate*, #13 (Summer 1981); and the reprinted volumes of *Mad* (West Plains, MO: Russ Cochran, Publisher, 1984), with marginal comments and interviews with participants. R. Crumb and Art Spiegelman, among other artists, have repeatedly acknowledged the key influence of *Mad* and Kurtzman upon them.

10. See the valuable discussion in Maria Reidelbach, *Completely Mad: A History of the Comic Book and Magazine* (Boston: Little, Brown, 1991), 3–41.

11. See Patrick Watson's *Fasanella's City: The Paintings of Ralph Fasanella, with the Story of His Life and Art* (New York: Ballantine, 1973). I wish to acknowledge my occasional meetings with Fasanella at public events, including a panel I shared with him at a conference on Italian-American radicalism, and the strong personal impression that he made upon me.

12. Unpublished interview with Fred Wright, 1982, by Paul Buhle, archived in the Oral History of the American Left Collection, Tamiment Library, New York University. Wright's collections, especially *So Long, Partner!* (New York: United Electrical Workers, 1975), can be found in some libraries. His cartoon history of the industrial revolution was never completed, his experiments with animation were abandoned amidst other work, and some of his most interesting pages, oversized drawings of vacation days, have never been reprinted.

13. See *Bye! American: The Labor Cartoons of Huck & Konopacki* (Chicago: Charles H. Kerr Co., 1987); and *The Labor Joke Book* (St. Louis: Workers Democracy Press, 1986), edited by Paul Buhle. The latter has samples from the handful of interesting labor cartoons from the 1950s–80s.

14. Later AFL-CIO president Lane Kirkland's private collection of highly priced abstract expressionist canvases marked a new phase, obviously: the Inside-the-Beltline sophisticate with no union past and no organic links to blue-collar life. See Paul Buhle, *Taking Care of Business: Samuel Gompers, George Meany, Lane Kirkland and the Tragedy of American Labor* (New York: Monthly Review Press, 1999), for some reflections.

15. Special thanks to Franklin Rosemont, "A Short Treatise on Wobbly Cartoons" for reminding this longtime observer of underground comics about the UCWA. It is interesting that the most class-conscious character of the underground comics, the picaresque "Reed Fleming, World's Toughest Milkman," was a Canadian import, drawn brilliantly by David Boswell and published in Vancouver, rising out of the local underground paper, *Georgia Straight.*

16. Conversations with Trina Robbins are gladly acknowledged here. Her frustrations with male underground cartoonists, who focused so often on sex (and even violence against women) so as to practically exclude social issues, are well known. Likewise, conversations with and communications from Harvey Pekar, Jay Kinney, Art Spiegelman, Bill Griffith, and R. Crumb over the years have helped place the role of the political comic.

17. Eva Cockcroft, John Weber, James Cockcroft, *Toward a People's Art: the Contemporary Mural Movement* (New York: Dutton, 1977); Eva Cockcroft, "Murals," Encyclopedia of the American Left (New York: Garland Publishers, 1990), edited by Mari Jo Buhle, Paul Buhle, and Dan Georgakas, 499.

18. Grace Glueck, "7-Story Village Mural of Stars of the Left," *New York Times*, Sept. 7, 1988. The city's Department of Sanitation issued citations for unauthorized posting of handbills advertising the appearance of a Nicaraguan artist and a violation notice upon the painters' scaffolding, even though such leafleting was common and a permit had been granted for the scaffolding; Mayor Koch, himself deeply involved in U.S. projects to overthrow the Sandinistas, denied any element of political repression. In a further ironic note, the *Times* subheaded the story, "The Social Realist work," obviously confining any non-abstract and politically radical work to something like "socialist realism." A 1989 *Daily News* editorial called it "a colorful, cheery celebration of mass political murder, slavery, repression and human misery."

19. Alewitz's parting shot at the SWP, an internal document titled "What Is the Pathfinder Mural?" was reprinted in the 1991 Art/Work pamphlet quoted below. A later art report, Justin Brown, "Old Revolutionaries Fading Away," *New York Times*, Nov. 16, 1996, noted the SWP had decided to cover the murals' remnants with metal siding, party leaders vaguely suggesting that another mural might eventually take its place.

CHAPTER 1

1. Some early points of parallel interests for this book's artist and writer: Paul Buhle was recruited into the Socialist Labor Party in San Francisco in 1963 and brought back DeLeonism to another midwest community, Champaign-Urbana, Illinois. The infusion was unsuccessful and Students for a Democratic Society soon offered more promise, but the stamp of the syndicalist-minded socialist, famed as a founder of the IWW and best known for his attacks on labor bureaucrats, remained with the writer. Buhle's magazine *Radical America*, published in Wisconsin during the New Left years with a heavy dose of satirical art (including a large admixture of surrealism) might be called a partial precursor to Alewitzian practice.

2. See David Kunzle's authoritative volume, *The Murals of Nicaragua, 1977-1992* (Berkeley: University of California, 1996). For another account, see David Craven, *The New Concept of Art and Popular Culture in Nicaragua Since the Revolution in 1979* (Leweston, NY: Edwin Mellon Press, 1989).

CHAPTER 2

1. Peter Rachleff, *Hard-Pressed in the Heartland: The Hormel Strike and the Future of the Labor Movement* (Boston: South End Press, 1993), 9-56. This is a wonderful mini-history by a longtime local labor activist, Chair of the St. Paul P-9 Committee and a distinguished labor historian. See also Hardy Green, *On Strike at Hormel* (Philadelphia: Temple University Press, 1990). Neither of these works describe the role of the mural, however.

2. See Martin Ritt Interview by Patrick McGilligan, in Patrick McGilligan and Paul Buhle, *Tender Comrades: A Backstory of the Hollywood Blacklist* (New York: St Martins, 1997), 556-70; and Carlton Jackson, *Picking Up the Tab: The Life and Movies of Martin Ritt* (Bowling Green: Bowling Green State University Popular Press, 1994). Ritt, a former college football player in the South, was cast as "the worker" in many 1930s–40s stage dramas, and treated racial working class themes in many of his other films, such as *Sounder* (1972).

3. Meridel Le Sueur, "They Want You to Perfume the Sewers," speech presented to the Alliance for Cultural Democracy conference in San Francisco, 1988. Daughter of Arthur Le Sueur, a leading figure in the farmer-labor movement, Meridel had been an actress in 1920s silent films, a much-acclaimed writer of the 1930s, and a survivor into the regional radical movements of the midwest and plains states of the 1950s-80s. See, e.g., Elaine Hedges, "Introduction," to Le Sueur's *Ripening: Selected Work, 1927-1980* (Old Westbury, NY: Feminist Press, 1982).

CHAPTER 3

1. The best coverage is Bill Onasch, "Pittston Strike: Pivotal Battle in Coal Field War," BIDOM [*Bulletin in Defense of Marxism*], September, 1989, excerpting an essay by Peter Rachleff from the St. Paul Pioneer Press-Dispatch. Thanks to Paul LeBlanc (an editor of BIDOM) and Peter Rachleff for making these sources available.

2. Eric A. Gordon, "People's Art Tears Through L.A. Tinsel," *Guardian*, June 20, 1990.

3. On a comical note, the pro forma dedications of such murals dedications posed union leaders at the podium, unaware of the figures of Marx, Lenin and Rosa Luxemburg behind them, only slightly disguised and clear enough in photos of the event.

4. Eric Gordon, "Mike Alewitz Strikes Again and Again," *Heritage* [newsletter of the Southern California Library], Spring, 1994. Indeed, Alewitz devoted his talk to the undocumented workers and their children, support that the late Chavez himself had been most unwilling to extend to "illegals" but which the subsequent farmworkers' leaders embraced.

5. Among the signers of a statement calling artists to support the labor party was Rudolf Baranik, the Lithuanian-American modernist painter who helped organize Angry Arts against the War in Vietnam. The occasional magazine *Cultural Correspondence*, published and edited by Paul Buhle from the middle 1970s to 1981, became (under the new editorship of Jim Murray) a de facto organ of PADD. A not-so-near miss: the artist and author of this book's text did not meet until the birth of Scholars, Artists, and Writers for Social Justice (SAWSJ), which sought to build upon the 1995 "palace revolution" and semi-reform of AFL-CIO leadership.

6. "Work Week," *Wall Street Journal*, Oct.17, 1995.

CHAPTER 4

1. See Alfred Young and Terry J. Fife, with Mary E. Janzen, *We the People: Voices and Images of the New Nation* (Philadelphia: Temple University Press, 1993), which contains a careful analysis of the labor icons of the age. See also Paul Buhle and Edmund Sullivan, *Images of American Radicalism* (Hanover, MA: Christopher Publishing House, 1998) for a sampling of these images and contextualization of them within American labor iconography at large.

2. A cogent summary of the labor party movements can be found in Franklin Rosemont, "Workingmen's Parties," and David Montgomery, "Farmer-Labor Party," in *Working for Democracy: American Workers from the Revolution to the Present* (Urbana: University of Illinois, 1985), edited by Paul Buhle and Alan Dawley, 11-20 and 73-82.

3. See Paul Buhle, *Taking Care of Business: Samuel Gompers, George Meany, Lane Kirkland and the Tragedy of American Labor* (New York: Monthly Review Press, 1999). Several unions, notably the California Nurses Association and the United Electrical Workers, endorsed Ralph Nader's candidacy in the 2000 election.

4. "Resolution on Cultural Work," Adopted uanimously by the Cultural Workers & Artists Caucus (CWAC) of the labor Party, May 31, 1996.

5. *Murals, the People's Art: Remembering Our History for Tomorrow*, Oil, Chemical and Atomic Workers illustrated pamphlet, n.d. [1996].

Acknowledgments

MURAL PAINTING IS ONE OF THE BEST JOBS available under capitalism. You look at the world from the top of a scaffold. You paint, listen to music, enjoy the sunshine, discuss art, get into political arguments, join picket lines, go on demonstrations and make fun of the ruling class. Everyone compliments you on your work as if you did it all by yourself. Actually, mural painting is a process that involves lots of people.

Here are some of the many people who contributed to the work described in this book:

My parents, Beatrice and Sam Alewitz, taught me working-class principles. They taught all their children that money was not important. This was a lesson we learned well...none of us has any.

Paul A. Rasmussan had some money, though, and with his generosity we were able to produce this book. We will always be in his debt.

The financial support from the dedicated folks at the Puffin Foundation and the Mid-Atlantic Arts Foundation was essential for the completion of many of the projects described in these pages, and in the case of Puffin, the production of the book itself.

The members of the advisory board of the Labor Art & Mural Project (LAMP) deserve thanks for their willingness to lend their names, without conditions, to our often controversial work.

My friend Bob Allen had his hand in a lot of this work. His insight and good humor are always appreciated.

Others who gave their moral, financial, personal, or political support to this work include John Ruhland, Angela Ying, Denny Meally, Thiago DeMello, David Fichter, John Connolly, Helen Lee, John Regan, Jerry Zero, Mona Fox, Mia Kuwada, Gary Huck, Joe Uehlein, Rocky Delaplaine, Vic Thorpe, Bill Kane, Tony Masso, Wells Keddie, Tony Mazzochhi, Fatin Musa, Bob Wages, Phylis Ohlemacher, Marina, Angelica Santamauro, the Kambiz Group, Melissa Singler, Gary Meske, Eric Gordon, the Persky Family, Sonia Cano, Jim Sessions, J.R. Horne, Lowry Burgess, Brant Mazlowski, Jessica Ripton, Judith Helfand, Abe Graber, Rod Holt, Robin Alexander, Deborah Bedwell, Jacqi Warner, and Kim Wilson. This list is by no means exhaustive.

Dumile Feni, Dick Wassen and Meredith Helton, are no longer with us but they shared in the joy of creating this work.

I would like to acknowledge the contribution of all those who censored, expelled, spied on, slandered, ridiculed, red-baited, white-baited, male-baited, shot at, tear-gassed, pepper-sprayed, fined, clubbed, jailed, beat, fired, removed, threatened, sand-blasted, painted over, covered up, or misled me. Your passions have enriched my art.

As this work goes to press, I want to express appreciation to my new colleagues at Central Connecticut State University, who have initiated an important new mural program, and invited me to join them in this effort. Perhaps we will help to educate a new generation of mural painters.

Danielle McClellan adopted this project as her own, and put in a super effort in editing this book. Thanks also to Martin Paddio, and the rest of Monthly Review for their insights and determination to publish this work.

Martin Sheen is all too rare in Hollywood, an artist who acts out of conscience and not out of self interest. It's an honor to work with him, and to have his Foreword.

My friend Keith Christensen, an extraordinary public artist and designer, did an amazing job of grasping the intent of these works and bringing them to life on these pages. He has created something greater than the sum of its parts.

Paul Buhle has absolutely forbidden me to acknowledge that he represents what is best about working class intellectuals, or that what is of value in this book has come from his keyboard, or that his generous nature and revolutionary optimism remain a tremendous inspiration. So I won't.

My long-suffering companion, closest comrade and harshest critic, Christine Gauvreau is jointly responsible for many of these projects. Her critiques and corrections were essential for the creation of this book. Her intellectual honesty and generosity of heart are a daily reminder of what is best about humanity.

Finally, to all the workers whose brave actions laid the basis for this book, to the people with no names, you have entrusted me to give visual expression to your fighting spirit. I will never see or hear from most of you again, yet time and distance will never separate us. I consider you to be the authors of these works as much as I am. Without you I would have nothing to paint. This book is for you.

It is the beginning of a new century. Artists and workers have much to do. There are new political battles to wage. There are walls to paint and bosses and bureaucrats to torment!

MIKE ALEWITZ

Two Sandinos
City Hall, Leon, Nicaragua
Acrylic, Approx. 16' x 10' each part
Collaborative project/ Group Mural
with the Leon Center for Popular Culture
Sponsor: Nicaraguan Ministry of Culture &
Arts for a New Nicaragua
1983

Ventana Banner
Enamel on canvas, Approx. 4' x 8'
1983

Ancient Figure
FSLN Offices
Managua, Nicaragua
Enamel on stucco, Approx. 5' x 12'
1983

Frente Billboard
Installed near Masaya, Nicaragua
Collaborative project with AMLAE,
(Nicaraguan Women's Organization)
Acrylic on plywood, Approx. 8' x 12'

1983

The Few, The Proud, The Dead
Massachusetts College of Art, Boston
Enamel on plaster, Approx. 9' x 15'
1983

P-9 Mural
Austin, Minnesota
With Denny Mealy nd striking
members of Local P-9, United Food
and Commercial Workers Union
Enamel, Approx. 18' x 55'
Sponsored by Local P-9, UFCW
Dedicated to then imprisoned
Nelson Mandela
Sandblasted by UFCW international officers
1986

Farm Workers Portable Mural
Painted on-site Yakima, Washington State
Enamel and oil on plywood, 8' x 12'
Sponsored by the United Farm Workers of
Washington State
Dedicated to the farm workers of Nicaragua
1987

Malcolm X Banner
Painted for an Artmakers exhibition in NYC
Oil on canvas, Approx. 4' x 10'
1988

Pathfinder Mural
Manhattan, 1988
International Collaboration
Oil and enamel, Approx. 70' x 85'
(Censored and mutilated by Pathfinder Press,
1989)

Artwork banner
Enamel on flexel, 4' x 8'
1989

Che
Sandinista Youth Building
Esteli, Nicaragua
Oil and enamel, Approx. 10' x 15'
Sponsored by the JS19
Dedicated to the Cuban Internationalists
in Nicaragua
1989

Ben Linder
NICA School
Esteli, Nicaragua
Enamel, Approx. 10' x 15'
Dedicated to the Internationalistas
who gave their lives in Nicaragua
1989

Mother Earth
Childrens Hospital
Managua, Nicaragua
Enamel, Approx. 8' x 60'
Assisted by Claudia Rocha

Dedicated to the children of Palestine
Sponsored by the Asociacion Sandinista
de Trabajadores de Cultura; Ventana
1989

Solidarity Forever
Painted on site, Camp Solidarity, Virginia
Collaborative project with Christine
Gauvreau and Robert Allen
Sponsored by NY Sign and Display Local &
United Mine Workers Union
Enamel, Approx. 8' x 30'
1989

Camp Solidarity Banner
Painted on site, Camp Solidarity, Virginia
Collaborative project with striking Pittston
miners, Art/Work and UAW Region 9
Enamel on flexel, 4' x 16'
1989

Teamsters Banner
Camp Solidarity, Virginia
Enamel on flexel, 4' x 8'
1989

Holloween Mask
Lithograph
Poster for striking Pittston Miners, used for
Holloween demonstration at Douglas
residence (Paul Douglas was CEO of Pittston)
1989

Eastern Airlines Strike Banner
Donated to striking New Jersey
workers during the Eastern Airlines strike
Enamel on flexel, 4' x 8'
1989

Eastern Airlines Strike Banner
NYC Labor Day Parade
Enamel on flexel, 4' x 8'
1989

Strike Float
Collaborative project with
International Association of Machinists
for NYC Labor Day Parade
Mixed Media, Approx. 10' x 10' x 20'
1989

Justice for Miners
Enamel on flexel, 4' x 8'
1989

The History of the United Mine Workers Union
Commissioned for the 100th anniversary
convention of the UMWA
Enamel and oil on flexel, 7' x 100'
Assistance by Darlene Sanderson, Mike
Eisenminger, Linda Iannacone, Mike Grey,
Alane Poirer, Bob Allen & Bill Kane
1990

Pro-Choice Puppets
Washington, DC
Collaborative project with Art/Work
Mixed media
1991

An Injury to One is an Injury to All
New Jersey Industrial Union
Council Convention
Enamel on flexel, Approx. 4' x 14'
1990

Labor Solidarity Has No Borders
South-Central Los Angeles
Acrylic, Approx. 23' x 48'
Assistance: Juan Garcia, Mauricio Cabrera,
Lydia Velasquez, Spark Bookhart
Sponsor: Social & Public Art Resource
Center and the Library for Social Studies
and Research
Dedicated to the undocumented workers
of the world
1990

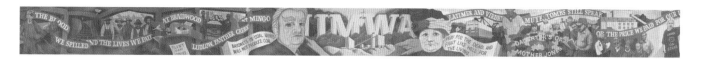

Che Guevara Banner
Enamel on flexel, 4' x 8'
1991

Newspaper Workers Strike Banner
Enamel on flexel, 4' x 8'
1991

OCAW Womens Banner
Enamel on flexel, 4' x 8'
1991

NJ Industrial Union Council Banner
Enamel on flexel, 4' x 16'
1991

An Injury to One is an Injury to All
Los Angeles, California
Airbrushed acrylic, Approx. 16' x 16'
Dedicated to the victims of police violence
Assistance by Nancy Carr and members
of Local 9000 Communications Workers
of America
Sponsored by LAMP, the American Federation
of Television and Radio Artists, and numerous
other locals
1991

The Murder of Shaun 'Unity' Potts
by Sgt Zane Grey of the New Brunswick Police
Taken from the walls of Walters Hall Gallery
and used to protest the police shooting of
the son of New Brunswick union official
Jackie Potts
Enamel on flexel, 4' x 8'
1991

Shaun Potts Banner
New Brunswick, NJ
Collaborative project with Art/Work
Enamel on canvas, 5' x 6'
For community rally against the police
murder of Shaun Potts
1991

Joe Hill
Painted on site, Great Labor Arts Exchange
George Meany Labor Center, Washington, DC
Airbrushed enamel on flexel, Approx. 6' x 8'
1992

The History of the United Auto Workers:
The Battle at Bell Helicopter
Enamel and oil on flexel, 7' x 10'
1992

CLUW Banner
Enamel on flexel, 4' x 8'
1992

Viva Cuba
Enamel on flexel, 4' x 6'
1992

Artists and Workers of the World Unite!
Redlands, California
Airbrushed acrylic on flexel, Approx. 8' x 12'
On site painting at labor culture conference,
Dedicated to Jesse Helms and Tipper Gore
1993

Auto Workers Banner
Labor Day Parade, Philadelphia
Enamel on flexel, Approx. 4' x 16'
1993

Si Se Puede
Oxnard, California
Airbrushed acrylic, Approx. 14' x 14'
Cesar Chavez School
Dedicated to the children of immigrant work-
ers and the children who work in the fields
1993

Textile Workers Banner
Donated to striking Paterson, NJ,
textile workers
Airbrushed enamel on flexel, 4' x 8'
1993

Mother Jones Banner
Acrylic and enamel on flexel, Approx. 4' x 6'
1993

Equal Pay for Equal Work
Banner for conference at the
George Meany Center for Labor Studies
Washington, DC
Enamel on flexel, 8' x 8'
1993

Labor Notes Banner
Airbrushed acrylic on flexel, Approx. 4' x 12'
1993

Newark Teachers Union Banner
Enamel on flexel, Approx. 8' x 12'
1993

Labor Party Advocates Banner
Acrylic on vinyl, 4' x 8'
1994

Patterson Silk Strike Pageant
Haledon, NJ
Recreation Backdrop
Painted in collaboration with students from
Patterson High School
Sponsor: American Labor Museum
1994

Organize/ Organizar
Kennett Square, Pennsylvania
Acrylic on flexel, 7' x 10'
Painted in collaboration with striking
mushroom pickers
Sponsored by the Mid-Atlantic Arts Council
Artist-in-Residency Program and PHILAPOSH
1994

History of the Oil, Chemical &
Atomic Workers Union (OCAW)
Five 7' x 10' banners
1994

Sit Down and Read
Painted on site at George Meany Center
for Labor Studies 25th Anniversary
Washington, D.C.
Acrylic on vinyl, 10 x 10
Sponsored by the George Meany Center
1995

APWU Banner
Acrylic on vinyl, 4' x 8'
1995

Organize Workers/ Agonize Employers
Acrylic on vinyl, 4' x 3'
1995

Viva Zapata
Acrylic on canvas, 7' x 10'
1995

Workers Get Screwed
Acrylic on paper, 4' x 12'
Collaboration with the Cultural
Action Committee,
NJ Industrial Union Council
1995

Tombstones
CWA Demonstration Props
Acrylic on plywood, 2' x 3'
1995

CWA Environmental Banner
Acrylic on vinyl, 4' x 12'
1995

The Worker in the New World Order
Washington, DC
ICEM founding convention, Brussels, Belgium
Five 7' x 10' banners
Sponsor: International Federation of Chemical,
Energy and General Mine Workers Union
1995

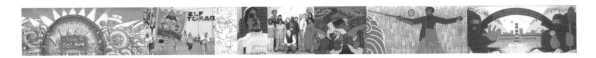

Organize/ Solidarity
Miami, Florida
Acrylic on vinyl, each 10' x 10'
Banners for ILGWU-ACTU
Merger Convention
1995

United Electrical Workers Portable Mural
Burlington, VT
Painted on site at the UE Convention
Acrylic on vinyl, 7' x 10'
1996

*Cultural Workers & Artists Caucus
of the Labor Party*
Acrylic on vinyl, 4' x 8'
1996

Health & Safety Conference Banners
New Brunswick, NJ
Acrylic on vinyl
1996

HERE Banner
NY Labor Day Parade
1996

Labor Party Founding Convention Backdrop
Cleveland, Ohio
8' x 12'
1996

NY Labor Party Banner
NYC Labor Day Parade
1996

Monument to the Workers of Chernobyl
Slavutich, Ukraine
Assistance by: Sergei Shutov, Olga Bondar,
Ksenia Bagrai, Viktoria Cherniavskaia, Olga
Lazarenko, Marina
Acrylic on cement, Two walls—8' x 15'
1996

From the Ashes of the Old
Chernobyl, Ukraine
Portable Mural for the Workers of Chernobyl
Assistance by: Viktoria Cherniavskaia,
Olga Lazarenko, Marina
Acrylic on canvas, 10' x 30'
1996

Oil, Chemical & Atomic Workers
International Union
Convention backdrop
Acrylic on vinyl, 10' x 30'
1997

Scab Free Zone
Painted on site, Seattle Folk Festival
Acrylic on vinyl, 7' x 10'
1997

Teamster Power
New Jersey
Acrylic on vinyl, 4' x 8'
Donated to striking UPS workers
1997

Teamster Power
Teamster City, Chicago
Acrylic on brick, approx 20' x 130'
Assistance by: Mona Fox, Janet Gould, Doris
Mendez, Tom Nightwine, Laurie Johnston,
Steve Matter, Van Barnes, Jim Sylvester, John
McCormick, Timo Rodriguez, Pasquale
Lombardo, Jill Tench, Daniel Romero, Janet
Hotch, Jesse Miranda, Rob Bartlett, Brendon
Reidy, Monica Anton, Dennis Grimes, Dan
Smith, Silvia Lozano, Adriana Saldano, Mark
Postilion, Ed Benesch, John Pitman Weber,
Bernard Williams, Lynda Zero, Gloria, Joannie,
and the many unnamed artists and activists
who failed to sign the volunteer sheet.
Sponsored by IBT Local 705
Painted to commemorate the historic 1997
strike victory against UPS, and dedicated to
the women and men, living and dead, who
built this great industrial union
Photo by Marc PoKempner
1997

The Resurrection of Wesley Everest
Centralia Square, Centralia, Washington
Acrylic on stucco, Approx. 20' x 40'
With assistance from: Amy Eitel, Anne Fischel,
Helen Lee. Bill Henry, Tom Shook, Brian Dow,
John Regan, Sascha Fischel, Jen Shiffert, Ron
Jennings, Ben Winter, Linda Thompson,
George Shader, Echo Tylor, Rebecca Bauen,
Stephen Barlow, Korsch Apusen, Elaine Stone,
Jim Smith, Hugh Crawford, Rita Shaw, John
Ruhland, Yolanda, Bill Anderson, John Baker,
Kathleen Campbell, Jess Grant
Sponsored by the Centralia Union
Mural Project
Photo by Anne Fischel and George Shader
1997

Sindicalismo Sin Fronteras
Mexico City, Mexico
Frente Autentico Trabajadores Auditorium
Airbrushed acrylic, Approx. 8' x 30'
Assistants: Daniel Manrique Arias, Gustavo
Diaz, Eduardo Candelas, Veronica
Hernandez Martinez, Daniel Lopez G., Robin
Alexander and numerous volunteers
Sponsored by Frente Autentico del Trabajores
(FAT,) the United Electrical,
Radio and Machine Workers of America (UE,)
and the Labor Art & Mural Project (LAMP)
Dedicated to those who have fallen in the
struggle for union democracy
1997

Frente Autentico Trabajadore (FAT)
Mayday Banner
Mexico City, Mexico
With Daniel Manriques
1997

Without Action There Is No Education
New Market, TN
Highlander Research & Education Center
Airbrushed acrylic, Approx. 20' x 25'
Assistance by Lisa McCarthy &
other volunteers
Dedicated to literacy and cultural workers

who have given their lives in the working-
class struggle
Photo by Jim Thompson
1998

No Sanctions
Academy of Fine Arts
University of Baghdad, Iraq
Assistance by Fatin Musa and volunteers
Acrylic, Approx. 12' x 18'
1998

Temporary Sanity
Roosevelt School
New Brunswick, NJ
1999

Explosion
Memorial Library, Lodi, NJ
1999

The Creation of Wealth
Frederick Douglass Library
University of MD, Eastern Shore
2000

Education for All
Magnolia School
Joppa, MD
2000

The Decapitalization of Fall River
UNITE Building
Fall River, MA
Approx. 25' x 50'
2001